THE·STATE·OF·THE·ART

THE·STATE·OF·THE·ART

ARTHUR C. DANTO

PRENTICE HALL PRESS

· NEW YORK ·

Published by Prentice Hall Press
A Division of Simon & Schuster, Inc.
Gulf+Western Building
One Gulf+Western Plaza
New York, NY 10023

PRENTICE HALL PRESS is a trademark of Simon & Schuster, Inc.

Library of Congress Cataloging-in-Publication Data

Danto, Arthur Coleman, 1924–
The state of the art.
Originally published in *The Nation,* Oct. 20,
1984–September 6, 1986.
Includes index.
1. Art, Modern—20th century. 2. Art. I. Title.
N6490.D24 1986 701'.1'80973 86-25193
ISBN 0-13-770868-8

MANUFACTURED IN THE UNITED STATES OF AMERICA

10 9 8 7 6 5 4 3 2 1

FIRST EDITION

For
Elizabeth Pochoda
and
Ben Sonnenberg

ACKNOWLEDGMENTS

PORTIONS OF THE PROLOGUE APPEARED IN "MORE THAN MEETS THE EYE," MY contribution to a symposium on the state of contemporary art in *The Soho News* of September 23, 1981. The final chapter, "Approaching the End of Art," is a considerably revised version of my lecture in the series of Distinguished Lectures on American Art and Culture of the Twentieth Century, delivered in February 1985 at The Whitney Museum of American Art. I thought the Whitney displayed exceptional generosity of spirit in inviting me to speak under its auspices when I had written so severely of certain of its exhibitions, and most particularly of its Biennial, and I am grateful to Russell Conner and to Thomas Armstrong for this gesture. It greatly amplifies views on the End of Art, which I have published elsewhere.

The remaining pieces appeared first in my column on art for *The Nation,* and, besides Elizabeth Pochoda, I am most particularly indebted to Maria Margaronis, a demonic rescuer of drowning prose. Many of the exhibitions were seen in the helpful company of my wife, Barbara Westman. The book owes its existence to the enthusiastic effort of Philip Pochoda, and to the sympathetic labors of Kathy Kiernan, Randi Reich, Tracy Behar, and the design department at Prentice Hall Press.

CONTENTS

Prologue **1**

1 BLAM! The Explosion of Pop, Minimalism and Performance, 1958–1964 **8**

2 Van Gogh in Arles **13**

3 Leon Golub **18**

4 "Primitivism" in 20th Century Art **23**

5 Post-Graffiti Art: CRASH, DAZE **28**

6 Lee Krasner: A Retrospective **33**

7 Jonathan Borofsky **38**

8 Julian Schnabel **43**

9 Robert Motherwell **48**

10 The Age of Caravaggio **53**

11 De Kooning's Three-Seater **58**

12 Kandinsky in Paris: 1934–1944 **62**

13 Henri Rousseau **67**

14 The Albertina Drawings **72**

15 The Whitney Museum's 1985 Biennial Exhibition **77**

16 Mistakes Of Blank (Forming Space) **81**

CONTENTS

17 The New Path: Ruskin and the American Pre-Raphaelites
 George Inness 85

18 *Tilted Arc* and Public Art 90

19 Marc Chagall 95

20 Kurt Schwitters 101

21 Works on Paper 106

22 The Vietnam Veterans Memorial 112

23 Public Art and the General Will 118

24 The Thaw Collection 124

25 India! 129

26 Geometrical Abstraction 134

27 Ralston Crawford 140

28 Henri de Toulouse-Lautrec 146

29 Transformations in Sculpture 153

30 The Sculptures of George Sugarman 159

31 Jennifer Bartlett 165

32 François Boucher 171

33 Richard Serra 177

34 Dürer and the Art of Nuremberg 183

35 Diego Rivera: A Retrospective 189

36 The Vital Gesture: Franz Kline in Retrospect 196

 Approaching the End of Art 202

 About the Author 221

 Index 222

THE·STATE·OF·THE·ART

PROLOGUE

POLUS: What sort of an art is cookery?
SOCRATES: Not an art at all, Polus.
POLUS: What then?
SOCRATES: I should say a routine . . . for producing
a sort of delight and gratification.

—Plato, *Gorgias*, 462

IN AN ESSAY ON THE CLASSIC SAUCES OF FRANCE, A CONTEMPORARY FOOD writer compares the gourmet's pleasure in them with the pleasure to be derived from painting: "The eye is pleased while the mind explores the esthetic windings of a technology and willed structure." So the sensualist goes to Colmar for the Isenheim Altarpiece, awarded three stars by the green Michelin, and to Illhaeusern for the *sauce poivrade grand veneur,* awarded three stars by the red Michelin, depending upon whether he is bent upon ocular or gustatory delectation.

The ancients, who thought art dangerous enough for its practition-ers to be exiled from the ideal republic, or at best heavily censored, were as contemptuous of cookery as they were of rhetoric, both of which they regarded as ways of flattering the senses. So it would have astounded them that art, as an activity close enough to philosophy to be its rival, should be bracketed with an activity Plato ranked scarcely higher than fashion. It would have equally depressed the heroes of modernism to see their complex and demanding work viewed as little different in kind from galantines and cakes. Part of the complex conceptual revolution fought by modern art has been to de-estheticize the artwork—not out of some

perverse endorsement of uglification, but because some deeper identity than that of compounding visual sauces for the eye of the artlover has always belonged to art. The struggle has been to retrieve this identity from the esthete. On the other hand, treating art as little more than pleasure-giving might be a brilliant way of disarming it. If it could be kept together with fine tailoring and haute cuisine, its fearful powers might be tamed. Certainly a great deal of the philosophy of art has treated art as little more than occasion for gratification. If philosophers concur in this, why expect more from critics?

Recently I read through a file of *The New Yorker* from the middle 1950s and was struck by the resemblance between art criticism as practiced there and restaurant criticism as widely practiced today. The food critic compares dishes, makes recommendations, advises on the evenness of quality and service over time, carps, ecstacizes, keeps track of reputations, bestows or withdraws stars. And this, more or less, is what the art critic of *The New Yorker* did in that era. The reader was counselled on what galleries to visit, which artists were presenting what dishes for the refined eye, while the artist himself was measured against the connoisseur's knowledge of what that artist had done before, or what other artists were doing then. In any given column, as many as five exhibitions would be dealt with in as many short, genial and urbane paragraphs. The implication was that artists were bent upon achievements not remarkably, if at all, different from those of chefs: to give pleasure to a clientele sufficiently advanced in taste and discrimination to be responsive to subtleties, artisanship and an occasional audacity. In a way, the art critic was like the famous fop gazing through a monocle at a decorative butterfly, whose annual reappearance on the cover of that singular periodical marks the passage of another year.

The New York art world at that time was a scene of intensity and turbulence. Paintings of astonishing vitality and novelty were being produced by artists whose names are now legend, and who shouted themselves hoarse in protracted boozy debate over the meaning of their art and of all art. A body of world-important work was being made for which a body of interpretative thought was struggling to come to consciousness. It was a period of denunciation and controversy, of competing orthodoxies and of the stunning prophetic optimism given to participants in undertakings of near-religious urgency. It was as though art were being reinvented in its entirety, but this reinvention entailed a subversion of the way even great art from the past was to be understood. To most of this

THE STATE OF THE ART

The New Yorker critic was deaf so far as I could gather from the columns I read, but I do not offer this as a criticism especially of him. His approach was, rather, a structural artifact of the way the critical enterprise itself was conceived. Indeed, it is my sense that the art he was describing shared his view of criticism and defined itself in terms of his sort of educated sensibility and optical refinement. It was nevertheless a style of criticism wholly unsuited to the downtown art of those years, and it would be a cartoon worthy of *The New Yorker* to show its logographic fop peering through his eyeglass at one of the desperately splashed and paint-dashed canvases typical of the New York School. The critics we remember are those who sought, with whatever success, to articulate the structures of thought and meaning that transfigured those wild canvases into works of transcendent power and significance.

A dozen years later, one of these critics, Harold Rosenberg, was hired by *The New Yorker.* This was in the middle 1960s, when the entire art world underwent another change, and when the movement Rosenberg had done so much to bring to an understanding of itself had given way to something altogether different—a style of artistic creativity that mocked the romantic postures and the bombast of Abstract Expressionism. Rosenberg was deeply out of sympathy with the art being made during his tenure as *The New Yorker* critic, and he measured it against a theoretical standard that had no application to it. Had Baudelaire survived into the 1890s, David Carrier once speculated, and continued to celebrate Daumier and Constantin Guys, we would have a parallel to Rosenberg's *New Yorker* period. But beyond that, it was as if Rosenberg had lost sight of the distance between a strategy of critical response and a philosophy of art, as if he had confused a thought that pertained to a moment of high painterly achievement with a definition of art valid for all seasons. Rosenberg is always rewarding to read, unlike his predecessor, whose column simply seemed to amplify some of the identifying phrases the magazine helpfully prints in its listing of current shows. But he was also painful to read inasmuch as one wanted clarifications of the new work that he was incapable of giving.

In fairness to Rosenberg, it must be stressed that philosophies of art down the ages have often been little more than critical responses wildly generalized. Few experiences can be more routinely disillusioning than the standard college course in esthetics, where the student is conducted through a canon of writing that has, typically, so little to do with the art he or she is gripped by as to reinforce a thesis that philosophers philos-

ophize in the void. But in truth the irrelevance of esthetic theory is due to the fact that it has often been a response to a particular body of art, and of limited application to art of another order. Plato, Aristotle, Hume and Kant, powerful and systematic thinkers all, were giving universal validity to thoughts suited to a very local art, so that, in large measure, esthetic theory is a body of criticism concealed as such by the unacknowledged provincialisms of its authors. A work of art is composed of a material object given life by a structure of thought, much as a human person may be regarded as a body animated by a soul. Criticism, in its highest vocation, identifies the thoughts that give life to a work or set of works. A philosophy of art, on the other hand, like a philosophy of the human person, must work out the systematic relationships between the components of works of art in the most general and universal way. And philosophers of art, in my view, have often believed they were doing the latter when they have at most achieved the former.

I believe that philosophy of art, or "esthetics," could not begin to achieve the universality of a true definition of art until art itself had revealed the full dimension of its nature, which did not happen until relatively recently. It is possible to read the history of art as the progressive coming to consciousness of the nature of art—a progress which, for reasons I shall discuss in the final chapter, may have come to an end, making a philosophy of art finally possible. Especially in the twentieth century, when this history of self-revelation accelerated enormously, and as definition after definition emerged only to be overthrown and replaced, was it possible for artists themselves to believe that they had discovered the philosophical essence of art at last, and that nothing that failed to conform to the new criteria was *really* art at all. So in a way, Rosenberg's abrupt generalization only echoed the attitudes and orthodoxy of the artists he celebrated, and it was as disillusioning to them as to him that in a mere decade another contender for the golden bough had seized the galleries and dominated the pages of the influential journals. I can still remember the paint-stained downtown artist shaking his head in disbelief at the soup cans, Brillo boxes and Mickey Mouses the early 1960s brought to the uptown galleries.

Even if he failed in his theoretical ambitions, Harold Rosenberg was for a certain time an exemplary critic of art, having formulated the philosophical thoughts that flickered, like a flame in a jewel, at the metaphysical heart of the works he admired, and which changed the moral geogra-

phy of art. He remains an interesting writer because, unlike the anthologized philosophers, he retained an intimate contact with the concrete works of art that occasioned his speculations. The philosophers were too particular in their scope to achieve the generality to which they aspired, but at the same time too prematurely abstract to give us much insight into the art to which they were responding. Esthetics wanders mainly in a limbo of abstract particularity.

When I undertook to frame the beginning of a philosophy of art, I felt it urgent to work with the most vivid examples I could find—to write, as it were, the art criticism for these examples, and then to show the philosophical limits of these criticisms if they are construed as philosophies of art. My book *The Transfiguration of the Commonplace* proceeds from case to case, and at a certain level can be read as a sequence of critical essays, arranged as a sort of philosophical stairway, in that the limits of each give rise to the basis for the next. It would be a great presumption to suppose that stairway completed in my book, which at best has solved the architecture for the first three or four steps. But at the very least, I felt, each of the steps served as a set of instructions as to how a given work or set of works was to be understood. At the very least the reader of that book would know something about art as it really is.

It would never have occurred to me to write art criticism in its own right, and not as part of writing philosophy, had a phone call not come out of the blue from Elizabeth Pochoda, inviting me to write on art for *The Nation.* I have yet to discover what prompted her reckless summons, but I realized, with the force of a revelation, that the space between philosophy and art was congenial to me, and that there was nothing in the world I would rather do than explore a territory bounded on one side by conceptual analysis, and on the other by the works it had always been my joy to study. It offered an opportunity to bring together two sides of my own life but, even more important, to bring together two aspects of culture that deeply require each other. Kant wrote that concepts without experience are empty and experience without concepts is blind. Criticism, as I practice it, has consisted in giving vision to experience and substance to concepts, filling the void between art and thought with structure.

I was particularly fortunate that the first exhibition about which I wrote was one that sought to chart the transition in New York art between Abstract Expressionism and Pop Art. BLAM! at The Whitney Museum of

American Art, corresponded to just that kind of progress I had tried to articulate in *The Transfiguration of the Commonplace*—a show made to order for someone obsessed with the philosophical history of art. The next show was of a very different order: Van Gogh in Arles, at The Metropolitan Museum of Art, was a magnificent record of a year in that genius's artistic life, and it could not easily be assimilated as an illustration to thoughts I had already had. It called for a fresh analysis and a new concept. As such, it defined the program that was to guide me as a critic through one of the most astonishing seasons in memory. Each show—Caravaggio, Rousseau, Motherwell, the Albertina Drawings—made plain to me that my contribution to the critical enterprise was to raise each work, or body of work, to a certain philosophical consciousness, a different concept for each. Art criticism has to be pluralistic when so understood. It has to take the works on their own terms and find their philosophies for them. Philosophy itself cannot be pluralistic if it is to find a formulation that must apply to all works of art, however various. Because he believed that what was true for Abstract Expressionism must be true for art as such, Rosenberg mistook a critical insight for a philosophical definition.

In the course of that season I began to articulate certain theses regarding the logic of exhibitions themselves, which with a certain mock seriousness I designate *Ausstellungskritik,* in my review of the Thaw Collection. The best example of *Ausstellungskritik* is in the violently misconceived exhibition of "Primitivism" in 20th Century Art at The Museum of Modern Art, which rested on a demonstrably false philosophical assumption. Other examples are the almost equally ill-conceived India! exhibition at The Metropolitan Museum of Art and that same museum's somewhat less misguided display of the magnificent works of Caravaggio. The Whitney Biennial I found hateful, much as I respect the curators who assembled it. My thought is that an exhibition stands to works as a sentence stands to words, and that it says something of great philosophical meaning that works should be thought of in terms of the syntax of different exhibitional structures.

Professor Robert Spector, of Long Island University—a specialist in eighteenth century literature and administrator of the George S. Polk awards—drew my attention to an inspiring passage from an early number of *The Spectator,* in which Joseph Addison and Richard Steele put forward the program they meant to pursue in the journalism for which they are remembered today:

THE STATE OF THE ART

It was said of Socrates that he brought philosophy down from heaven to inhabit among men; and I shall be ambitious to have it said of me that I have brought philosophy out of closets and libraries, schools and colleges, to dwell in clubs and assemblies, at tea tables and coffee houses.

I certainly share Addison's ambition. But I am also ambitious to have it said of me that I have brought philosophy out in order to bring art itself out of the precious precincts of the connoisseur, the collector, the dealer and the rebarbative art writings that obscure the place and importance of art, which of course belongs in whatever is now the equivalent of the coffee houses of Addison's age.

I continue to write philosophy for philosophers and continue to walk the galleries as a spectator. But the happiest moments of my life today are those in which I exist on both planes simultaneously—in the practice of critical writing where I have the opportunity denied by the austere pages of the professional philosophical journal, namely to philosophize in the large way of the earlier essayists. I greatly hope some measure of this happiness is transmitted to their readers through the essays that follow. They are printed in the order of their appearance, as no order other than chronology seemed at all appropriate. Taken as a series, they represent two seasons of critical reflection on the state of the art world, which I seek to define philosophically in the final chapter.

· 1 ·

BLAM! THE EXPLOSION OF POP, MINIMALISM AND PERFORMANCE, 1958–1964

IT IS POSSIBLE TO VIEW THE HISTORY OF PAINTING IN THE PRESENT CEN-
tury as a sequence of revolutionizing questions of increasing scope. Cub-
ism was a narrower investigation than Abstractionism, since it assumed
that painting would remain representational while asking why it must
remain tethered to our optical experiences of the visible world. Abstrac-
tionism denied representation altogether, but assumed all the conven-
tions of pictorial space. Abstract Expressionism broke the identification
between painting and pictorialism by making the act of painting central,
with the work itself but a record of fierce interaction between artist and
pigment. But even this abrupt reduction of paintings to the energy of
their execution assumed all the formal boundaries that segregated paint-
ing from sculpture, from dance, from poetry or music or drama. The final
revolution sought to erase even those, not to speak of the deeper bounda-
ries between art and philosophy on the one side, and art and life on the
other.

"Erase" is too mild a term: "explosion" is more violently apt, and
the inspired exhibition at The Whitney Museum of American Art (until
December 2) surveying the crash of barriers breached or broken in the
hectic period between 1958 and 1964 is appropriately titled "BLAM!"
BLAM! is also the title of a painting by Roy Lichtenstein, pivotal in this
show, which embodies all the revolutions that preceded it and made it
possible by holding them at a distance. It is perceptually equivalent to a
real visible object: namely, what could be a panel from any of the standard
adventure comics of the era; it is utterly pictorial because it is no longer
important not to be; it camouflages painterliness by appearing to be as
mechanically produced as its subject; it internalizes the boundary be-
tween fine and popular art; and it flaunts the boundary between word and

image by presenting the image of a word—"BLAM!"—the violent sound of shell striking plane, sending the pilot spinning from his anguished cockpit. It encapsulates by negative synopsis the history through which the art of our century has defined itself, and stands in defiant liberation from divisions it rejects as arbitrary. It is a perfect emblem of the spirit of its time.

Pop Art drew its energy in part from the fact that it allowed itself everything that had been repudiated as extrinsic to painting by earlier revolutions, in much the same way that triumphant feminists might allow themselves to look "feminine" if it were no longer required to submerge that quality in order to claim their autonomy. From this perspective, Pop would be philosophically equivalent to Minimalist Art—a second category in the Whitney show—which explicitly eliminates what it pleases Pop to tolerate, seeking for a kind of pure, reduced artistic essence through systematic subtraction. Drawing its subtractionist imperative from the history of successive artistic purgations, Minimalism at last arrived at objects—cubes, slabs, planks, poles, metallic squares—that could finally not be told apart from their industrial counterparts in the real world save with reference to the mere concept of art. But this achieved in Minimalist vocabulary what the Pop artist achieved with Campbell soup cans and Brillo boxes and Tide cartons, the domestic flotsam of commercial reality jostled into the space of art by a kind of conceptual determination. Both Pop and Minimalism were in effect philosophical exercises, for each was groping toward something that had finally to be recognized by philosophy itself: whatever was to distinguish art from reality was not going to be something evident to the eye. Once this was acknowledged, the visual arts became detached from the act of vision, and the way was open to fusion with the other arts. And it became a matter of artistic choice what is to be the relationship between work and eye, and whether the eye is to be treated as part of the mind or as an organ of sense that can be stimulated or violated.

The happening, which is the third of the forms arrayed in the Whitney exhibition, addressed itself to breaching the boundaries between art and life by inviting viewers to participate as agents of artistic modification, enabling art to become, reciprocally, an agent for the modification of life. In a moment admittedly more often hoped for than attained, all esthetic distances were to collapse. Allan Kaprow's original happenings were exciting in part because the insulating conventions of gallery space could no longer be counted on to protect work and viewer from each

other, and one entered them with a sense of danger: just to experience the works in the way they demanded required decisions of an order not commonly called for in the moral spaces of museums or theaters. Of course, nothing like this is possible any longer, and the reconstituted happenings at the Whitney are distancing quotations of original environments which the visitor now enters as a tourist, secure in the identities the happenings once attacked, as little in danger of being swamped as the visitors to colonial Williamsburg are of turning into Minutemen.

This is true, I think, even of the spectacular jumble of tires, hundreds and hundreds of them, deployed in the areaway below street level in front of the museum. It reenacts an environment of 1961 which Kaprow created in the *cortile* of the Martha Jackson Gallery. Called *Yard,* it was to have made a transcultural reference to the raked gravel gardens of Zen, and in the manner of Zen it was supposed, I imagine, to illuminate through the sudden shock of seeing worn tires in the atmosphere of refined sensibility the art gallery once stood for. The 1984 reconstitution is vastly augmented in size and number, but it cannot resuscitate the shock. Piles of tires, piles of anything, are what people expect to see in proximity to museums these days. The only avenue for serious shock, at least within the limits of moral possibility, would have been for the Whitney to have allowed some of its more famous holdings—its Hoppers and Averys, Gorkys and Motherwells—to be strewn outside and exposed to the fumes of taxis and buses, or to the tossed butt. We are all prepared to see tires elevated to art, but there is a barrier against seeing paintings demoted to the status commonly occupied by tires. There is a political asymmetry in artistic revolutions, where rude objects clamor for the prerogatives of artistic aristocracy, but aristocrats are seldom flung into alleys or even symbolically junked except by maniacs.

The entire brief period canvassed at the Whitney had, in its own right, some of the properties of its most representative achievements. It was itself a kind of happening, in that no one who entered it knew how it was to come out, and everyone was driven by the most extraordinary optimisms regarding the transformative powers of art. The period began insidiously, under the sullen shadows of Abstract Expressionism, and ended sharply, when everyone became slick and expensive, and the art world became a precinct of the world of high fashion, and the great dealers assumed the role of makeweights in the marketplace of taste. The works here have a tacky urgency, a willed impermanence, which gives the show its air of paradox. For these works were not aimed at museum

installation, but were meant to be effective in some way that is at odds with the apparatus of preservation and connoisseurship and constrained presentation that defines the space of even the liveliest museums. The initiating works of Jasper Johns and Robert Rauschenberg, for example, have the dusty look of memorabilia dragged from the attic. Rauschenberg's legendary combine, in which a lonely tire rings the neck of a stuffed goat, is too fragile now to travel, I was told by Barbara Haskell, to whose superb curatorial enterprise the exhibition is due. There is something grimly comic in the thought of that pretty funny assemblage being kept intact by geriatric measures when it is the destiny of stuffed goats to fall apart. But in a way this is true of almost everything here: in almost every instance ephemerality is given permanence by artificial infusion—a kind of esthetic taxidermy.

The way these works were meant to be effective was the way the political happenings of the later 1960s were meant to be, and one cannot overlook how the spirit of the artworks surfaced in what we refer to as The Sixties (well after Johns and Lichtenstein, Warhol and Oldenburg, Rosenquist and Rauschenberg had become established as cultural monuments) in the forms of protest and confrontation. Politics, it was often enough observed at the time, had become a genre of happening, and protest a mode of theater, and rebellion a style of life. The transformative ambitions of the artists were transmitted, perhaps through the massive publicity these movements received in the popular press, and inherited by the counterculture. And the ragbag thrift-shop look of so many of these works became the costume of political participation in the peace marches and teach-ins, the demonstrations and rock festivals that swept the youth of the world. Much in the way that young people began to "dress for success" and take up positions in the corporate establishment, the prefiguring artworks took on the air of permanence we find among those that made it to the second floor of the Whitney, where visitors wander reverently past crushed automobiles and elaborate rearrangements of shambled furniture.

But here, in suitably temporary quarters on the fourth floor, everything is rowdy and daring and playful and brash. It was a moment of delicious freedom, when the rules of the game became part of the game and everything seemed open. The giant presences of Abstract Expressionism had lost their power to paralyze, and the corporatization of the art world had not yet taken place. The Whitney has given the art world of today a glimpse, shattering in its innocence, of its marvelous, irrecov-

erable childhood. It did not grow up to what it promised, but the boundaries it trampled deserved, mostly, to be trampled, just as the boundaries assaulted in the 1960s deserved, mostly, to be broken. It is often claimed that artworks offer metaphors for life. What the Whitney has done is to show how a period of art history is a metaphor for social transformation. Its short, boisterous duration is sobering, though it would be nice to believe that the spirit of liberation might live on in society, despite the cautioning rigidities that have overtaken the art world.

There is another perspective under which the exhibit may be pondered: that of the historical counterfactual, which enables us to speculate about what might have become of these artists had the movement not taken place. Rosenquist, and certainly Warhol, were so congruent with the movement that gave them prominence that we cannot imagine an identity for them outside it. Oldenburg would have been a master whichever way art had gone, and Judd might have been. So might Lichtenstein, to judge from two exuberant drawings of 1958, though of Bugs Bunny and Mickey Mouse. I am provoked to this reflection by a haunting, even exquisite portrait collage by Tom Wesselmann, as luminous as an old master. Wesselmann is represented here by later works, irreverent and audacious, incorporating the appurtenances of bathrooms and kitchens. And he went on to paint his variations on the Great American Nude, pink, heavily nippled female forms with neat pubic triangles, bathing and lounging, like plastic cutouts of the women of Bonnard. They are fine, sassy pieces, but the collage of 1959 is a poem, and it induces a nostalgia for the artist Wesselmann might have become and for the art world in which he might have become it. Of course this might be only a deflected nostalgia for a world in which such an art world would be possible rather than the one to which, considered now as social documents, these works were a collective response.

· 2 ·

VAN GOGH IN ARLES

ON DECEMBER 23, 1888, VAN GOGH CROPPED HIS FAMOUS EAR. ELEVEN DAYS later, on January 3, Nietzsche flung himself, weeping, across the neck of a horse being flogged. I am uncertain what, if anything, to make of the fact that the most advanced painter and the most advanced philosopher in Europe should have gone spectacularly into madness at so nearly the same moment. But the parallels are worth considering. Both men were northerners, drawn south to "the orange-gold land where the lemons flower" by the promise of a healing warmth and light. Both were medical cranks, watchers over their wasting bodies, complainers of surprisingly congruent symptoms. Passages in their letters could be translations of each other in their litany of physical pain and malfunction—eyes, brain, stomach, bowels. Each sought a kind of domestic love so consistently denied him that one must infer a deep sexual unattractiveness. So both resorted to prostitutes—the *grues et grenouilles* ("cranes and frogs") that figure as rebuses in one of Vincent's uncharacteristic visual puns—to whom one supposes the fateful pathogens of their breakdowns were due. In both cases, insanity climaxed a decade of intense, transformative activity, during which neither was appreciated outside a circle of negligible diameter.

When recognition came at last, both seemed instantly accessible to audiences which knew little of philosophy or art. Nietzsche remains the philosopher of those who do not read philosophy, while the Van Gogh reproduction has been the standard decorative touch in middle-class living rooms throughout our culture. And finally, the biographical realities were so vivid as to provide universal mythic paradigms of true genius —so vivid as to make it all but impossible to think of their work save in the context of the experience it came from, rather than in the wider

historical framework of the discipline each revolutionized and made anew. But, in fact, this response is justified by the theories each stands for. Nietzsche taught that philosophy, his own presumably included, is essentially confessional, the projection onto the screen of the world of the thinker's own will and perspective. And though a degree of expressiveness is to be found throughout the history of art, one cannot overestimate how much our perception of its existence is due to Van Gogh, who knew that he was bending representational accuracy to expressive ends; each of his works must be understood as a response to a scene or a moment transfigured by his feelings. So there is a singular appropriateness in an exhibition that maps his work against the chronicle of his life.

Van Gogh in Arles (at The Metropolitan Museum of Art until December 30) is a curatorial triumph in saturated pictobiography, covering the climactic period in the artist's truncated creative life: 444 days in the Provençal town, supposed to be "the land of the blue tones and gay colors." It begins in a daze of almost ecstatic optimisms, as Van Gogh embarked upon what he hoped would be an adventure in artistic, personal, social and moral fulfillment, an exaltation of love and color. It ended, of course, with the violent clash with Gauguin and the legendary mutilation. Subtracting the stretches of ill health and the struggle to establish the fragile and finally futile routines of mere living, it was a time of total artistic productivity: 200 paintings, many of them large; about the same number of letters, in effect esthetic reflections as well as analyses of the paintings he copied for his correspondents; and a hundred or so watercolors and drawings.

It is clear that he cannot have spent any great time on single works, and indeed he often did several in a single day—one of the two versions of *L'Arlésienne* was painted up in less than an hour. The parallel with Nietzsche's rhythms is exact, at least if we construe the relevant literary unit not as the book (though he published a book a year in the decade of his power) but as the aphorism or the short essay, which he composed with the same intensity and urgency as Van Gogh did pictures, striding about much the same meridional landscape some kilometers to the east. The severely abbreviated *durée* of these works has to connect with the temperament the two figures shared, and the artistic and philosophical agenda each evolved to justify a style of creativity neither could especially help.

The first room of the exhibition shows a number of the fourteen

orchards Van Gogh painted in March and April 1888, in joyous response to an aspect of nature made intoxicating by the harsh cold that had greeted him when, instead of the bath of colored brilliance he had anticipated, he stepped off the train from Paris into a foot of snow. Part of the joyousness must be explained with reference to the congruence between the subject—trees in blossom—and one of the standard motifs of Japanese art, for it was one of his hopes, confided to his brother, Theo, "that looking at nature under a bright sky might give us a better idea of the Japanese way of feeling and drawing." Japanism was a constant spiritual possibility for him: one of the self-portraits deliberately presents his shaved and bony head as that of "a simple bonze worshipping the Eternal Buddha," and many of the late landscapes show the unmistakable angles and proportions of depictions by Hokusai or Hiroshige of bridges or roadways or rivers. The late colors of absinthe, sunflower orange, glassy blue, the red of blood and poppies, have not yet appeared: these canvases have the pale tonalities of the North and the lightly touched surfaces of Impressionism rather than the gouged, plowed viscosities of the late, heavily pigmented works.

Impressionism made Van Gogh possible, since it employed a particularly direct imposition of paint and hence an immediacy of contact between artist and canvas: he could not have achieved the artistic personality we know by means of slow drying glazes or under the material constraints of fresco painting. But much as those first paintings of orchards in flower resemble, with their dabs and drags and iterated brushmarks, the signature of Impressionism, the artistic impulses are perfectly opposed. For Impressionism was finally concerned with representation, with getting the colors of the seen world right—hence the ideologized denunciation of black shadows—and so the movement led naturally to the kind of optical scientism we find in Seurat. But Van Gogh really was concerned with feeling, simply appropriating the inventions of Impressionism as his own vocabulary of expression—the dots of Pointillism, Monet's bright, immediate daubs, the strokes of Cézanne. By August he writes that the Impressionists will find fault, "because instead of trying to reproduce exactly what I have before my eyes, I use color more arbitrarily, in order to express myself forcibly." So it was with drawing. Van Gogh could not have been Vincent through grisaille or silverpoint, or the textural crayoned geometries of Seurat: he reinvented the reed pen, and the lines refer as much to him as to forces in nature—they are realized

energies rather than outlines, emotive rather than depictive. "Could I, in Paris, have done the drawing of the boats *in an hour . . .* just by letting my pen go?"

It is very moving that after the breakdown he wanted to return to the orchards of his Arlesian virginity, a desire frustrated by his prolonged hospitalization. It is very moving as well that one of the final paintings is a view of Arles through blown trees, with a blasted trunk the color of an aged elephant as its main element, its broken, barren branches stuck hopelessly up into the surprisingly cheery sky. But the body of the show is the sequence of images, collectively as famous as any in the history of art, of the bedroom and of his chair, the night cafe, the Zouave, of the Arlesian woman, stacked hay and sheaved wheat suffused with what he ruefully speaks of as "the high yellow note that I attained last summer," when he kept going, as he admits, by means of coffee, alcohol and no food to speak of at all.

The show's terminal painting is the terrifying self-portrait with the bandaged ear, done early in January 1889. Since the lopped ear is the one art-historical fact everyone in our culture may be expected to know, everyone is obliged to work through the show with the foreknowledge of its occurrence: we stand toward the exhibition just as the audience to a tragedy does toward its enactment, knowing things the hero does not know, namely how it will inevitably end. What he was heading for is finally here, in the last room, on the last wall. Wearing a fur hat painted perhaps symbolically blue, the color of ice—the sojourn ended as it began in the gelid southern winter—Vincent stares into the pathetic mirror we saw in the study of his bedroom, his eyes slightly crossed, green as wine bottles. Wherever he is, he is cold, for he is wearing his heavy coat, and the yellow smoke from his emblematic pipe spirals upward, past the maroon band behind him, into the ocher space above, where it disappears in the strokes of lemon yellow which press down like a steady rain of paint.

There is a great temptation to see this painting as an exercise in color theory, with its pedagogic use of complementaries, a kind of lesson in chromatic necessity. It is also tempting to read it as an effort to demonstrate that he was in control again, "an unsentimental and composed self-appraisal," as Ronald Pickvance writes in the superlative and indispensable catalogue. Indeed, at first glance it has the air of an advertisement for something that requires the image of a Dutchman at peace—tobacco, perhaps, or beer, or cheese. But then one has to think of how much fury, how much madness, was being kept at bay, of what moral

energy it required to hold that bandaged slash at an esthetic distance—as so much white to contain the acute greens and yellows, just a curve to balance that of the black-blue edges of the hat. The title could have been *Ceci n'est pas un fou.* And it would have been false. The picture cannot be separated from the man, and the man was lost. It is a mute scream.

It is a relief to round that panel at last and enter the frantic sales place, where the visitor can turn in his tour guide and make his purchases from among the jigsaw puzzles and engagement calendars, the posters and reproductions and finally the postcards where the images somehow belong and where they are safe. Reproductions with an undeniable decorativity, they are actually quite gay. The painted reality on the other hand is shattering, and it takes a particularly strong soul to think of walking through it twice. It makes one think of the horrors of exact recurrence of which Nietzsche made so much.

· 3 ·

LEON GOLUB

TWO PAINTINGS BY LEON GOLUB IN THE 1983 WHITNEY BIENNIAL MADE THE
bulk of the works in that cynical and dispiriting exhibition seem like
meretricious toys. Scraped onto heavy expanses of unprimed, un-
mounted canvas—tarpaulins, in effect—his were images of political ter-
ror, scenes of torture, though their power can only be partially explained
through the unredeemed horror of their subjects. Golub had painted
horrifying things before, in a sense had painted scarcely anything except
horrifying things, but until these extraordinary canvases I had not seen
anything of his that captured the affect of the subjects he treated. Hereto-
fore his *subjects* made us wince, and the paintings seemed merely to raise
questions of taste.

Indeed, those earlier canvases seemed exercises in frustration, as
though the artist had pushed and piled paint, scratched and tormented
pigment until it became a sort of chemical sludge, trying to get it to
incarnate feelings that his subjects unquestionably evoked even if the
paintings never did. This frustration was nowhere more evident than in
the "Napalm" series he painted in response to the enormities of Vietnam
combat. These were images of terminally scorched humans depicted
through scraped, reddened paint, as though the treatment of the paint
reenacted the effect of this most fearsome of chemical weapons. But of
course the distances between surface and subject were too great for the
paintings to do more than show an agony it was almost impertinent to
suppose they could emblemize, and the viewer turned away in embarrass-
ment and discomfort. What had begun as invocation ended as porten-
tousness.

So until quite recently, Golub's paintings have been those of a man
whose moral concerns have coexisted uneasily with certain aspirations for

THE STATE OF THE ART

his art, which seemed doomed to remain mythic. For they were the aspirations of Pygmalion. Pygmalion fulfilled an erotic longing by a magical artistic transformation: the ivory votive image he fashioned of Aphrodite was animated by that goddess, who had until then refused him. Now she lay with him as Galatea, medium transacted into the flesh of love, art become life. Well, something as unlikely as this took place in the Whitney canvases, some magical breakthrough to a power Golub's earlier works failed to coax into paint. And the Whitney canvases turn out to be representative of all Golub's new work, uncannily successful.

Ten of his large recent canvases may be seen at The New Museum in New York City, until November 25, where they are displayed in the context of his early and middle periods. It is always instructive to survey an artistic life in the framework of a retrospective exhibition, but this abrupt and unexpected achievement is a rare kind of occurrence. It is a challenge to our understanding of the creative process—that a painter distinguished chiefly by the intensity of his effort should, as if in answer to his prayer, touch at last on artistic greatness.

The paintings are of terrorists, interrogators, mercenaries, whom we see at work, as it were, with their victims; and at play, as it were, with girlfriends leached of any attribute save those of arid sexual recreation. The victims too are leached of all features save those through which they suffer the methodical inflictions of men past caring. Little by way of information or confession can be agonized out of the trussed and naked bodies, since one victim has his head tied up in a black sack, and another has her mouth taped shut. In one scene of interrogation (not exhibited at The New Museum), the victim is suspended upside down, as helpless as the carcass of beef in Rembrandt's moving depiction, while one of the tormentors examines his instrument to see, perhaps, if it has not been damaged by a body whose bones remain the only agent of resistance. All the figures, perhaps even the victims if we knew their histories, are moral monsters—sometimes black, sometimes white; sometimes with Third World faces, sometimes Yanks; sometimes government forces, as evidenced by jackboots and puffed breeches, sometimes rebels, wearing the anonymous utilitarian vestments, coveralls and fatigues, of the underground fighter. It is as though there is little to choose between the sides, as though it cannot deeply matter who wins or loses. Like mercenaries, they are all on the side they are on, though they could as easily be on the other. They are there for the fun and the money.

The inhumanities are utterly unredeemed, by comparison, say, with

those in depictions of martyrdoms. I once learned of a series of these done by Rubens, and I expected them to be thrillingly deep, since the relationship between martyr and martyrizer has traditionally been as fateful and elemental as the relationship between mother and child, or between lovers. If one believes that suffering redeems sin, then each martyr reenacts the sacrifice familiar from the vast number of crucifixions which after all form so substantial a segment of our artistic culture, and the martyrizer accordingly has a cosmic role to play. But after the decision by the Council of Trent to use depictions of suffering to *cause* vicarious suffering on the part of viewers, Christian art became lurid, as I am afraid Rubens's scenes of martyrdom finally turned out to be—no more capable of augmenting the anguish shown than, say, the earlier paintings of Golub are. These new paintings depict political realities unredeemed by any of the purposes politics is supposed to serve. But they nevertheless have a power that even the redemptive martyrdoms lack—so the power cannot derive solely from the subject matter.

To understand it, it seems to me, we must incorporate as part of the work the relationship in which the artist depicts *himself* as standing to his subjects. For he does not merely depict them, as it were, from without: he engages with these persons as someone who has somehow gained their confidence. It is as though they have allowed him entry into their frightening, airless places. He addresses them as a photographer who seems to show himself almost as indifferent to the enormities he sees as the agents of those enormities themselves are. It is as though he is there, in the same terrible space as victims and tormentors, asking the latter to stop for a moment and pose for what today is called a "photo opportunity." They are asked to say Cheese. And good-naturedly they comply, grinning at the camera, hamming it up, horsing around, waving to the camera, perhaps pointing at what they are working over, as indifferent to it as a mechanic might be to an axle. They might even ask for a copy to send home, so deeply have the realities of suffering receded for them. In a way they act toward the subject of pain the way we as museum-goers act toward depictions of pain.

The same interlocking glances fix the artist together with his subjects in the paintings of mercenaries on their days off: one poses, smirking, with a woman who clutches his crotch. Another woman sits on a black man's knee lolling a suggestive tongue at the camera, waving a bottle. In one painting, a member of the White Squad looks over his shoulder while

he stuffs someone—dead or alive?—in the coffin-shaped trunk of an automobile, and appears undisturbed by the interruption, as though he were thinking, Oh, it's only you. Another time the photographer catches a mercenary with three subdued blacks at pistol point, as proud as a hunter with so many elk.

The power of the works derives from their moral optics, from the fact that the artist has entered the world he had previously been separated from by his noisy surfaces. Of course the new surfaces have a great interest. The figures have the jerky marionettelike quality of some of Egon Schiele's painted portraits. The heads have a kind of Sienese condensation, and their teeth are as memorable as those in Mantegna. By comparison with the earlier work, the paint has almost abandoned the canvas: there remain only dry scrapes, with the tonal feeling of fresco. All the energy is in the complicity between painter and persons with whom he has made a bargain. They are finally like the images of Diane Arbus, which had to be bizarre and extreme in order to raise the question of how she managed to negotiate the photograph. The catalogue says, "The artist's placement of the viewer in a precarious psychological relationship to the depicted scene has become the fundamental mechanism at work." It has not. We are not involved at all because the artist has put himself there instead, at the cost of suspending his judgment. Those men are not looking at us but at him. We see their glances, but we are not seen.

Lately Golub has stressed in interviews that he is only a reporter. The energy of the painting lies in the price the reporter has had to pay in order to get the news: he has to become part of the news by sacrificing a propensity to condemn and by stifling moral impulse. For a moral personality as strong as Golub's this represents a terrible cost. I am not certain that art even in its highest aspirations merits such a cost. But his willingness to shoulder that price gives his work an undeniably Faustian dimension—with the consequence that the political subject has become only one element in a mythic transformation which has morality as another and art itself as a third. The drama is as intense as any the stage holds or can hold.

I could not help but notice that several of the late paintings (and none of the early ones) are owned by Doris and Charles Saatchi, of London. Charles Saatchi is one of the great powers in today's art world, and his acquisitions here put me in mind of a great Socratic question. In the *Euthyphro*, Socrates asks whether the gods love something because it

is good, or whether it is good only because they love it. I used to think that an artist was important if collected by Saatchi, that that was what importance had come to. I now see that it is occasionally possible for Saatchi to collect what is independently important, as these paintings are.

· 4 ·

"PRIMITIVISM" IN 20TH CENTURY ART

IN ONE OF ITS LESS FELICITOUS EFFORTS TO INSTRUCT ITS READERSHIP IN matters of high culture, *Life* once ran a photographic essay on Abstract Expressionism. It consisted of juxtapositions of paintings with objects in the world that resembled them, sometimes quite precisely: heavy black scaffolding silhouetted against a blank sky went with a painting by Franz Kline; tangles of waterweeds were put next to a Jackson Pollock, perhaps —my memory here grows vague—faded and peeling posters on a worn fence, a found collage, were placed beside a Willem de Kooning. All this was meant to reassure readers that these new and perplexing artists had not really abandoned the mimetic imperatives of Western art but had merely changed the subjects to be imitated, copying fragments of reality heretofore neglected. The implied rule of appreciation was to treat the paintings somewhat like the photographs of most-wanted criminals in the post office: carry the image around until you find something to match it, then collect your reward. It would be difficult to think of a more serious perversion of the art movement this essay set out to clarify. If the artists in question had not altogether forsaken what was referred to as The Image, they never used images in the manner of exact resemblance that the *Life* juxtapositions required.

I am reminded of that dim didactic effort by the publicity for "Primitivism" in 20th Century Art at The Museum of Modern Art, which sets beside one another examples of primitive and modern art: an elongated Nyamwezi effigy is yoked with Alberto Giacometti's *Tall Figure* of 1949; a Zuni war god is put alongside Paul Klee's *Mask of Fear* of 1932; a Mbuya mask from Zaire keeps company—both have concave noses!— with one of the heads from the right side of *Les Demoiselles d'Avignon,* and so on. All this is placed under the teasing title "Which is primitive?" The

difficulty of answering that question on the basis of visual data alone—there are, admittedly, the resemblances, making the title teasing in a different way from, say, placing a wigwam beside the Château de Versailles—is doubtless meant to make the observer rethink his or her concept of primitivism. If those dark exotic cultures could produce objects indistinguishable from artworks produced by some of the most celebrated artists of our culture, well, either they are not so primitive or we are not so advanced as we might have thought. Nothing, I believe, could more seriously impede the understanding either of primitive or of modern art than these inane pairings and the question they appear to raise.

If there is a single lesson to be learned from recent philosophical analyses of art, it is that it is possible to imagine objects that are visually indistinguishable though one is a work of art and the other not; or where both might be works of art with such different meanings, styles, structures, references and thematizations that their perfect resemblance is incidental to any point save the demonstration of its irrelevance. That lesson could be nowhere more usefully kept in mind than in approaching so stupendously misconceived an exhibition as the present one, which obligingly deconstructs itself by making that very point midway through. Next to an Ibibio mask from Nigeria is installed Edvard Munch's celebrated lithograph *The Shriek*. The print provides the visual equivalent of an auditory phenomenon in that we not only see that the woman on the bridge is screaming, we in effect *see the scream*, since the artist has transduced the landscape into a pattern of soundwaves. The mask, like Munch's screamer, has an open mouth, and it is covered with a linear pattern which, if read like the one in the Munch, would yield the stunning interpretation that the mask bears a scream on its forehead. I heard a number of visitors express doubts about this pairing, but had they read the guide booklet, they would have seen it was made precisely to raise that doubt. "This association would be fortuitous on the formal level," the booklet reads, "and badly misguided with regard to meaning."

But where in this entire display are the pairings not, in this fashion, fortuitous and misguided? Picasso, who collected and admired primitive objects, certainly gave the heads of his crouching demoiselles the power of African masks, but the connotations of primitiveness available to him were scarcely available to the mask makers themselves, for whom masks meant whatever they did mean in the magical transactions of tribal existence, but certainly not whatever heart of darkness Picasso may have meant to paint in a harlot's corner. He was not painting pictures of masks

in the way in which Max Weber painted a Congo figure in one of the still lifes shown, one of the few cases where there is a convincing but almost pointless connection between a primitive and a modern work: the former is the subject of the latter, as if it were a plate of apples or a vase. Nor was he simply borrowing exotic forms, as Victor Brauner did in an awful 1934 canvas which takes over a frightening image of the God A'a from the Austral Islands. Mostly, as with the Picasso, we are told of "affinities," "prototypes," "influences," "reflections," "compelling resemblances," "uncanny similarities" and similar tenuous relationships conveyed with the thin and dreary lexicon of the art-appreciation course. One watches the visitors playing the imposed game of resemblances, pointing with excitement to the meaningless similarities the framers of the exhibition have assembled for their edification. It is an unhappy experience to observe these hopeful pilgrims coerced by as acute an example of museological manipulation as I can think of. The only outcome can be a confusion as deep as that which underlies the entire array.

I don't think we really know the first thing about primitive art, not even whether it is right to treat it as art, however handsome and strong its objects may be. We do not know whether there is sufficient parity of purpose and content among all cultures identified as "primitive" to justify bracketing them together under an overarching designation. Indeed, this habit of identification may be as vivid a transport of cultural imperialism as the concept of Orientalism is according to Edward Said's famous polemic. In one room of the show there is a case with figures from New Guinea, Zambia, Zaire, Nigeria. But what do they have in common, really, with one another, or with objects from Easter Island or the American Southwest or Papua or New Ireland or the Arctic?

One may speculate that whatever ends they serve will not be esthetic, or will rarely be that, and that they typically exist in a universe of forces, powers, gods and magic with which they may put their users in touch. There is in this respect a possible "affinity" with some Western works, Byzantine icons, for example, in which the saints were believed not so much to be depicted as to be actually and mysteriously present. Such a concept of presentness contrasts sharply with the distancing manner of representation that animates a good bit of Western art, including most of the modern works in the exhibition. Primitive art, if indeed primitive in this sense, was not meant for audiences, viewers, dealers and collectors, but for participants and celebrants. The objects are instruments of ritual existence to which the suitable response might be a dance or a howl,

not the peering and pointing that goes on in museums. In saying they are not works of art I do not mean that they cannot be treated esthetically but that treating them so is at odds with their raison d'être. The cultures they came from almost certainly lacked a Western concept of art, and these things answered to something deeper and—well—more *primitive* than art as art can tap.

In a sense, their appropriate habitat in our culture is the glass case of the ethnographic museum, where they squat in a kind of quarantine that underscores their aboriginal dangerousness. The only primitive pieces that look at home in MoMA just now are some exhibited in a case brought over from the Musée d'Ethnographie de Trocadéro to show us where Picasso—"in all likelihood"—made his acquaintance with objects that expressed? influenced? stimulated? reinforced? his own use of primitive motifs. Liberated from their cases, allowed to be perceived as "art objects," they become decorative touches destined for tasteful interiors, as in the failed Rockefeller Wing of the Metropolitan Museum, which looks like a detached segment of Bloomingdale's. Because we only know how to treat these objects as artifacts or *bibelots,* they are crudely manhandled to suit our own concepts of art: as expressive objects or, more often, as objects which satisfy the ever-ready formalistic premises, enabling curators to do violence to things that have no real business with one another just because they may look enough alike to be perceived as exercises in good design. A section of this exhibition is called "Affinities," grouping objects together with reference to the shallowest criteria of similitude, like seeing faces in clouds. There is no other way to describe wrestling into contiguity a Miró and an Eskimo mask. Under formalist principles, all works are brothers and contemporaries, but at the cost of sacrificing whatever makes them interesting or vital or important.

The idea of such an exhibition is, of course, a splendid one. There is little doubt that primitivism plays the role in twentieth-century art that Orientalism did in the nineteenth century or that classical forms did in the Renaissance. But then what must be shown is not adventitious visual congruities but what these objects meant to artists and how, not especially caring to understand them, they made them their own. Sometimes the impact was moral and transformative, if the same impulses that drove Gauguin to employ aboriginal forms explain as well his going native in Tahiti. Sometimes the connection is more narrowly artistic. There is the fascinating question of why Picasso and not Braque, both shown here in wonderful old photographs with some of the things they collected, used

primitive objects to recognizable artistic purposes. Here one must conjecture, but the way the primitive masks rearrange features of faces, leaving them all the while identifiable as faces, must have been a powerful stimulus to the art of rearrangement and reinvention that is the mark of Picasso. And perhaps the license furnished by the primitives must enter partially into the explanation of Cubism, even when direct citation of primitive orderings is absent, as from the still lifes and interiors of Braque, who may after all have responded to the same stimuli as Picasso. But to show such things requires something more than finding explicit counterparts for the eye to make out, especially because they may only conceal the vast distances that separate primitive from modern object. Giacometti, for example, did make totemic-looking objects. But the thin presence forced here to share space with the marvelous Nyamwezi figure surely derives from different formal impulses, even if Giacometti "probably saw this particular object." His attenuated figures are drawn up out of their heavy feet in an almost godlike gesture making man out of earth, and possess the verticality of cathedrals.

"Primitivism" in 20th Century Art is a failed product of misapplied ingenuity, a ransacking of the ethnographic collections to compose parallels which yield a triple misunderstanding, first of primitive art, then of modern art, then of the relationships between them. A three-way failure in a show meant to be educational raises serious doubts about how qualified MoMA is to use its exceptional resources to carry out its didactic aims.

· 5 ·

POST-GRAFFITI ART: CRASH, DAZE

WHEN TONY SILVER AND HENRY CHALFANT SET OUT A FEW YEARS AGO TO MAKE a film about what they perceived as the endangered culture of the South Bronx—graffiti, break dancing, disco rapping—their motives were, in a sense, ethnographic. Those forms of expression *were* endangered, but not quite in the way the filmmakers had supposed. By the time their *Style Wars* was shown on PBS to wide critical acclaim, the entire Hip-Hop culture had moved horizontally through suburban culture, where it was already beginning to fade, and vertically into the reaches of high culture, where it was appropriated by artists very different from those who had invented it. Break dancing had been incorporated into ballet, rapping doubtless awaited an operatic future and the idioms of graffiti had been internalized by painters who lived far from the violent matrices of ghetto streets. Hip-Hop culture was thereby gentrified from two directions, to the marginal advantage of its originators. Rappers, to be sure, made tapes, at best an ephemeral monument; breakers, thin and tough as rope, instructed members of the leisure classes who saw in their contortions the next thing after yoga and jogging. But the writers, as they called themselves, were scouted by the art world and, for the first time, cash became a factor for young men and women who had heretofore operated for glory and beauty alone. The most dispiriting sequence in *Style Wars* shows these young knights of the spray can being lionized by crass esthetes.

There can be few developments in the history of art quite so remarkable as that which began with the inscriptions "TAKI 183" which covered New York around 1971 and culminated, almost immediately, in the full-scale subway-car calligram with its elaborate iconography, its brash signatory notations and its witty communications to a population that saw, mostly, disorderly evidence of a municipality held hostage by vandals.

THE STATE OF THE ART.

Sprouting abruptly as mushrooms, a spontaneous art complex as nuanced and structured as that of Siena in the trecento was in place. It had workshops, masters and apprentices; a system of nicknames or "tags" (most artists of the Renaissance are known to us by their tags: Barbarelli as Giorgione, or Big George; Tommaso Guidi as Masaccio, or Bad Tommy; Jacopo Robusti as Tintoretto, or Little Dyer; and so forth); a critical vocabulary; an esthetic code; a philosophy of art; and the elements of an art history. Since the subway system was at once art school and cathedral wall, a preponderance of awful scribbling accompanied the majestic progress of the masterpieces through dank and scary tunnels. Few who observed the visual cacophony from stops in four boroughs were prepared to make fine distinctions, and even those responsive to the masterpieces—those "bouquets of colors from the Caribbean," as Claes Oldenburg described them—had some doubts as to whether the costs were worth the occasional splendor. And everyone was aware that the laws were being broken so that the writers could, as the expression went, "get up." There is little doubt that the consciousness of lawbreaking and its attendant risks was an important element in subway art, perhaps contributing to the decision to work monumentally, since the penalty was the same whatever the scale. But it is important to recognize that writing was not a means for breaking the law. In their own eyes the writers were not brutalizing bourgeois sensibility, like Céline, but enhancing public property to the intended gratification of all and the particular fame of him or her who took such risks for art. Artists have legendarily suffered a great deal to get up—but who took greater chances against greater odds than these?

There had always been some speculation as to how the writers' unquestioned talent might be sundered from the squalor for which they were responsible, and now the social transition has been made, at least by the few who have forsaken the train yard for the uptown gallery and the savageries of the art market. Graffiti continues sullenly in its natural habitat, having been reduced in people's minds to little more than a sociological problem and an administrative headache. But now we can see whether its transplanted gifts can survive—whether the moral luck through which the ivory portals have swung open to outsiders can be exploited as the beginnings of artistic careers.

This is a very different matter from the elevation of popular forms to high cultural levels. One would, for instance, have expected enfranchised artists to incorporate something of the spirit of graffiti in their

works or even, as with Keith Haring, to descend into the tunnels to make a mark on public walls and expose themselves to the same set of sanctions —though to my knowledge Haring has contented himself with stationary surfaces and has not attacked the motile ones of the true subway writer. Super- or hyperrealists might even paint illusionist canvases of flamboyantly embellished subway cars, might even make them life-size. I can imagine a market growing up for salvaged panels from abandoned cars, semiartistic collectibles for authentic lofts. I can even imagine, if Rockefeller were alive, a new wing at The Metropolitan Museum of Art filled with cars purchased from the M.T.A. and generously donated for the instruction and enjoyment of future generations. *My* concern is with what sort of paintings the original writers can make when enabled by patronage to become studio artists working on surfaces rather more standard than the heavy-duty sheet metal of the I.R.T. The spray can may be a genuine augmentation of the artist's toolbox, more promising perhaps than the drip-stick of Pollock, since it facilitates the staining of large expanses without any special compromise in expressive vitality. And after all, a number of jazz musicians have ascended the stage at Carnegie Hall with no notable dilution in the quality of music. Why should DAZE and CRASH not make the same transition upward to the Janis Gallery, a little farther east on 57th Street, slightly to the left of The Russian Tea Room?

I have been shown some pretty classy "burners"—whole cars done in "wild style"—by CRASH and DAZE. I would place them in the A-minus class of writers—not quite up to SEEN, DONDI, BLADE, SKEME or KASE 2 (a brilliant draftsman)—but of fairly high quality on their own turf. I am struck by the fact that they continue to paint under their *noms de métro* rather than as John Matos and Chris Ellis, and that their show is advertised by Janis as "graffiti art"—as though they or the gallery had not enough confidence to display their work without benefit of a sociological excuse. But in candor, I think neither of them could survive without benefit of the pedigree and paraphernalia of the culture that formed them, which raises a question of paternalism at least. I was not even tempted to say something like, Not bad for a graffiti writer, since I think well of graffiti when it is good, and as graffiti writers they are good to very good. But working under the imperatives of gallery artists, DAZE and CRASH, for all the vividness of their imagery and the phosphorescence of their coloration, are pretty feeble. And I find it instructive that this should be so, since I think there is an easy answer to the question, Why? It has to do with training rather than talent. Their trouble is knowing too

little and knowing how to do too little. They need the benefits of a good art school. Energy alone can only carry you so far.

CRASH is the abler artist, I would judge, and a sign of this is that he remains closer to his original success as a writer. He uses his name as a motif, for example, but works it up into a pictography of things that actually crash, as though within the frame of a comic strip. Inevitably there is a suggestion of Roy Lichtenstein, and it is not surprising that CRASH should use certain mannerisms from Pop Art. Pop must have been the first of contemporary art movements to be publicized in media accessible in the South Bronx; the writer FRED did a car with a row of Campbell soup cans in 1980. Since there was very little visible difference between Warhol and a mere advertising illustration, or between Lichtenstein and a panel from a comic book, CRASH and others might have inferred that since Lichtenstein is Art, by authority of the media, and looks just like comic strips, well, comic strips too must be Art. After all, curators in exalted museums make the same inference every day: since Picasso and the primitive look so much alike. . . .

But Lichtenstein was an artist of immense sophistication, steeped in the history of art and in the art world of his time, with a marvelous sense of the semiotics of mechanical reproduction. What he uses wittily and allusively, CRASH employs without any sense of why it is there to begin with. Think of the use Lichtenstein makes of the dot pattern of the Ben Day screen—a mechanical effect carefully painted in by hand. CRASH picks up on such things because they are there, with no clear sense that in Lichtenstein they carry a significance wholly absent from his own work. CRASH uses huge cropped heads, and there is a clever portrait, recognizable, of Keith Haring, with little replicas of Haring's familiar icons running around the rims of his glasses. This is certainly an inspired representation, but in execution it is flaccid: the copies of those icons have none of the energy that they radiate in Haring's drawings. It is simply a matter of control. CRASH cannot draw, he can only copy the outsides of drawings without conveying their life. The energy in every mark Haring makes evaporates in these tentative efforts with the magic marker—so different from the authentic sweep of the spray can of which CRASH is master. He of course cannot go back to his train sides, so he must go forward. I hope he sells enough to go to the kind of school that will liberate him from the compromising status of being an exhibit himself—like that warrior who danced for the opening of the Maori art exhibit at the Met.

DAZE, I think, has made genuine progress toward becoming Chris

Ellis; the forms of writing are vestigial in his work, which chiefly shows images of street people—prostitutes, toughs and musicians—but executed in his adolescent sick greens and reds. His work is affecting without being promising, and his use of collage—cutout heads from subway and bus maps—does not cover the desperate innocence of his endeavor. But here and there are scraps of energy, a certain linear vitality, that suggest potential for a more auspicious order. For all the floundering of art education against the forces of the age, one sees how finally indispensable to the existence of art its discipline is.

The show, alas, closed on December 1, and the meager catalogue put out by Janis will afford a very inadequate idea of the strengths of these writers. I dare say CRASH and DAZE will be seen again, but I fear they will cling, tragically, to the forms that gave them entry to the difficult world they hope to conquer. For a marvelous glimpse of the difficult world from which they have graduated, you cannot do better than get hold of *Subway Art* by Martha Cooper and Henry Chalfant (Holt, Rinehart and Winston), which is full of breathtaking photographs of writers and writing. It is worth comparing with the 1974 text *The Faith of Graffiti* by Norman Mailer (with photographs by Merwyn Kurlansky and Jon Naar), if only to see the stupendous progress this curious art form made before it was, like so much else, co-opted by our insatiable appetite for the raw and the new.

· 6 ·

LEE KRASNER: A RETROSPECTIVE

IN *ITALIAN HOURS,* HENRY JAMES DESCRIBES AN EXPEDITION TO GROTTAFER-
rata, where, he tells us, "I was careful to visit the famous frescoes of
Domenichino in the adjoining church." Domenichino is little known
today, but in his time his Saint Cecilia frescoes in Rome were regarded
as the very apogee of painting; no less an authority than Nicolas Poussin
considered him second only to Raphäel. Poussin's opinion prevailed until
the middle of the nineteenth century, but even the guidebook James
carried claimed that the *Last Communion of Saint Jerome* was "the second
finest painting in the world." A world which contained only one painting
finer than this Domenichino would be a pretty sorry one, James thought,
and he wondered why he himself "drew the line" at a painter who re-
mained "an interesting case in default of being an interesting painter."
Here is what he says: "He is so supremely good an example of effort
detached from inspiration and school merit divorced from spontaneity
. . . an artist whose development was a negation." Domenichino, James
conceded, possessed talent but lacked charm, and his imagination "went
about trying this and that, concocting cold pictures after cold receipts,
dealing in the second hand, in the ready-made, and putting into its
performances a little of everything but itself."

James's assessment—harsher, he realized, than warranted—came
back to me the other afternoon as I stood among the late Lee Krasner's
paintings in the large-scale retrospective given her at The Museum of
Modern Art, wondering why I drew the line at an artist whom esteemed
persons esteem highly. I had gone because I hoped that I might be
bowled over but also because Krasner is more interesting as a case than
as a painter. It is difficult to respond to her save as a shadow of artists
greater than her—her teacher, Hans Hofmann, her husband, Jackson

Pollock, and her luminous contemporaries of the New York School. That she was at least as good as those artists is what this show sets out to prove.

The installation of her work at MoMA does everything it can to suppress shadows. There is no narrative, none of those helpful legends museums post at the entry to an exhibition to orient visitors. It was evidently the curatorial intention to put nothing between the viewer and the work, in the conviction, presumably, that the work could stand on its own. As one enters, there is an enlarged photograph of Krasner in her East Hampton studio, surrounded by paintings. One passes through a vestibule hung with early paintings, all abstract, before emerging into the large spaces given to her mural-size works, which are illuminated by an almost metaphorically uncompromising light. The museum can create a harshly reductive atmosphere when it is emptied of everything the viewer could have used, and perhaps everything the paintings may need, to effect an understanding encounter. How appropriate it would have been, I thought, to have had a few plants about to set off the floral motifs Krasner favored, and to provide a counterpoint of sympathetic reality. Barbara Rose has described a visit to Krasner's studio where she sat, as her hostess made tea, looking at "the huge ferns and plants, the shell and rock collections, the incredible richness of natural forms that she collects to correspond to a life lived richly, organically, bravely, in an art one could describe in the same manner." Here, by contrast, is an incredible poverty of natural forms: bare white walls, labels, light fixtures, guards, alarm boxes. It is not clear that this is the right way to see paintings, or in any case Krasner's paintings. By erasing the appurtenances of life, one erases a certain vitality from the works: the paintings seem driven back into the canvases by the relentless light, as though negatively phototropic.

The one touch of life was the spirited gallery lecturer, who pointed things out to an earnest handful of visitors. The throngs who lined up to check coats, buy tickets, make phone calls, purchase refreshments and even to pee, did not penetrate the austere threshold of a show that was quite empty. She drew attention to the way Krasner "sort of sprayed where Pollock instead dripped," seeming to imply some gender difference in the application of paint: more "misty," she said, "less bubbly." Her charges traced out certain breastlike shapes for one another, but they all seemed as subdued as the paintings, or as intimidated by the clinical constraints of those inhumane spaces.

But I cannot blame the infelicitously sterile installation for my numbness to these works. I had seen, a few summers back, a wonderfully

animated exhibition in East Hampton, curated by Rose, called Krasner-Pollock: A Working Relationship. A good bit of that show consisted of juxtaposed paintings by the two artists, in which it was clear enough that they worked at the same time with the same ideas, and that there was an artistic interchange as part of, perhaps as the basis of, their relationship. In point of history, it could be argued that Krasner arrived at certain solutions first, and if art were like science, where priority matters, she ought to receive a credit denied her by the unkindness of historical accident. A painter of whom I am fond boasts that he had the drip before Pollock, and indeed he can show you an early painting where there is, unmistakably, a drip. But this drip arrived on the canvas from so different a direction that it does not really belong to the same history as Pollock's —something one cannot say, of course, about what Krasner did with paint. Nevertheless, such issues as priority are rendered irrelevant by the differences between a great artist and a very determined one. Pollock's least effort had a life and energy Krasner never touched. He had the indispensable gift of being able to stand aside and allow paint to burst into life, as though he were there only to enable the miracle to take place. And this difference was apparent over and over in that East Hampton show. It had nothing to do with Krasner being a woman or a wife. It had only to do with Pollock being the genius he had to be in order for that much light and power to have surged, through his mediations, into the world. The show at East Hampton was a cruel if well-intentioned conjunction—like the marriage itself, perhaps.

All explicit references to Pollock have been erased at the MoMA retrospective, where the space is wholly Krasner's. Even so, he casts very heavy shadows over the paintings she did under his acknowledged domination, and those shadows cannot be dispelled by the unforgiving illumination of the museum. I was struck by how little would be left of Krasner's work if one could succeed in driving all the shadows away: those of Matisse, Hofmann, Mondrian, de Kooning, the Cubists and the rest. Just consider the vestibule with the early works: *Blue Painting* of 1946, *Noon* of 1947, *Untitled* of 1948 and the collages of shredded canvas glued on linen and daubed over in earth colors. Krasner was no beginner in 1946: she had begun working with Hofmann nearly two decades before and painted steadily, or as steadily as life allowed, ever after. *Blue Painting* looks like a diffident version of Pollock's mode of abstraction from the period just before his discovery of the drip. *Noon* is hieroglyphics, with the paint seemingly pasted on the support in thick curls and whorls, as

though squeezed out of a pastry tube. *Untitled* is dense pale calligraphy, done in the widely approved manner of Mark Tobey. There may have been a dozen artists working in canvas collage. These paintings might have been done by several different people.

A great artist is fully present in each of his or her works, however various the styles. No one went through more styles than Picasso, but every Picasso is unmistakably his. There is no recurrent touch, or whatever may be the pictorial equivalent of voice, in Krasner's canvases. There are only the shadows of other selves, the echo of other voices. Hofmann once said Krasner was one of his best students but "She gave in all the time. She was very feminine." We may discount his ascription of gender to a quality of Krasner's artistic personality, but that quality is nevertheless patent. The little set of abstractions with which the exhibition begins could, if one did not know otherwise, be a group show of minor abstractionists. The whole exhibition is a series of surrenders to artistic personalities stronger than her own, and those surrenders are what enabled her to paint. Even though huge and bold, Krasner's work has something of the art school exercise about it.

It may occur to the visitor that it is odd not to find the sorts of early works one expects in a retrospective, works that show the artist coming to terms with visual reality through the standard genres of representation: still life, landscape, figure study. There are, in fact, some early works, but they figure in the show in a curious way. At the end of the exhibit are certain collages made up of her student drawings cut into fragments and then sliced through with generous blank forms, sometimes angular and angry, sometimes in floral patterns and in the manner of the late decoupages of Matisse. I find it affecting that she should, near the term of her productive life, have found her end in her beginnings, and these collages compose one of the most powerful gestures of the show. She had kept those energized, cubistic figure studies against the time when she might use them, and she evidently emptied her portfolios, slicing and cropping her drawings, seeking to enhance their power by the greater power of their forced superimposition. The tensions between them are more interesting than the tensions within them, and it occurred to me that her method here illustrates one of Hegel's most difficult concepts, that of *Aufhebung*. The word carries three distinct meanings: to preserve, to negate and to transcend. Hegel meant for all three meanings to be understood at once, and perhaps two and a half are in fact present here. The drawings are preserved and negated. But they are not finally

transcended, for the works in which these two moments of *Aufhebung* are plainly achieved do not rise to the intended synthesis. They fall short of Krasner's ambition for them, as I think her work falls short of the high assessment of those who are trying to thrust her into the front ranks of American painting.

It is not a terrible thing to have been Domenichino. Any museum would be proud to own a work by him, and it is something to have been thought one of the great artists of the world, even if no one would now advise a friend traveling to Rome not to miss the Domenichinos. It is not a terrible thing, either, to have been Lee Krasner, discounting the tragedies she lived through. To be good is a lot. She is a representative artist of her time. Almost every one of her paintings is a window into the main currents of artistic influence to which she responded. But that is as much as can be said. "Everything is what it is, and not something else," Bishop Butler once wrote. "So why should we be deceived?" Lee Krasner is what she is. Or, perhaps more accurately, she is what she isn't.

· 7 ·

JONATHAN BOROFSKY

IN 1982, A SPECTACULARLY MERETRICIOUS EXHIBITION OF FORTY-ODD HOT
artists was mounted in West Berlin under the depressingly exact title
Zeitgeist. Housed in the war-scarred Martin-Gropius-Bau, an ornate neo-
Renaissance relic of the nineteenth century, *Zeitgeist* cynically exploited
the natural political symbolism of its locale. The shell-gouged facade of
the Gropius-Bau faces the archetypically gray Eastern European edifices
on the other side of the Berlin wall; it is separated from them by a
desolate patch of weeds dotted by truncated columns and a headless
statue. In an adjoining vacant lot, bleak as a flintscape by Beckett, a
tattered sign in four languages marks the site of Gestapo torture cham-
bers. Decades of wall-writers have scribbled subdued and diffident graffiti
—both political and scatological—on the terrible periphery of the unholy
city. The Brandenburg Gate is not far away; Checkpoint Charlie stands
at about the same distance in the opposite direction. Under the shallow,
glazed dome of the building's atrium, arrayed along the two-tiered colon-
naded gallery, were hung and placed the artworks being promoted by the
show. The not very carefully concealed motive of the enterprise was to
proclaim that contemporary European art, particularly West German art,
was commercially viable and ready to compete with the work of the
dominant hot Americans.

Art has always been a business, and successful artists have owed their
success as much to acumen as to talent or even genius—think of Monet
or Picasso—but what made *Zeitgeist* so rebarbative an enterprise was its
cheerful appropriation of Germany's unspeakable political symbolism to
reflect an unmerited importance on shallow artworks. The artists them-
selves, nearly all members of the Neo-Expressionist fraternity, were char-
acteristically lurid and brash, and their use of strident symbolisms in the

interest of self-proclamation was a bench mark of the collective style. But the entrepreneurs of *Zeitgeist* raised all that to a power undreamed of by the artists, who began to look almost modest by comparison with their handlers. In the crass degradation of meaning, *Zeitgeist* passed from tastelessness into evil. It may even have left a queasy feeling in the normally strong stomach of the art world.

Of the ten Americans exhibited, the one who seemed most to rise to the occasion rather than exemplify it was Jonathan Borofsky. In that context his three works appeared powerfully symbolic. Hovering over the glass dome and thus visible from within the main courtyard, Borofsky had placed a huge silhouetted effigy of what looked like a salesman, with overcoat, soft hat and briefcase. Just outside a window on the second floor there was a figure of a flying man, ambiguous as to whether it was fleeing the exhibition or heading for East Berlin. Finally, painted on the wall itself, and leaving visible what I suppose was independently written graffiti (TRASH), was a figure, *Running Man,* handsomely if primitively executed in gray with black hatching. Since they were situated *outside* the Gropius-Bau, all of these works might have been taken to express the wish to put some distance between the exhibit and themselves; and since each of them takes on, or appears to take on in that atmosphere, a political or even moral significance, it would have been difficult not to ascribe to Borofsky's work exactly the seriousness and weight flaunted by the exhibition itself.

So it is altogether surprising that the very images that carried so palpable a charge at *Zeitgeist* dissipate into frivolity when they appear in other contexts, such as Borofsky's current grand exposure at the Whitney Museum in New York City. (The show originated at The Philadelphia Museum of Art, will go on to the University Art Museum in Berkeley, California, then to The Walker Art Center in Minneapolis, Minnesota, and from there to the Corcoran Gallery in Washington next year.) Here *Running Man* dashes, like an acrylic streaker, past an enlarged and rather comical painting of *The Maidenform Woman* reviewing the troops in her greatcoat and lace underthings. The *Man with a Briefcase* stands blankly about like an aluminum cutout, and the little flying figure looks as though he has escaped nothing grimmer than FAO Schwarz—or at worst, Disneyland.

What this show, in contrast to *Zeitgeist,* makes plain is *not* that the same images carry different symbolic charges in different contexts, but tha Borofsky's images refer us at best to one another and finally simply

to the artist himself. The apparent meaning they conveyed at *Zeitgeist* was only an accident of juxtaposition, for the works are actually no more than recurrent elements in Borofsky's dreams, and like dream images they refer us to moments in the mental life of the dreamer. The show is simply the man himself, distributed through four vast rooms. Borofsky is the most confessional and autobiographical of contemporary artists, and his work, like his personality, must be taken as a whole. "All is One" is a phrase he often employs (he sometimes writes it in Persian) to impose unity on as heterogenous an assemblage of objects as one could imagine a single person capable of producing. "You are alone" is another Borofskyan phrase, part of a word painting, which has as its bottom line "There is no one to please but your[self]." What we have then is Jonathan Borofsky, alone, pleasing him[self]. It is less an exhibition than exhibitionism.

As an exhibitionist, whose philosophy is that all is one, Borofsky's steady impulse is to let it all hang up. (His first obtrusion into the general consciousness of the art world was an installation at the Paula Cooper Gallery in New York City in 1975, for which he literally emptied his studio.) "All is One" implies at least two attitudes. First, individual works are actual pieces, parts of a whole, pieces of Borofsky, thus dependent on the whole for what interest they may have. And second, one piece is as important as any other—"It's all one"—you happen to show. There is a spirit of egalitarian tolerance in Borofsky's periodic studio-sweeping to fill this gallery or that, any doodle counting for as much as one of his enormous *Hammering Men.* There is naturally a question about how any of this gets sold, but it has long been clear that the true geniuses of the contemporary art world are the dealers, capable of extracting cold cash for what most of us would suppose was to be thrown away. In whatever way this miracle of merchandising is transacted, Borofsky has clearly prospered, with larger and larger studios to empty into larger and larger spaces. He has reached the point where there is enough material to instill a dense disorder on the whole fourth floor of the Whitney.

One of the rooms is like a bulletin board, with pieces of paper—pages, sheets, scraps—pinned to the wall. If not clippings from newspapers, they are memorandums, jottings, doodles, sketches, calculations, plans, lists, all done on the most utilitarian paper—spiral notebook pages, cheap stationery, from-the-desk-of pads and the like. Some of them are actually interesting: a letter, for example, that the artist dreamed had been sent him by Salvador Dali. It reads: "Dear Jon, There is very little

difference between the commonplace and the avant-garde. Yours truly, Salvador Dali." This was "done" in 1978, and I wish I had seen it then, since it corresponded to some thoughts about art I was working on at the time, which were published a few years later as *The Transfiguration of the Commonplace.* But it is not really part of Borofsky's intention to produce things more interesting than others. Referring to his first installation at the Cooper Gallery in 1975 he writes, "It represented my attitude that everything is good—there was no real selection process, or if there was, it was minimal." That show, the first in a series culminating in this one, "seemed to give people a feeling of being inside my mind."

In many ways it is, almost, a child's mind, if children are really as innocent as we used to like to believe. There are no erotic thoughts, or very few: even when his self-portraits are naked, there are no genitals, though in one drawing he carries a flute. There are a lot of dreams, mostly of the sort our children tell us in order to be comforted. "I'm walking the streets of some strange town with my mother. I hustle with my mother and a huge crowd into a supermarket for protection" is the subtitle of *Dream #1.* He dreams he climbs a white mountain covered with electrical cables; that a man in a tower is being shot at; that he found a red ruby; that his father's tooth was bleeding; that a dog was walking a tightrope; that he could fly. Each dream is illustrated with an appropriate image or object. He thinks about the two sides of his personality—his male and female selves. When he thinks about politics, it is as a child would: "I dreamed that some Hitler-type person was not allowing everyone to roller skate in public places."

Mostly he likes to play. The initial impression of having wandered into an exuberant toyland is overwhelming. Everything seems to be moving. Five immense *Hammering Men,* black and thin as shadows, raise and lower their mechanical arms in an endless silent Anvil Chorus. Against the ceiling, the light in a blue neon helix zips back and forth. Near the window *The Friendly Giant,* sheathed in a bubble wrapping, does pushups. Leaflets are strewn beneath him. The place looks as though a troop of naughty children had been given carte blanche, emptying baskets, tilting paintings, scribbling on walls, cutting pictures in half, playing with the TV and behaving, generally, like rowdy poltergeists. Random noises from four loudspeakers form an acoustical cascade. The dominating figure is a sort of dancing doll, with a large sentimental clown's head and a female body, its legs drawn into webbed pantyhose, wearing one pink ballet shoe and one blue one, to mark (perhaps) the male and female sides. The

figure emits, while turning his-her toe, the familiar strains of—naturally —"I Did It My Way." It is as though Calder's circus, grown too large for the lobby, had taken over one of the main floors.

I saw the show just before it was finally in place, and the atmosphere was enriched with dollies, ladders, pushcarts, wires and tools which might have been part of the show but which one knew were not, since everything belonging to the show is easily identified by the number it carries as its signature. Borofsky tells us that for two years he did little artistically but count, and indeed in a kind of reliquary one can see a stack of sheets, thirty-two inches high, the result of that monotonous labor. The counting continues, perhaps now carried on by the *Hammering Men,* perhaps by the exercising *Friendly Giant.* The numbers painted on individual works mark the point in the counting process at which the work was done. The *Dancing Clown* was at 2,845,325. Borofsky is already up to 2,970,882, the number borne by the poster for the show, of *Man with a Briefcase,* evidently a kind of self-portrait. This figure seems more representative of Borofsky's artistic energies than the slightly nightmarish photograph of him pointing to numbers imposed upon his forehead, face, arms and chest, and looking as though he had survived the inscriptional punishments of *The Penal Colony.*

Joseph Masheck has spoken of Calder's "no fault circus," as though Calder could do no wrong in the eyes of the Whitney's patrons. Neither, in his own view of himself, and perhaps in that of others, can Borofsky do wrong: All is One. This is not a posture a critic can assume, but it at least means that if we take him at his word, there is only one work to judge, namely everything he has done, taken as a whole. My sense is that if it is the inside of his mind, it's not a very interesting mind, and if it is not—well, the justification for showing everything dissolves. You have only "your[self]" to please, and I think you would enjoy the show. It is a marvelous installation, but very minor art. There's a bit of the *Zeitgeist* if anyone is still looking for it!

· 8 ·

JULIAN SCHNABEL

IN THE 1940S, WHEN THE GREAT NEW YORK SCHOOL OF PAINTING WAS JUST a bunch of obscure and impoverished artists known almost to no one but one another, a decision was made to paint large canvases, since nobody was in any case going to buy small ones. Something like this is true today: painters produce large canvases because no one is interested in buying small ones. The difference is that the Abstract Expressionists did not expect to sell their large canvases either, and so there was something deeply touching in giving their work a monumentality, an almost public character—rather like not allowing the fact that you are unloved to stand in the way of writing marvelous love letters. The painter today realizes that there is no significant market for anything save the Important Painting, destined for the Important Gallery, the Important Collector and, ultimately, the Important Museum. The inaugural exhibition recently at The Museum of Modern Art consisted almost exclusively of Important Paintings in this sense: works expressly made for such occasions as inaugural exhibitions at MoMA. These days, making it large is a condition for making it big. If you do not make it big, you do not make it at all.

Few have made it larger or bigger than Julian Schnabel, ten of whose freshly made and gigantesque canvases are on display, through December 1, at the Pace Gallery in New York City. It is an exhibition that serves inadvertent pedagogical ends by providing students of the art scene with clear examples of what, size apart, the Important Painting is obliged to contain. A lot of pigment, for example, is a desired attribute, since this enables the artist to deposit evidence of creative frenzy on the very surface of the work, smearing, scooping, dripping, squeezing, gouging, scraping—mannerisms from the time when the physicality of paint seemed the most urgent artistic fact about paintings, and the palpable

action of handling paint the most urgent fact about painting. Then there must be a subject commensurate with the importance of the Important Work. Nothing finer for that than a crucifixion, a yellow Jesus, say, and all the better if it has breasts, to make it timely: a woman on the cross! And let it be badly drawn, just to make it clear that feeling trumps dexterity. This is, after all, hard-rock painting, part of the heavy-metal *Zeitgeist,* all yowls and guts.

Schnabel's standard composition is of a piece with his crucifixion: a large space bisected vertically by a single figure, a huge voodoo doll swathed like a goggle-eyed Lazarus, some kind of King of the Sacred Woods peering out between spruce roots ("Spruce roots separate," the checklist says, mysteriously, leaving it unclear if this is for facility of shipping or only that it costs more if you want the spruce roots too). This takes care of surface, subject, scale and composition. What one has to add is something to serve as signature, which Schnabel does with his legendary sharded crockery, giving his paintings a vitality all the whipped pigment and portentous imagery aspire to but miss. The crucified yellow woman among broken plates may just be oppressed womanhood nailed to the cross of domesticity. But the plates make the work as gay and primitive as the Watts Towers.

It is difficult to imagine a more amiable show; the paintings are so anxious to please that it is as though they are wagging their tails. One cannot help liking, or even admiring, the person who made them for perceiving what the times require. And in fact the artist tips a sly wink of collusion at the critic by painting everything on velvet. Velvet is the fabric of vulgarity, the texture chosen by those who aspire to opulence without knowing what class really is, the stuff of cheap ornamental pillows and sham tapestries found in bazaars and *puces* in bordertowns or in the luxury motel. Schnabel's use of velvet is the one witty and allusive feature of his work, a nose thumb at his plushy clientele and an acknowledgment of the crass structures of the art world he has so ingeniously internalized. It is nevertheless these very structures that he draws on for his importance and even his great interest, for Schnabel was the first of the Hot Artists, and the attributes I have identified in his paintings are exactly those features the Hot Artist's work is supposed to show.

The Hot Artist is an artifact of the contemporary art world rather than a person who works within a defined style that someone, but certainly not I, might designate as Hot Art. I have no intention of announcing a new movement on the model of Pop or Op—though the desolate

acreage of loud and awful paintings in that inaugural MoMA exhibition, where the museum made its bid for contemporaneity by underwriting a kind of Hot Show, might give the impression that it was a show of Hot Art. What MoMA in fact presented was a body of painters each seeking to proclaim his or her hotness by appropriating the scale and idiom it was Schnabel's historical mission to have hit upon as what must be expected if an artist is truly hot. But there is a certain incoherence in the idea of a group of painters, all painting in more or less the same manner, being corporately hot. Hotness consists in being there when the art market demands someone new and fresh, able to knock one's eyes out (this reads like a want ad for a seraglio). The paintings at MoMA were by and large as indistinguishable as preppies.

To understand the phenomenon of hotness, one must understand something of the extraordinary transformations in the concept of patronage that define the economics of art in the late twentieth century. To some degree patrons have always called the shots, insisting on size, shape, subject, tone and, of course, price. When the chief patrons were the church and court, their taste pretty much determined the structures of artworks as well, since given the expense of maintaining a workshop, very little, unless "work on paper," can have been done on spec. Artwork done on spec became an economic possibility (realized primarily through easel painting, hence painting small enough not to represent too heavy an inventory) when it became a social possibility. It became a social possibility when, in the nineteenth century, something like a competitive market developed, with the small collector able to indulge his personal taste and the artist able to indulge his freedom. Romanticism offered an ideological compensation to artists who did not sell—the belief in their recognition by posterity became their consolation—and freedom became one of the conditions of marketability. It did so because the collector wanted what came freely forth from the artist's creative soul. This, of course, meant that the collector or dealer did not intervene in the creative process itself, but chose from what spontaneously appeared. Something like this arrangement lasted well into our own century, and it remains the dominant myth even today. The freedom of the artist was an internalization of the competitive freedom of the art market.

With the museum as consumer, a secondary market emerged for works regarded as of singular quality, usually works that had, as the expression goes, stood the test of time. Museums did not interact directly with the artist, whose death was the condition for his collectibility. They

dealt with the dealer as indispensable middleman. Standing, as it were, outside history, the museum did not intervene in the process of creative production any more than the collector did. The artist was free to produce what he did produce, to experiment with his medium and his muse, always with the hope that someone would like it enough to buy it and that it might someday be enshrined in the sacred precincts of a museum. In those days going to the museum was like going to church: one was placed in the presence of the timeless.

Almost every component of this structure has now changed, though the freedom of the artist and the discrimination of the museum remain crucial myths. One reason for the change was the decision by museum people to be more responsive to the art of their own times; hence the museum show of contemporary art became an inevitable force in the market. Another reason has to do with the emergence of important collectors and important dealers who together took on the roles once played by church and court. Prices became too baronial not to affect artistic production. And beyond these reasons lies the not-so-hidden hand of the tax deduction for gifts to the museum which, to make a significant difference at the bottom line of the tax form, requires setting a high value for artworks. Finally, I think, there is the profound historical fact that painting has been systematically revolutionized from within throughout the present century. Each season was expected to bring forth something new, and seasons themselves got shorter and shorter. The sharp dealer was the one who spotted the latest energies in artistic revolution and who could make the necessary connections with the collector, the museum and the agencies of publicity, assuring big bucks all around. There really was no place left for the small painting by the small artist. You had to paint to the market or do something else with your talent: teach, illustrate, decorate.

All this machinery was in place, the money was there, when the revolution suddenly ground to a halt in the early 1970s. It was as if all the possibilities had been exhausted, as though art had come to a kind of end. There is no reason, after all, that creativity of the sort historically expected should have gone on and on, and through the last decade a philosophy of pluralism overtook the art world. There was for the first time no particular direction, perhaps no possibility of a particular direction, though the demand that there be a direction remained intense. This was the artistic, spiritual and economic reality into which Schnabel crashed as *the* Hot Artist, and the jubilation of the art establishment has

not abated yet. Everyone with any claim to power in the art world either has to get a piece of the action or must find his own Hot Artist. Such is the nature of the art world at present. On the artist's side there is an inevitable stridency as a certification of Hotness. On the consumer's side there is the hospitable checkbook, since the investment is secured by the almost instantaneous exaltation of Hot Artist as Modern Master, as gigantic objects move from chic gallery to chic loft to chic museum, where they become nightmares for the departments of preservation and restoration, required to deal with missing spruce roots and falling crockery.

There is a genuine talent in Schnabel's works, and an ingratiating, almost boyish charm. No doubt there are interesting biographical facts to be learned in order to explain this image or that. There are opportunities for ingenious interpretations. There may even be genuinely significant formal analyses to be given in the classroom, comparing Schnabel's crucifixion with, perhaps, that of Perugino. But all this pales, it seems to me, alongside the external significance of these works as fuel for the engines of the art market today, the laws and principles of which have scarcely been grasped even by those who control it. The one really interesting question for the future of art that arises from all this is, What will happen to the market when its principles are widely understood?

· 9 ·

ROBERT MOTHERWELL

STEPPED DOWN ALONG THE SINGLE HELIX OF THE GUGGENHEIM'S GALLERY, about 150 bright works by Robert Motherwell convey the impression of a thread of DNA on some colossal scale. Motherwell's work falls into four sorts—elegies, opens, collages and a somewhat ill-defined type I shall designate occasional paintings—about the same number as the bases, sugars and phosphates that compose a nucleotide unit in the DNA polymer. No representative collection of contemporary art should have less than a whole Motherwell unit—one each of the elegies, opens, collages and occasional paintings, which come in various sizes to suit the acquisitional resources and ambitions of different museums. Such a tetrad is the very minimum necessary for coming to terms with an artist it is clearly easier to rhapsodize about than analyze, and even at that, one's understanding would be limited. For Motherwell's total corpus—he turned 70 this year and has been showing his paintings for four decades—is characterized by a remarkable degree of replication: there are about 150 elegies so far, for example, and more than 200 opens. It is as though he had, in the spirit of the Nietzschian yeasayer, endorsed a kind of eternal recurrence, and it is this recurrence that gives his career a weight unpredictable from the seeming lightness of the single works.

Not every artist can stand up against the cruel demands of the Guggenheim space, where each painting must be experienced in several distinct ways. One traces a single path down the narrow ribbon of the main gallery; if the display is chronological, one internalizes the life externalized on the walls, and if the life there is barren, the experience is bleak. But the dimensions of the path itself, as of the interior space of the museum's core, impose severe constraints on the appreciation of single works, since one cannot help seeing each work twice, once close up and

once across the vast shaft of emptiness the building winds itself around. For certain paintings this may be too close and too far. The fairly narrow ramp forbids the optimal distance for certain paintings, which is somewhere behind the retaining wall in the unoccupiable void. But by the time one sees them across the void, one sees from too far. I remember that the Rothko show, which ought to have been overwhelming, failed the test of this museum, for at the imposed distances his banded canvases looked like so many Indian blankets, slightly garish. But Motherwell and the Guggenheim were made for one another, and the show is a triumph and a rare fulfillment of what must have been Frank Lloyd Wright's generating vision. The Guggenheim's brooding spiral affords a rare interpretive opportunity, especially since the whole of this show has a different interest—because of the repetitions—than the modular parts. The Watson and Crick in each of us want to crack its code.

Describing two of his paintings, *Iberia* and *Spanish Painting with the Face of a Dog,* Motherwell observes in an interview that one would have to know certain things about Spanish bullrings and indeed about Spanish bulls in order to understand what is going on. Both the paintings, he says, "have a bull in them, but you cannot really see the bull. They are an equivalence of the ferocity of the whole encounter." What he shows, and this is general, is the feeling rather than the look. He thus complies with a famous imperative in Mallarmé: "Paint not the thing but the effect the thing produces." Two points follow from this. First, Motherwell's work is abstract in the sense of being nonrealistic but not in the sense of being nonobjective. Each painting is about some definite thing that could have been shown realistically had the artist decided to paint against Mallarmé's injunction. Each of the works is a response to some visual reality, in principle accessible to us all. From this his art derives its universality. And the essential objectivity invalidates in advance the standard formalistic responses to his paintings.

But second, the effect a given visual reality will have on us varies profoundly according to our individual experience and sensibility, our psychic histories. Motherwell's style derives from his personal experiences, and this severely limits the sort of interpretation that refers to the influences of other artists. You cannot subtract his world or his affective substance from the paintings and concentrate merely on what is left, for they are severely reduced if they are not perceived as a double opening into a painted world and a soul. Small wonder then that openings should play so central a role in his iconography: the opens exemplify his philoso-

phy of art. And small wonder that the linear experience of the whole show is so powerful: here is a powerful life responding powerfully to powerful stimuli.

The collages are perhaps the most natural entries into the somewhat complex interpretation each work demands, simply because each has an object pasted on it to which the whole work responds. Two of them show wrappings used by the French publisher Gallimard to ship issues of *NRF*, presumably to R.M. himself. This says something about the kind of person the painter is: *NRF*, for a time edited by André Gide, is an intellectually rarified magazine of French thought and imagination. It is difficult to imagine other members of the New York School reading it, let alone subscribing to it. Another collage, *The French Line*, contains a label from a sachet of *gressins*, a kind of gourmet emblem one could not imagine figuring in the gustatory life of Jackson Pollock. Motherwell stands out from his artistic peers like the preppie in the Gashouse Gang—intellectual, refined, fastidious, sybaritic. But the label is also patterned with vertical stripes, alternately orange and white, and must allude to his prophetic *The Little Spanish Prison* of 1941, which uses stripes in a way later made central by Sean Scully. The label is pasted onto a white rectangle, surrounded by an orange arch, the same color as the stripes. Arches connote triumph. The work might then mean triumph over taste; it is so tasteful as to falsify itself. It is a witty, allusive work, but also the signature of a personality at home in atmospheres only dimly known to the roughnecks of Abstract Expressionism, with whom he was also at home.

The occasional paintings, on the other hand, distance the objects which occasion them in favor of their effect, though you can usually tell, often from the helpful titles, to what they refer. *Fishes with Red Stripes* plays off the prepositional ambiguity of "with," since these are red-striped fish but also fish which occupy the same space as a red horizontal stripe. You can tell that the painting is of fish by the shapes on the canvas, which convey the feeling of fish—not, I think, a very deep feeling for Motherwell. A deeper feeling is displayed toward the figure in *Interior with Pink Nude* of 1951, where the nude is not a life study but an eroticized set of protuberances, a synesthesia of skin and palpability. For the deepest feelings of all, one must address the two great suites: the Spanish elegies and the considerably more demanding opens.

I know of no paintings by a contemporary artist more moving than the Spanish elegies. Their power must somehow be explained by the feeling in Motherwell that he has managed to objectify, and which has

driven him in an obsessive way to deposit repeatedly much the same array of forms. I recall being transfixed the first time I saw one of them, which I knew, instantly, to be a great and serious work, even though I did not know the title or the specific meaning. The elegies are typically composed of two or three ovoid forms, clearly living and probably human, interspersed with vertical bars, clearly inanimate and probably architectural. All the forms are black. One knows without reflection that one is not looking merely at a heavily painted pattern of ovals and bars, an expressionistically painted segment of an egg-and-dart frieze, in part because one knows that the shapes are not painted *against* a white background but are located *in* a white space. It is a space purged by violence, leaving human remnants and architectural fragments to testify to a vanished plenitude. The power of these works is unaffected by variations in scale or by the addition of auxiliary colors or by an increase in the number of elements. Whatever the feeling underlying them, it can neither be denied nor eradicated, and the spiritual meaning of the repetitions transcends, accordingly, the meaning common to the several instances. Repetition in some artists can simply be evidence of a dried inspiration. In others it is part of the content of the work: Donald Judd's works contain repetitions as components of their identity. In Motherwell, the repetitions are not in the works but in the *oeuvre*. They reexpress an enduring feeling. His Irish elegies, on the other hand, are not convincing in this way. The muted color of shamrock is too mechanically iconic a color to go with depth, and I doubt the feeling is there to sustain a series. It is too willed.

The opens, finally, are the most demanding of Motherwell's works because they are initially the most empty. They characteristically consist of a single monochrome rectangle, horizontal and very large, usually red, on (or in) which is drawn a vertical rectangle. That is the "opening." The lines of the interior form are thin and almost casual, and seem weak in relation to the large rectangle, whose edges are the edges of the canvas. The opens present themselves as walls of paint, much in the manner in which Balzac describes the legendary *chef-d'oeuvre inconnu* in his overwhelming parable of artistic search. They *are* walls, and they are *of* walls. The smaller form depicts (or is) an opening into some marvelous occluded space beyond. This is a great metaphor for the human condition, to which Motherwell, trained as a philosopher, must be sensitive, but it is least compelling when most literary, as in the somber *In Plato's Cave No. 1* of 1972. Hegel speaks of philosophy as "painting its grey in grey," and so this is a philosophical painting in substance and in execution. But just

because Motherwell thinks philosophically, he should know better than to show the wall of Plato's cave in this way. Plato's cave *is* our world, full of the colors and shapes whose absence makes the world of the Spanish elegies so wasted. To see that this very world, noisy and bright and warm, is also as insubstantial as a show of shadows is to grasp the great dislocating force of Plato's stunning image. The cave is not a drab opening to something more radiant, but the very surface of the perceived world as a window into a colorless abstraction.

Well, this is a beginning. It is a sobering thought that the words of appraisal one wants to apply to these works—elegant, thoughtful, austere, intellectual, critical, aristocratic, subtle, tasteful, refined—are almost terms of studied abuse in the art world of our time. In this sense Motherwell's paintings stand as a mirror of our age: in their grace we see our tawdriness.

· 10 ·
THE AGE OF CARAVAGGIO

THE MAGNIFICENT ASSEMBLY OF CARAVAGGIO'S PAINTINGS ON DISPLAY AT THE Metropolitan Museum in New York City through April 14 is embedded in an exhibition designed as an upper-level course in its subject who, with characteristic unruliness, blows this edifying format sky high. So the Met furnishes an experience inadvertently at odds with the museum's pedagogic intentions, but very close, I think, to the historical reality of Caravaggio's impact on the world he swaggered into in the early 1590s.

Here is the way one is supposed to see the show. First, one studies fourteen works by Northern Italian artists which Caravaggio is presumed to have seen in his formative years in Lombardy. These were not his "precursors," as the catalogue describes them, for he had none, any more than Thomas Hart Benton was a precursor of Jackson Pollock, who also had none. In any case, having digested these putative influences, one passes among Caravaggio's contemporaries and competitors in Rome in the exciting period from 1590 to 1610, when the overpowering example of Michelangelo had been tempered by Mannerism, and the High Baroque was getting under way. Rome at the dawn of the seventeenth century was like New York at the dusk of the twentieth, the place to make it, the place that reduced the remainder of the country to so many artistic backwaters. Here are the Carracci—Annibale and Ludovico—whose age this was, if anyone's, since it was their eclectic, classicist style that prevailed as the result of major commissions. Here, too, is Guido Reni, a major painter but not the creator of a dominating style, whom we see showing the unmistakable influence of Caravaggio. Then there is the Cavaliere d'Arpino, at the height of his success in 1600 and for a brief period Caravaggio's employer. And a scattering of others: Gentileschi, Domenichino, even Rubens (working in Rome just then), and a number

of fine painters who have disappeared from the consciousness of all but specialists. Now, after absorbing the artistic context from forty-six paintings by these figures, one reaches at last the Caravaggios, equipped to appreciate them diachronically and synchronically and detect the influence of this and that, here and there, more or less. One is meant to leave the exhibition (picking up the catalogue for further study), one's powers of connoisseurship enhanced, with a keen sense of where Caravaggio fit into his age.

Here is the way one in fact sees the show. The viewer is almost immediately afflicted with the glazed eyes familiar to those who have trudged the provincial museums of Italy—the first rooms almost smell damp and cold through awakened associations. Out of a sense of cultural duty one reads a label or two, noting with alarm that among the paintings one might have passed by is a Tintoretto, and one tries to summon up an interest suitable to this fact. Interest quickens somewhat when one comes to the Roman segment of the show, perhaps because the juxtapositions convey the air of aggressive competition—of style wars that livened the Roman art world at a time when painters vied to define a style suited to the majestic reassertion of Catholicism. And now one crosses the threshold into a room of paintings so luminous and powerful that one is knocked off one's horse. Whatever painting is supposed to be, one has been seeing it through a glass darkly in those preparatory galleries. The glaze dissolves, the spirit lifts, and for the rest of the show one has just that feeling the paintings show: of some mysterious light cutting through the darkness of the soul with the fury of a spiritual sword. And one leaves exhausted and exalted, as though coming down from some mystical high.

It might have been anticipated that an artist with this degree of visual drama would subvert the format that justified the show in the minds of its organizers, but the museum teaches a higher lesson by making it possible that this should happen. Very few of Caravaggio's words have come down to us, and most of those that have appear in the transcript of a trial, in which he is accused of slandering the artist Giovanni Baglione. Caravaggio's testimony is a series of sneering remarks about other artists. They are not, and Baglione certainly is not, what he terms *valenthuomini*, i.e., those who "have a real understanding of painting." He could have been more conciliatory, but only if he were a different order of man. In fact he was a punk and a knife-fighter, vain and irascible, intemperate and mean. But he was on history's short list of *valenthuomini*, and the show is cruel to those bracketed with him who were not. I walked through the

show three times, and each time I reentered the first room of Cara-
vaggios, I felt the same exhilaration.

The pictures in that room are mostly of unmistakably carnal boys,
fingering pieces of fruit, tendering a wine glass, recoiling from a lizard,
holding flowers, banging at lutes, usually draped in lowcut ambiguous
garments with pretty sashes. I expect that Caravaggio's reputation for
homoeroticism derives primarily from the visible evidence of these paint-
ings, in at least one of which—not shown here—he used himself as a
model, posing as Bacchus, grape-leaves wreathing his curls, his surly
muscles contradicting or perhaps enhanced by the feminine, off-the-
shoulder garment, leering at the viewer over a bunch of grapes he pre-
tends to require both hands to hold. But these were done when he was
struggling to maintain himself in the first difficult Roman years, and may
have less to do with his own proclivities than the tastes of a special market:
I see them as fantasy objects for corrupt cardinals to moon over, high-
class pinup boys. This may be confirmed by a painting of Saint Francis,
lying prone after receiving the stigmata, being comforted by a pleasure
boy disguised as an angel in a provocative chemise, an image which
connects the religious vocation and erotic preference which coexist har-
moniously in the same ecclesiastical breast.

Something more than luminousness and lubricity transpires in these
paintings, however, and in a way that takes us to the heart of Caravaggio's
vision: we must see these youths as situated at the intersection of two
orders of reality. They really are street boys, endowed to turn a scudo or
two in hot and sordid encounters, and it is essential to anything else their
representations may be that they are what they appear. But they are also
what they stand for in fantasy: incarnations of angels or mythic gods or
godlings. Caravaggio does not paint himself with the emblems of Bac-
chus; he is, at once, really Bacchus and really himself—a divinity and a
tough, existing on two planes. Exactly this mode of transfiguration may
be seen in Rembrandt, one of the true *caravaggisti.* In his painting *Saskia
as Flora,* Saskia is unmistakably Saskia, but she is also the flower goddess,
her identity as Rembrandt's wife not swamped but penetrated by her
other identity. Hendrijke Stoffels really is that dumpy, sagging and used
woman—but she is also Bathsheba, possessed of a beauty radiant enough
to drive a king to treachery for possession of her. The thought that
persons and events of the most extraordinary import and dimension are
present, here, in commonplace people—that innkeeper is Jesus, that
porter a martyrizer—is the deep conviction of Caravaggio's paintings,

derived perhaps from his own sense of himself, brawler as *valenthuomo*, Saint Luke as an assassin, artist as monster. Even a basket of fruit is irradiated by angelic possibilities.

The thought that some sullen boy might have a second identity, that he could be Bacchus or a cherub, answers a very ancient aspiration for art. Tragic drama provided a circumstance in which the hero, played perhaps by a youth very little different from these, could be possessed, at the climactic moment, by Dionysus himself. That the saints should be literally present in their icons made painting, in Byzantium, a dangerous and magical endeavor. The primordial meaning of re-presentation is that of a second presence. What was Baroque Rome but the theatricalization of common life in the constant hope of just such interventions? The members of the Cornaro family are depicted by Bernini in the chapel they dedicated, watching from box seats the transaction of a miracle, Saint Theresa pricked by a grinning angel as in an act of cosmic vaudeville you too could witness. In Caravaggio's own great chapels, the viewer of the painting—*The Conversion of Saint Paul, The Calling of Saint Matthew*—is also the witness of the event. In all or almost all the paintings here, real people are vessels of exalted personages. There is a young woman, for example, who seems to be represented as both Saint Catherine and Mary Magdalene but who is also Judith hacking off the head of Holofernes with just the right expression of girlish squeamishness and womanly resolution. When Caravaggio abandons nature and derives a profile from some antique motif, as in the angel who arrests Abraham's sacrificing hand, he degenerates into Mannerism.

We must surely refer to the premises of deep theatricality to understand the dark into which he sets his luminescent figures. The Renaissance painting, it is trite to say, was meant as a window through which we see more of the same reality we ourselves occupy. If it creates an illusion, it is an optical rather than a spiritual one, as the preoccupations with perspective and orderly recession imply. The Caravaggian blackness is not a naturalistic representation of night or shadow, but marks instead a metaphoric division between our space and the space in which the martyrdoms and ecstasies and the violent adorations of Baroque art take place. It is a reversal of what we take for granted in theater, where the audience sits in darkness while the characters enact a drama in a space of encapsulated light. Caravaggio's are spaces of encapsulated dark. It would have been beyond the technical means of the Baroque theater to control lighting with an exactitude sufficient to suggest a parallel, but

lighting in Baroque painting is a visual analogue to music as the accompaniment of action. Think of the extraordinary effect of a performer spotlighted not against but inside a surrounding darkness, and you will, I believe, have some sense of what chiaroscuro means in Caravaggio. The spaces are neither shallow nor deep. They have no proportion to lived space and are defined less by a geometry than a metaphysics.

In the climactic position, on the far wall of the final gallery, is a depiction of David holding and beholding the head of Goliath. It occupies the position in this show that Van Gogh's self-portrait with severed ear did in the show that preceded it. Here we have a self-portrait as severed head, for Goliath's head is the artist's head, trailing gore. The eyes are not yet dulled by death, the brow is knit in powerful concentration, the mouth is open in meditation and astonishment. David gazes obliquely downward at his trophy. His expression, too, is meditative. The lips are softly pursed, the sword is lowered. He is of the same breed as the boys shown in the first room, but utterly diseroticized: the flesh is luminous but opaque, the garment exposes his chest but is coarse. Victor and vanquished are locked together by the same mystical light and occupy the same enveloping darkness. All the elements of the art come together in an image heightened by its position in the exhibition. It is the image you will carry with you as you leave.

I would pass up the erudite catalogue when you do leave, unless your interests are quite scholarly, and pick up instead Howard Hibbard's lucid and sensitive study *Caravaggio* (Harper & Row). Hibbard did not live to see the exhibition, and we all are poorer for not having his responses to it. If reviews could be dedicated, I would dedicate this to his memory.

· 11 ·

DE KOONING'S THREE-SEATER

CHARLES VANDERVEER III, THE LEGENDARY AUCTIONEER OF THE SOUTH FORK of Long Island, is a resourceful and in many ways an idealistic man. Given his relentless curiosity about the archeology of his region, it was inevitable that odds and ends from the kitchen middens of the Abstract Expressionist tribe, which settled in the area in the late 1940s, should turn up as collectibles in one or another of his auctions. Recently, however, he has acquired an object that puts enough pressure on the borderline between artworks and curiosities to raise a question about the firmness of that borderline. Since the object is "by" Willem de Kooning, it seems somewhat urgent that the matter be resolved.

The philosophical question of separating art from everything else is given a certain comic turn in the present instance since the object at issue is a three-hole toilet seat from the period before Abstract Expressionists were in command of sufficient resources to afford running water. De Kooning did not so much paint the seat, in the way that a handyman might, as put paint on it, in a way that raises issues of connoisseurship. Yeats assures us through Crazy Jane that love has pitched his mansion in the place of excrement. If love has such a locus, why not art?

The question posed in the headline of the *New York Times* article that reported this find—"But Is it Art?"—has been raised at every stage of modern art since Impressionism, and doubtless it is made inevitable by the fact that the concept of art allows for revolution from within. Still, certain objects very like this one have made it across the border into museum space, and it was to be expected that someone would instantly draw an analogy between the de Kooning three-seater and one of the most controverted objects in the history of art, that urinal Duchamp titled *Fountain*. *Fountain* was signed with the pseudonym R. Mutt and dated

1917, and was rejected by the hanging committee in the jury-free Independents Exhibition of that year, though it is unclear whether the grounds were that it was bad art or just not art at all. Certainly it has been enfranchised as art since, and though the "original" has been lost—it exists only in a photograph by Alfred Stieglitz—it may even today be kicking around someone's barn. Were Charles Vanderveer III to stumble upon it, he need have few worries about his children's tuition payments or, for that matter, his old age. Esthetically, however, the urinal's loss is not as important as it might seem, since the relationship between the work and the object is tenuous. Duchamp's work dates from 1917, but who knows when the urinal was made or by whom? De Kooning put paint on the privy seat in 1954, but the seat must have preceded the work—if it is a work—by a good many years. It was crafted by an itinerant carpenter, perhaps, a contemporary of Walt Whitman for all anyone knows.

Not far from the site of the seat stands the structure where, in the first warm days of 1947, Jackson Pollock, in de Kooning's own words, "broke the ice." This was one of the epochal gestures of modern art: flinging skeins of house paint across canvas placed on the floor. Like Duchamp's work, Pollock's was vindicated not only as art but as great art, but in 1947 Pollock himself was far from sure of its status. Barbara Rose cites a very moving memory of Lee Krasner's: "You know, Jackson used to grab me by the arm, shaking, and ask 'Is this a painting?' Not a good or bad painting—just was it a painting at all." By 1954 that question had been massively resolved, though problems might have been created if Pollock's dropcloths resembled his paintings drip for drip, or if he had flung paint at a field mouse because of his well-known irascibility. Pollock's style spread to the outer bounds of artistic consciousness with the speed of light, and even in nursery schools, children were soon flinging paint "to express themselves."

In painting the toilet seat, de Kooning used what the *New York Times* speaks of as "angry blobs of black paint reminiscent of the style used by Jackson Pollock, who frequently visited the de Koonings." It is plain that an art-historical reference and an in-joke are being transacted across the punctuated boards: de Kooning put the paint on in just a few minutes, according to Elaine de Kooning, who "authenticated" the object, for the further gaiety of a croquet party. Art-historical allusions on toilet seats by master painters must be exceedingly rare, so we are dealing with something beyond mere artifact. But, as the question goes, Is it art? And

if it isn't, where is the line to be drawn between it and *Fountain,* or any of those Pollockian arabesques?

Let me complicate the matter with an example that has some claim to kinship with *Fountain* and with the de Kooning privy. In my student days in Paris, I used to enjoy philosophical conversation with Alberto Giacometti, whose studio I got to know quite well. One part of it I remember vividly: Giacometti's water closet was outside, in the courtyard. It was of an old-fashioned sort known as a *vespasienne,* two footrests on either side of a hole. It was a lonely place, it now occurs to me, in comparison with the convivial three-holer of Long Island. In any case, Alberto used to draw while squatting, and the closet was covered with sketches as precious and precise as those in the caves at Altamira. At the time I wondered whether, in the event of Giacometti's death, it should be transported intact to the Musée d'Art Moderne. I was in New York when he died and I have no idea what happened to it, but even if I had been in Montparnasse, I doubt my first or even last thought would have been to ask what was to become of the water closet. Yet I am certain that the walls did bear works of art—if Giacometti drawings are works of art at all. They were products of a restless artistic consciousness coping with the inconveniences of the body. Their being there, in that private space, is perhaps an unintended comment on Yeats's beautiful line. Needless to say, were drawings done by Michelangelo under similar circumstances, there would be little question of their status.

The first thing to note, it seems to me, is that "But is it art?" cannot be asked of isolated objects. There is an implicit generalization in the question, which asks: is a thing of this *kind* a work of art? *Fountain,* for example, was one of a class of ready-mades, commonplace objects transfigured into works of art through the acceptance of a theory. There would be questions about the scope and limitations of the theory, as well as questions about whether a given ready-made was good in its kind or bad, but the question of art had to be settled for the entire class. One may ask: What of the first ready-made? Well, even though there was only the single instance, the question of its kind was already settled, and the kind had a natural location in what Duchamp had already achieved as an artist. Also, *Fountain* made it possible for him to go on to the next kind of thing. Artistic kinds are like species, where the possibility of generation is a serious criterion. Much the same thing may be said of Pollock's paintings. They were enfranchised by a theory which evolved as the works evolved, and they fit in Pollock's corpus with what preceded them and what came

next. As for Giacometti's water-closet drawings, there is no problem at all: they were examples of his mature style, placed on an unusual surface.

None of this applies to de Kooning's three-seater. The mock Pollockian marbling is isolated from everything that went before and came after; it has no place in the de Kooning corpus. Objects similar to it were to become accepted in the next generation of artists. Rauschenberg could easily have made a combine out of a paint-streaked privy stool. There are well-known works of his with which this could have fitted: bedclothes, for example, streaked and smeared with house paint and hung on the wall. Critics and curators adore the language of anticipation, but it would be as inane as the principle that generates major exhibitions at The Museum of Modern Art to say that de Kooning was ahead of his time, that his privy anticipated the kind of works that were to supersede Abstract Expressionism, or that there was an affinity between Vanderveer's acquisition and —excuse me—a Johns. Perhaps de Kooning could have evolved in this direction, but he did not, and there is no space in his corpus for an object of 1954 like this. The great art historian Heinrich Wölfflin said, "Not everything is possible at every time." I incline to the view that Johns and Rauschenberg were not possible in 1954, and it would not be possible for this to have been a de Kooning at any time. The corpus is closed.

So here is my thought: this particular object can be a work of art only if it is a de Kooning, and there is no way it can be that; so it's not a work of art. Neither, in compensation, is a sheet of drawings done for an illiterate servant by Michelangelo, illustrating what he wanted for a meal: two rolls, some fish, etc. Nobody is going to throw that illuminated menu away, as there are more reasons for keeping things than that they are works of art. And this, I dare say, will be the case with the three-seater. It has some archeological interest as a reminder of *la vie de bohème* led by artists near Amagansett before they all became famous. Not even de Kooning has the Midas touch, turning everything his brush comes in contact with into the gold of art. It is not just that the intention is lacking here; the requisite intention could not have been formed, because of historical circumstance. Of course I am not saying what it is worth. I imagine it will go for a pretty price, just because collectors will be afraid not to purchase it.

· 12 ·

KANDINSKY IN PARIS: 1934-1944

THE GUGGENHEIM MUSEUM'S FINAL INSTALLMENT OF A THREE-STAGE BIO-graphically motivated exhibition of the work of Vasily Kandinsky will be on display through April 14. It is greatly to the museum's credit that it should memorialize in this manner an artist so closely linked with its own historical identity. "Piety," Santayana said, "is loyalty to the sources of our being." There is also a particular justice in giving the entire museum over to only the last decade in Kandinsky's life, as this is at once his least familiar period and the one least appreciated and understood.

The horizons of Kandinsky's life during this decade, spent in a Paris drained of light first by war and then by the German occupation, were scarcely wider than the walls of his studio, which he filled with compensatory colors. And though he managed a muted participation in the activities of a quiescent art world, he was for the most part on his own. Drawn in on himself as he was, it is hardly surprising that the sense conveyed by Kandinsky's paintings is that of a look into a private world populated by tiny beings of indeterminate biology. He was creating a world of his own in these last years rather than seeking to transform the larger world, as he had in his earlier periods, first in Munich and then in Dessau and Weimar. The overwhelming impression provoked by the exhibition, which requires that we measure it against the circumstances of his life, is that of a great artist who has entered his *Altestil*, the expression used by art historians to designate the late style of painters who have grown old without growing dry or weak.

Kandinsky was a vigorous painter to the end, and there is an endearing jauntiness, an almost jazzy cadence, in the syncopated deployment of biomorphic forms. These forms, laterally related to shapes in Miró and Arp and, above all, in Klee, who had been Kandinsky's close friend and

colleague in their Bauhaus days, were to become matrices for the decorative motifs of *art moderne.* It is all the more important, therefore, that we see them as the distillations of a lifetime, the emblems chosen by a man determined to show that whatever the critics and collectors might think, there was plenty of dance left. It is almost as though the minuscule organisms carry the promise of growth and exuberance, however reduced their world.

Each for Himself, painted in April 1934, only a few months after his arrival in Paris, is dominated by nine forms in a three-by-three array, each having the shape of a living cell, or perhaps an amniotic sac, and each containing some energized and vital creature as its nucleus. The suggestion of isolation and potentiality could not be more elegantly achieved. Each of these creatures, swimming in different colored fluids, represents a distinct artistic possibility: each could generate a different species of form. It is a wonderfully optimistic image.

What one wants in the *Altestil* of a serious artist is continuity and synthesis, the final harmonious conjunction of the strands of a life. We do not expect a radically new style since that would be a repudiation, an effort, as it were, to proclaim a spurious youth. Nor do we want repetitions of what went before, which would imply a falling away of creativity. By these criteria it would be difficult to find a more fulfilling coda than that furnished by the paintings and watercolors of this show. They incorporate and transform what preceded them, and they point to a future, if there is to be a future.

In Kandinsky's first phase, marked, of course, by the discovery of abstract or nonobjective painting, the forms are typically organic, even if they lack a precise biological identity. They refer us, if not to birds and insects or to winged creatures generally, then to the *idea* of flying matter. These early paintings radiate the optimism of a man who has entered a new life—Kandinsky was 30, with a degree in law and a future in academia, when he moved, abruptly, to Munich to become an artist—one who has been the first to set foot in an unexplored world of artistic possibilities. The composition is centrifugal, as though some explosive force were driving everything outward, past the frame. Kandinsky's time in Munich was one of visionary and utopian hope; art was to be the agency of spiritual transformation and moral rebirth. The early paintings condense all these moving and extravagant affirmations, and the brush work is appropriately expressionistic and impulsive. It is hardly astonishing that Kandinsky's admirers should have especially prized these great can-

vases and, as if to remind us of this, there is a singularly tasteless invitation from Alfred Barr on display, offering Kandinsky passage to America. One can almost feel Barr rubbing his hands together as he cautions Kandinsky to be sure to bring all his early canvases with him. Nor is it surprising that Kandinsky should have returned to these forms in his older age.

Work from the middle period (1915 to 1933), done first in Russia and then in Germany, is deeply geometrical and rather hard. It reflects a different situation from that in which the Munich enthusiast found himself: geometry emblematizes the spirit of construction and reconstruction, first for the revolutionized society seeking a new social architecture, then for the institutional framework of a school designed for designers. Today it is difficult to appreciate the degree to which geometry carried a spiritual meaning among the Russian avant-garde in the early twentieth century. The fourth dimension obsessed those artistic consciousnesses concerned, as Kandinsky's was, with art's role in the evolution of humanity toward a new level of moral being. The fourth dimension seemed to offer, quite literally, an utterly new space for a new order of beings who had left the material impediments of the routine three-dimensional world behind.

I stress this spiritual aspect of the fourth dimension because even at his most geometrical, Kandinsky was never a formalist, nor would he have been pleased with a formalist esthetic which would address his works as so many exercises in abstract design. But geometry communicates a different approach toward the means of spiritual progress than the organic forms did. The lines and angles, curves and intersections and sharp colors of the painting of the middle phase of his life define a style of undiminished affirmation. Inevitably, the expressionisms of the early work yield to a surface and treatment that might almost be perceived as austere but for the playfulness of arrangement, the witty internal references of form to form and the bannerlike boisterousness of the color.

The Bauhaus was closed by the Nazis in April 1933, and in late December of that year the Kandinskys were in the Parisian suburb Neuilly-sur-Seine, where the artist was to spend his remaining years. The world closed in, driving the forms back into the frames: there is little evidence left of that outward energy of bursting life. The organisms are submerged, as within the confining walls of an aquarium, and swim in highly geometrized spaces. The surfaces, colors, outlines and textures come

from the middle period; the forms, from the early period, at least for the most part.

Vivian Endicott Barnett has written a fascinating essay for the catalogue on Kandinsky and science, in which she identifies illustrations from various encyclopedias and textbooks Kandinsky may be presumed to have seen, which may have inspired the forms he reinvented and made his own. I find her ascriptions convincing and clever, but of course Kandinsky's elegant plankton, his amoeboid and paramecial entities, do not refer to their graphic origins, nor are the paintings interestingly analogous to scientific plates. The sporty insects romp with refugees from the geometric period—dots and spots and showers of angular confetti—and their microscopic universes are also populated by what might be toys and ornaments for peasant bazaars. The final period brings together, as it ideally should, components from the earlier periods, but the optimism now is subdued and rather private.

For all their nonobjectivity, the canvases are deeply pictorial. The urge toward flatness, which was the mark of a late stage of modernism, is not present here. The forms are as much located in illusory space as are the figures shown by Guardi in some Venetian piazza. It remains the traditional pictorial space of Western art. To be sure, there is little occasion for perspective when worlds, like drops of liquid, are enlarged through the lenses of a microscope.

It is possible to see Kandinsky battling with illusionism by making it difficult to identify where objects are in spatial relation to one another. Typically, forms do not occlude one another, there is no fading off of hue as in aerial perspective, there are none of the gradients of distal perception. So the space could be read as shallow and abstract. I prefer a different reading, and see a different order of statement being made.

The objects are isolated one from another, do not even, as in *Sky Blue* of 1940, make contact at their peripheries. Each floats in its own space, and the total space is a conjunction of independent beings. In that painting there are dots and worms, kites and coelenterates, birds and rocking horses, a bug with a clown's head, each vibrating in the same blue primordial soup, and each as gaily tinted as a Russian Easter egg. (What a marvelous excursion the show offers for those seeking an appropriate secular activity on Easter Sunday!) Alone among the alone, the forms make no concession to the metaphoric grays a more depressed spirit might have used to mark the condition of growing old in a world growing

dark. What could be a better expression of an old man certain of his powers but aware of the external limits imposed by the world without?

I find the work deeper than all that came before because I find it braver, less foolish, finally more realistic. In discharging its institutional obligations, the Guggenheim has mounted an inspiring show, transformed our perception of an artist too easily taken for granted and, beyond that, provided a treat for the eyes.

· 13 ·

HENRI ROUSSEAU

OF THE MANY INTERESTING FACTS TO BE GLEANED FROM THE CATALOGUE FOR the exhibition of Henri Rousseau's paintings at The Museum of Modern Art through June 4, I found none more illuminating than Picasso's claim to have painted *The Sleeping Gypsy* himself. As nothing Picasso said about painting was ever less than profound, and as the authenticity of the painting is not in question, it is clear that some deeper truth was intended. With equal justification Picasso could have claimed that it was he who made those legendary African carvings photographed in his studio. Art historians are obsessed with tracking influences—for example, of Rousseau and primitive sculpture on Picasso—but Picasso was implying a deeper structure of historical consciousness, namely that it is we who constitute our pasts. It was precisely Picasso's use of primitive forms, proportions and motifs that transformed those fetishes from objects of ethnological or merely esthetic interest and made them part of the history of modern art. By claiming them artistically, Picasso released an artistic energy up to then unavailable in those figures. And it is something like that relationship that constitutes the truth in his otherwise extravagantly false claim to authorship of Rousseau's painting. Until Rousseau was acclaimed a master by those who saw him as their predecessor, he was a curiosity of *fin de siècle* bohemia. It took Cubism and Surrealism to awaken structures in Rousseau's work that had to have been invisible to his contemporaries and very probably to himself. The slumbering forms in *The Sleeping Gypsy* yield a parable for the philosophy of art history which it was Picasso's genius to articulate.

The mandolin, lying beside the gypsy, had to have looked awkward until a new vision of the way objects define space made it seem powerful and intense. The gypsy, seen from above, being nosed by a lion, seen in

profile, had to have been considered primitive until a reinvention of pictorial space redeemed its visual authenticity. Looking down, or nearly looking down, as we do, on the gypsy, we see her as the lion must see her. The vulnerability of sleep is augmented by the vulnerability conferred by the angle from which she is viewed: the angle of an intruder, before whom she is helpless. Looking slightly up and sideways, we see the lion as the gypsy would see him, were she to awaken. The painting is the intersection of two dimensions of perception that define the space of a dream: we see the dreamer from without and the world of the dreamer from within. Peace and panic coexist within a single frame. Who in the nineteenth century but Rousseau could have achieved anything remotely like this? (The painting is dated 1897.) Painting had to be taken apart and put together in a novel way before this work could be understood. In its classical phase The Museum of Modern Art contained the two great paradigms of what it meant for art to be "modern," *The Sleeping Gypsy* and *Guernica.* The discoveries that made the latter possible unlock the structures in the former.

Rousseau had to work hard to look naïve. Nothing in the show is more instructive than the juxtaposition of his studies for paintings with the finished works. In a different period of art, when the energies of the loaded brush would be prized, when virtuosity would consist in defining a single form with a single stroke, these studies would have been considered achieved works.

Had the wonderful *Study for a View of Malakoff* (an industrial *banlieue* south of Paris) been painted in New York in the late 1940s, it would have been a finished work of unmistakable authority. Even in 1908, when the study was painted, it could have been shown with the Fauves and been striking for its restrained tonalities. All this bravura is submerged in the finished *View of Malakoff* in favor of hard-edged forms in paradoxical relationships to one another. We see the figure in the foreground, a woman with a wide hat and a parasol, from above, from an angle that truncates her. The telegraph poles behind her are seen from below, giving them a height, as it were, stolen from her. The figures in the same plane as the poles are minuscule: I measure the poles as thirteen times as tall as a coplanar human being. They would have to be seventy-odd feet were they realistically represented, but it is plain that they are not. Rousseau is exalting the telegraph. The choices of point of view and proportion are intended, and what he wanted to say about these techno-

logical intruders in the suburban landscape could not have been said with correct perspective and orderly spatial recessions.

For confirmation of this, consider the great *Myself, Portrait-Landscape,* the first picture you see as you enter the exhibition. Rousseau has painted himself as an artist—as *artiste-peintre.* Studied from the bias of naturalistic representation, the work is charmingly inept. His own figure, clearly painted from a photograph, does not stand firmly on the ground but seems to hover, like the balloon we see over his left shoulder. It is all out of scale with the tiny couple strolling on the *quai,* even with the ship gaily at anchor beside it: Rousseau dominates by his height as the Eiffel Tower, seen over his right shoulder, dominates the rooftops. (The Eiffel Tower was built in 1889, the year before the self-portrait was made.) It would be easy to rationalize the discrepancies in magnitude and location as the result of naïveté, just as it would be silly to pretend there is no naïveté here at all. But it is a naïveté of attitude, rather than execution; the execution is masterful. This is a painting of himself as artist, to be sure, but also a representation of artist as colossus, dwarfing the ordinary figures and objects put into the landscape to underscore the allegorical dimension of the artist hero. It is not that he does not know how to plant feet on solid ground, but that the personage of the artist is encapsulated in a space of his own, like a saint in a painting from the fourteenth century. He bears the emblems of his calling—beret, palette, brush—with the ferocity of moral ownership with which the saint grasps the instruments of his martyrdom. So, too, the artist wears the emblems of his recognition—the black suit and boiled shirtfront of the official reception and the rosette of the Legion of Honor—as the saint wears the aureole of heavenly acknowledgment. The exalted view of the artist is romantically naïve, but the presentation of the artist as higher being could not be more authentic.

To find the pictorial equivalents to Rousseau, we must go very far back in art history, to the time of the Orcagna—Andrea and his brothers, especially Nardo di Cione—who worked in Florence in the fourteenth century, just after the Black Death. The art historian Millard Miess has shown how painters there and in Siena responded to that devastating epidemic. Characteristically they perceived it as a punishment for the sin of arrogance, for the hubris of paintings in which holy persons were depicted as though merely human. Giotto, whose representational discoveries were responsible for this "arrogance," was repudiated by the

Orcagna, who began to paint saints and humans so deeply disproportionate that they could not even occupy the same space. The disproportion between sainted and ordinary beings in the Strozzi altarpiece is of a kind with the disproportions in Rousseau's self-portrait. Before their deviation, the Orcagna had been masters of naturalism, while Rousseau was never a master of the sort of naturalistic depiction that more or less defines the history of Western painting after the brief departure that followed the Black Death. Giorgio Vasari defines art as the systematic conquest of the appearances of things, and painterly success up to Rousseau's time consisted in presenting the eye with an array of stimuli as identical as possible to those with which the real world would present it. The strategies for achieving this took a very long time to discover, as Ernst Gombrich has tirelessly demonstrated, but once discovered, they are not difficult to learn. Rousseau could have learned them as easily as anyone, had they been pertinent to his artistic project. Clearly they were not. Clearly, he had something altogether different in mind.

This is not to say that what he had in mind was entirely clear to him. Very likely it was not, for painting had not evolved sufficiently to make his project intelligible, so it had to be understood in the terms that were available. This required that he be pushed to the peripheries of the art world as a kind of eccentric, as a kind of court fool. He showed almost every year at the Salon des Indépendents, and surely part of the motive for visiting this open and egalitarian show was to see, every year, what this improbable, laughable man was up to. It is difficult for me to regard the words of praise that have come down to us as anything but irony of the sort the French particularly enjoy. It must have been high, cruel entertainment, like those concerts given by a deluded singer, rich enough to hire Carnegie Hall and bad enough to fill it with people who will call for encore after encore for the pleasure of watching him make a fool of himself. The seriousness with which Rousseau took himself simply heightened the merriment. It was only when Picasso began to paint them that the stature of Rousseau's masterpieces became visible. Rousseau had to be innocent, since what was required for him to be sophisticated lay in the future and was historically inaccessible.

The earliest painting in the show, of a radiant black couple, in carnival dress, alone under moonlight in a delicate wood, is dated 1886. Symmetry really requires it to have been done in 1885, so that this could be a centenary celebration of a genius who demands that we rethink the logic of art history and the nature of painting, and who so longed for this

sort of official recognition. It is the first such exhibition of Rousseau's work ever mounted (it comes to us from the Grand Palais in Paris), and with it MoMA reclaims some of its tarnished luster. It is a gift to the art world to have so much brilliant innocence in its midst for the next months. With The Age of Caravaggio at the Met and Kandinsky in Paris at the Guggenheim, this is a blessed season.

· 14 ·

THE ALBERTINA DRAWINGS

THOSE PARTISAN TO A DIALECTICAL INTERPRETATION OF HISTORY MIGHT FIND a delicate confirmation of their views in the example of paper. The invention of printing necessitated the production of quantities of reasonably priced paper. But the availability of paper in large quantities is also credited with the emergence of drawing as an autonomous mode of artistic expression in the early fifteenth century. Since drawing is the paradigm of artistic spontaneity, there is a felicitous irony in the fact that the mechanical has given rise to the spontaneous.

Until an affordable supply of paper allowed drawings to be saved or even done for their own sake, it was common for them to be destroyed, either in the course of transferring their images to the panels on which paintings were to be executed or, if they were done directly on those surfaces, by submerging them forever under layers of glaze. There is a poignant drawing in Antwerp of Saint Barbara done directly on a panel by Jan van Eyck, who evidently lacked the heart to stifle it with overpainting—evidence that the sacrifice of drawing to painting was not a matter of indifference to artists. With the advent of industrial papermaking, the pleasures of drawing could be indulged at no great material cost to the artist, and as drawing shifted its status from means to end, draftsmanship became cultivated as a special accomplishment. Almost instantaneously, all the aspects of an art market fell into place: collecting gave rise to the specter of the mere copy, if not the downright fake, and fear of fraud in turn gave rise to the connoisseur. One of the great collectors and connoisseurs of the eighteenth century was Duke Albert von Saxe-Teschen, whose massive collection of works on paper constitute the basic holdings of the Albertina Museum of Vienna. Seventy-five of the Albertina's graphic treasures enhance the exhibition spaces of The Pierpont Morgan

Library in New York City until May 26, enabling us all to ponder the nature of drawing on the basis of some of its greatest instances.

To some degree, this is to ponder the nature of paper. For some of the physical properties of paper underlie the expressive properties of high draftsmanship in the West. Rembrandt's drawings, of which three are on display, presuppose a surface sufficiently absorbent to preserve the fluidity of his strokes while not so absorbent as to blot. So the strokes remain exactly as they were made, and the work is a visible transcript of the act of drawing it. What is true for pen strokes is true for washes: the splash with which a full brush defines a group of trees is self-recording, and is given a dancing vitality by the texture of the paper coming through. There is a soaring study of an avenue of cypresses by Fragonard, where the trees are summoned into being by wet touches: the paper sustained the artist's confidence that one spot would be dry enough to keep from puddling with the next spot, so the individual touches sum to a cascade of leafiness. Such effects couldn't be got on parchment or vellum, which in any case have no significant texture of their own to contribute, and demand slower procedures.

The texture of paper is more important for pencil line and chalk stroke, providing the friction needed to abrade them into tiny particles between which minute patches of untouched paper scintillate. Watteau, according to his friend and dealer Gersaint, was vexed by the discrepancy between his drawings and his paintings: he could not give to the latter "the spirit and truth he knew how to give his crayon." But surely the difference is as much a function of the paper as the crayon, as in the luminous *Two Studies of a Young Woman,* where the felted texture of the paper infuses the shadow on the woman's cheek with the effervescence of life. One would have had to use canvas in ways unacceptable to the eighteenth century, drag a brush dryly across the woven texture, in order to get a comparable vitality. But this would be to submit the logic of paint to the imperatives of drawing.

There are deeper liberations still. The edges of a sheet of paper do not seem to have mattered as much as the edges of a canvas or a panel. That is, the outer edges of the paper did not constitute the inner edges of a figurative window, to use the Renaissance metaphor for a painting. A window opens to the fullness of reality, which requires that every portion of the surface be accounted for in terms of a correspondent portion of the deeper reality. But the space of the paper was so much undifferentiated blankness, and the edges merely circumstantial. So there

would be no need to compose a drawing in relation to the boundaries of the sheet, and the artist could crop the paper he did not use, or draw several images on one piece, with no implication that they belonged together. The two women in Watteau's drawing have no spatial connection—how could they, being the same woman drawn twice? (If the same woman were painted twice in the same panel, that would imply a temporal dimension: they would be stages in the life of the same person.)

Even in what must be one of the most fully finished drawings in the show—not to say one of the most celebrated drawings in the world—Dürer's *Praying Hands,* we have, in effect, a fragment. The hands come out of carefully drawn cuffs attached to sleeves that fade off in casual brush strokes. The sheet itself is cropped, and in the lower left corner is the vestigial indication of a shoulder Dürer evidently saw no reason to go further with. A drawing is finished at any point where the artist stops, but in Dürer's time this could not have been true of painting: an unfinished painting would have to be of an unfinished reality, of which there could be none. Only Michelangelo, as far as I know, exploited the energies of drawing in a medium—sculpture—that otherwise simply inherited the realistic premises of the Renaissance painting. Michelangelo left an abandoned arm in the *Rondanini Pietà* just as Dürer left an abandoned shoulder. He treated stone as most artists treated paper. The use of paper prefigures the modern idiom of juxtaposing forms and images we are not required to integrate.

There are further properties of paper that connect with the mystery of drawing as such. I am using the word "mystery" unfloridly and descriptively, to designate a certain possibility of illusion which makes the simple act of drawing a matter of the most primitive fascination. When one inscribes a line sufficiently defined to be read as an edge, it not only implies the form it belongs to but that form immediately comes forward while the surrounding area recedes. And the form acquires an instant solidity by contrast with the blankness against which it stands out. But what is remarkable is that this happens without any further modification of the uniform tone of the surface. It does not change shade. Even so, one area will look solid and near and the other empty and far. That with a single stroke one can create solidity and space is as astonishing an act of creation as sundering dark and light by the utterance of a word. This mystery is overlooked when we think of drawing simply in terms of tracing outlines or replicating external forms, important as these functions have been in the practices to which drawing is central.

THE STATE OF THE ART

The mystery is nowhere better exemplified than in what I regard as the greatest drawing among the great ones here: Rubens's *Saint Catherine.* The saint's neck is sweetly bent, awaiting the sword stroke which will terminate the suffering she has endured and confer the martyr's station. But the head is twisted upward as she perceives, as we know from the painting for which this was a study, angels bearing the emblems of her triumph. Her body is twisted in a reverse spiral, turning away from the agony her head awaits. Look closely at the back of her neck. Rubens has drawn it with a single curve, as fine as a hair. It divides the paper cleanly. Beneath the curve the neck is solid and vulnerable. Above is the nothingness of blank paper. The whole of Saint Catherine's story is condensed in that one line. Its fragile submissiveness implies the brute swordsman.

In addition to substance and space, the great draftsmen could create light. There is a standard illusion in the psychology of perception: a line, in dividing a tone, seems instead to separate two tones, one darker than the other. There is a nursing Madonna by Dürer here in which this marvelous illusion is exploited. Without the tone of the paper being different, the mother and child appear luminous, their brightness more intense than the whiteness of the paper, even though exactly the same wavelengths would be reflected by the infant's head as by the area behind the Virgin's mantle. The same illusion is achieved over and over in the show, most dramatically, perhaps, in a late fifteenth-century Netherlandish depiction of Christ bearing the cross. That cross is the color of the paper, it *is* the paper, since the master who executed it left the cross a pure blank, or nearly pure. But it takes on a radiance that does not belong to the paper outside the area of the cross. Indeed, the cross itself is hardly even drawn: the artist has drawn what surrounds it in such a way that the spectator completes it through what psychologists call subjective contours. To be able to explain the effect would be to understand the eye, the hand, the nature of illusion, the power of art.

Perhaps this is enough by way of pedagogy. You are now on your own to enjoy the show. I cannot forbear mentioning an elephant by Rembrandt so awkward as to confirm a thesis of Gombrich, that artists have to discover a "schema" in order to represent something with conviction. But elephants were too little a part of life in the seventeenth century for an elephant-schema to have evolved, and even Rembrandt lost the battle to contain that unfamiliar bulk: Walt Disney (alas) could do it better. But I prize the drawing for the struggle. Nor can I forbear, again, from directing your attention to Jan Gossaert's *Fall of Man,* in which Eve

and Adam are portrayed with so much sexual tension that Adam's right arm has grown a left hand. And surely you will want to pause—as if she would let you pass by!—and admire the sly courtesan Urs Graf has drawn holding her skirt up as she steps into the river in an act supposed to be a metaphor for losing one's virginity. And oh! The Breugels! The Luini! The Saenredam! That Greuze! . . .

· 15 ·

THE WHITNEY MUSEUM'S 1985 BIENNIAL EXHIBITION

SILENUS THE SATYR FAMOUSLY SAID THAT THE BEST GOOD FOR MAN IS NEVER to have come into being, and the next best is to go out of it as early as possible. I was reminded of Silenus' gloomy wisdom as I confronted the individual works in the Whitney Museum's Biennial Exhibition (through June 2). There is, I think, scarcely a single work here the world is better off for having, scarcely a single one whose disappearance would not contribute to the goodness of the universe at large. Few of these works, if displayed elsewhere, would be worth anyone's special effort to see, and many, to borrow a phrase from the badly needed Michelin Guide to Horrors, would be worth a detour not to see at all. But for just these reasons it seems to me imperative to visit the exhibition. It must say something significant about American art in 1985 that what five curators judge representative should in fact be so appalling. It cannot have been easy to reject everything of artistic merit being done in the country today in order to make a point; but if the purpose of the exhibition is to reveal some deep disorders of artistic consciousness in the land, that knowledge may compensate for the agony of having to look at the show.

The contrast between the exhibition's lesson and its contents is signaled by the catalogue's cover. Front and back are a mottled gray, like a photograph taken from a distant satellite of the earth after a nuclear holocaust, but in the title, "Biennial Exhibition" is printed in yellow, made all the brighter by the bleakness of the background ("1985" is appropriately printed in a foreboding gray). The endpapers are black, black, black. The mounting of the show carries forward those funereal allusions. The works are widely spaced; there is an atmosphere of mortuary dignity; conversation is stifled as visitors stand in respectful silence before stillborn paintings. Jasper Johns's new work is executed in encaus-

tic, the medium of the burial portrait in ancient times. Donald Judd's two untitled works look like a display of vertical coffins and a disturbingly gay horizontal columbarium, respectively. The museum is filled with sounds resembling the wan keening of electronic ghosts, the auditory components (generated by an anemometer on the roof) of a work called *Whitney Windspun,* by Liz Phillips. As one clutches the catalogue, listening to these mournful noises while waiting for the elevator, one peers into the lower level where mosaic columns arise like the excavated remnants of a long-extinct civilization. The language of the installation could not be more legible, nor more effective in creating just the right mood for pondering disintegration and decay.

The few viewer-friendly works in the show are those that express and do not merely justify the overall attitude the curators must have taken such pains to achieve. These are works that, as it were, mourn for themselves, like poems about the death of poetry. Two mutually referential paintings by Eric Fischl compose a fine emblem. In *Portrait of the Artist as an Old Man,* the old painter has his back to the canvas on his portable easel, his right hand holds a newspaper to cover whatever he is doing with his left hand, which looks like masturbation. His nearly blank canvas and the easel standing in *plein air* connote a period of art to which Fischl's work belongs at least in manner: the late Impressionism of Bonnard and Fairfield Porter. The sun is setting, as we can tell from the long shadows cast by the easel's legs and the artist's shanks. This is no country for old men, Fischl's painting says, pointing to the biennialists around it. In the companion work, a nude boy—too young to do what the old artist can evidently do no longer—also has his back to a painting which we recognize as one of Warhol's iterated effigies of Marilyn Monroe. The sun is rising on the new generation, blanking out part of the depicted work with the morning light. But the boy's eyes are closed as he sways to private sounds from his headset. Fischl suggests that the time is past for work like his. The wry self-referential pathos of the two paintings is enhanced by the surrounding evidence of its claim.

The exhibition as a whole turns its back on painting of the sort that Fischl's beautifully brushed and deeply intelligent work exemplifies. Of the eighty-four artists shown, thirty-three have chosen film and videotape as alternative forms of expression to painting and sculpture. Of the remaining fifty-one, a substantial number rely on some kind of photography. I hesitate to say that this shows a preference on the part of the curators, whom I interpret instead as highlighting their respect for an-

other sort of art by not hanging it in this company and, where they have
selected paintings, by choosing ones that use paint as though the artists
had forgotten how to, or never knew. So the show is an elegy for the sort
of art the curators believe in, but which is threatened by the work dis-
played. Fischl has made a gesture of heroic sacrifice in allowing them to
make their point with his work which, admittedly, takes on a heightened
significance in the context, a bit like Odysseus in the underworld.

And like the shade of Achilles, who expresses grief for his vanished
substance, many of these works refer to the art of a more vigorous period
with a nostalgia deepened by the frequency with which it is expressed.
Two panels by Jo Anne Carson are animated by Cubist and Futurist
cadences, and refer explicitly to Picasso and de Chirico, among others.
John Duff's *Irregular Column (Orange)* refers to Brancusi's regular *Endless
Column.* Johns refers to the Mona Lisa. Sherrie Levine refers to the Rus-
sian avant-garde, Lissitzky, Chasnik, Malevich. There is a dopey depiction
of an armless and headless torso next to an old-fashioned palette in Kim
MacConnel's *Prince Charming.* Perhaps nothing conveys this impossible
longing for artistic reality better than *Mondrian Dancing,* by Susan Rothen-
berg. In this artist's customary, but here especially significant, swipes and
wipes of grey, black and white paint, Mondrian waltzes, ghost to ghost,
with a spectral partner. His face bears the dim remnants of forms and
colors we used to think of as austere but now appreciate as alive. Rothen-
berg's and Fischl's works are the only ones that seem to recall the life
paint itself once had, the only works belonging to the world to which they
refer.

These rare signs of self-reflectiveness and historical awareness
flicker with an enhanced brilliance against the mindless art that composes
the body of the show. Mindless, joyless, irreverent, raucous, jeering,
portentous, desperate and sad, the typical entry moves the viewer to
compassion more than to criticism. Since criticism treats objects that are
subtle enough to require a particular analysis and understanding, it really
has no application here. What is called for is some social diagnostic since,
after all, we are dealing with a whole group of works, by different artists,
responding to what one must assume are common determinants. My own
view, which I can but sketch here, is this: Twentieth-century art has been
marked by a sequence of upheavals, each of which has challenged the
premises of what went before. The several upheavals were so many stages
in an effort to identify the nature of art, and the art's history has begun
to resemble a philosophical investigation collaboratively pursued. These

stages began to decrease in duration and increase in number through the 1960s until, I believe, the enterprise exhausted itself. But it was at just this point that forces of a different order began to impinge on the art world. These came for the most part from the world of fashion, which saw in the history I refer to something identical to a quite different sort of history—the history of fashion itself, which requires, for deep economic reasons, a new look each season. What were strenuous efforts at self-understanding in the art world were misperceived as strivings for novelty. And as the novel is the new, the media took a heightened interest in art: each new show, each new artist, is treated in the *New York Times Magazine* side by side with the latest in fashion, in decoration, in cuisine, in beauty.

So there grew up an intense external demand for novelty in art well past the time when there was any internal reason for it. And such is the nature of money that demand will create a supply if conditions permit. The art of the 1980s, and certainly much at the Biennial, is the art world's response to the restless appetite for the new. Work is accordingly reduced to being "new," to being "now." Ephemerality becomes almost a metaphor for the message. Hence, anything that looks as though it might last longer than a season is immediately under suspicion. Hence the raucousness. Hence the contempt and the simultaneous nostalgia for older values. Hence the desperation. And because of the immensity of the rewards for making it and the dismal consequences of not doing so, it is inevitable that each work should seek to outshout its rivals and that the art season should take on the tawdry assertiveness of the harlot's alley. What could be more disheartening than the effort to satisfy an empty impulse with the borrowed vitality of images that occur simultaneously in the nonartistic areas of our culture: the subway scrawl, the video arcade, MTV, the schoolyard, the Pentecostal tabernacle and the like?

The Whitney Biennials have more and more tended to participate in the frenzied pursuit of novelty, perhaps in the belief, borrowed from the fashion world, that the revolutions will continue perpetually and that every two years there will be a new one to record. I believe the curators of the 1985 Biennial have seen through this and have decided to end it by assembling work so awful that one cannot but wonder, If this is the cutting edge of art, whose throat is being threatened? They took a great risk in this, but if it changes the insane practices it will be worth it. In that case the show turns its back on itself, reenacting the gesture of Fischl's penetrating work. Of course I may be wrong, in which case the exhibition is by a considerable degree worse than its contents.

· 16 ·

MISTAKES OF BLANK (FORMING SPACE)

IT IS A LEGEND OF ZEN BUDDHISM THAT ITS FOUNDER, BODHIDHARMA, AT-
tained enlightenment after sustained contemplation of a blank wall. I find
in this encounter a parable for addressing the recent paintings of
Arakawa, on view at the Ronald Feldman Fine Arts Gallery (31 Mercer
Street, New York City) until May 11. Many of the paintings have the
magnitude of walls; they are vast in proportion to the viewer. They are
not blank, but blankness is their subject and, in a certain sense, their
substance. Enlightenment is to be achieved only through a concentrated
meditation on their stubborn meanings. Bodhidharma, a favorite motif
in Zen painting, can always be identified by his immense eyes: he is, in
effect, a pair of enlightened eyes. In this, too, a parable may be found for
our interchange with Arakawa's extraordinary works, for we leave them
with a widened vision. And as the blankness of the wall required Bodhid-
harma to reveal its significance, Arakawa's panels require viewers if they
are to be fully realized, for their truth exists in the space between them
and us.

Here is an example of the sort of thing I mean. Many of the paintings
include a panel with a kind of street map as its subject. Perhaps it would be
more accurate to describe these as diagrams of sectors of cities—Rome,
Florence, Manhattan—showing streets, squares, intersections, building
sites, traffic circles. They are very severely executed and, consisting only of
outlines, have the look of an engineer's drawings. But as we trace out the
streets, some of them undergo a subtle change. One turns into a sort of
strap and begins to curve out of the map—becomes an entity with no
relationship to the map and, in a sense, sharing no space with the map from
which it arose. It playfully forms knots with other straps which, if we follow
them back, eventually resume their identity as diagrams of streets.

ARTHUR C. DANTO

Initially, the diagram lies on the surface of the panel, where diagrams belong. When the streets transform themselves into knots, the knots exist between the diagram and the surface, in an illusory space. When we trace the knots back to the diagrams from which they arose, the streets are once more on the surface. In brief, we are confronted by representations that are on the surfaces and not on them. Two-dimensional and three-dimensional. Empty and full, abstract and palpable. We are left with a set of questions about the nature of pictorial illusion. The interaction has awakened us to our perceptual assumptions. It also introduces an extreme instability in the work itself, which oscillates between two incompatible identities.

The struggle of streets to become straps is a comic allegory of the metaphysics of art. Art has always sought to escape representation and become reality. The knots mark a liberation from the surface, only to define a dimension that is also illusory. In a way, the streets have a greater claim to reality than the runaway knots, for they belong to diagrams, and diagrams are on surfaces which occupy the same space as we do. So the diagrams seek to return to the surfaces while the knots interpose themselves in such a way as to make such returns only temporary. These conflicts are only part of what is taking place—the exhibition is filled with parallel comedies—but I was eager to give you a sense of one sort of engagement between viewer and painting before describing the exhibition as a whole.

The Feldman space is divided into a north and a south gallery, the latter immense. Four paintings occupy the smaller space, eight paintings the larger one. Three paintings occupy entire walls. The largest is eleven feet high and nearly twenty-nine feet long. One's initial impression of emptiness is illusory, since every inch reflects complex artistic decisions. I recall visiting the desert in the spring and being at first disappointed by the absence of promised flowers, which of course were revealed in time, when their fragile colors released themselves to vision and the seeming blankness yielded a carpet of subtle differences. So it is with Arakawa's work, which happens to be beautiful—almost a gift to the viewer in exchange for the arduous intellectual collaboration it requires. Indeed, they have an almost edible beauty: creams and lemons and pale mochas, pistachio, rose sherbet—and then silvers, grayed whites and touches of confectionary blue. Some of the paintings have four panels with intricate relationships to one another. One of the four may be a street diagram. Within it, there may be a heavily schematized corner of a brick wall,

advancing toward the viewer in an abrupt perspective, only to be driven back into the space it seeks to escape by the diagram, which affirms its unreality.

Any given painting will have an inscription, written or printed, always allusive and difficult, on the subject of the paintings of which it is a part. In some of the paintings there will be a shower of arrows; on some panels there will be pale and translucent silhouettes of familiar objects with uncertain meanings: lamps, a ladder, a light bulb, a pendulum. Some are of shapes that insist on a definition we are not quite prepared to grant. In one, a skewed optometrist's chart is slipping off the bottom edge, where it can no longer test the eye. Another consists of extraordinarily faint squares of pink.

Every work carries a title that connotes the concern with nameless-ness and formlessness we associate with certain oriental teachings: *Along the Way, The Forming of Nameless, Naming* echo Taoist themes. One of the main works has as its title the first line of a sonnet by Mallarmé, in an awkward translation. The entire exhibition has a title: Mistakes Of Blank (Forming Space). I hesitate to interpret the title, but trying to become a strap if you are a street might be an example of the kind of mistake intended.

Arakawa's work has always enlisted its viewers' participation in one way or another. One of his achievements, never completed, consists of some eighty panels, all the same size, and never, so far as I know, exhib-ited all at once, called *The Mechanism of Meaning.* It is a work done in collaboration with his wife, the poet Madeline H. Gins, and it combines images and words. The panels are extremely witty exercises in surrealist pedagogy, somewhat in the manner of Duchamp. Each one addresses the viewer directly, giving him or her a task to perform, usually impossible, or posing a question whose unanswerability is its answer.

The panels contain instructions and imperatives one eventually recognizes as being chiefly about themselves. They reminded me of Hegel's comic masterpiece, the *Phenomenology of Mind,* since it too is about self-consciousness, but in such a way that those who read it realize that it is finally about their reading of it, that it is about *them.* A good bit of *The Mechanism of Meaning* exists in a book (Abrams, 1979), and because the relationship between painting and reproduction is exactly the sort of thing the work is about, it is possible that the book adds a dimension to the work. (Certainly the German edition does, since the paintings have to be translated.)

ARTHUR C. DANTO

The more recent work is animated by questions and instructions as well, but they refer to a range of ideas narrower and more remote than those of *The Mechanism of Meaning.* Arakawa is interested in "cleaving," for example, which means, in English, attachment and separation, and which condenses the sorts of tensions that are the soul of his paintings. And he is concerned with "blank," a concept I understand very little. Perhaps a clue to its meaning for him may be found in a pair of broken inscriptions that form part of the painting *Naming.* On the left of the canvas, where we would begin to read, it says "ITHOUT BLANK." Then, to the right and running off the edge, it says "THERE IS NO THOUGHT W," clearly the beginning of the sentence whose ending we have already read. I suppose "blank" is described as well as displayed, since the two parts of the sentence are divided by a visible blankness on the surface of the canvas, and an invisible one behind it. At the bottom of the canvas, upside down and direction reversed, is a similar ruptured phrase: "AYS BLANK PART OF DOING IS ALW." One is obliged to think of that passage in the Tao-te ching which celebrates the powers of the void.

For all their size and intellectual energy, the new works are very quiet, and the imperatives they project are all but inaudible against the current music of the art world ringing in our ears—a charivari of cracked kettles, tom-toms and kazoos. So do not rush in as though you were a critic for the *New York Times* with a deadline for shelter. The best thing would be to come with a friend and begin a three-way conversation with the works. Take nothing for granted. Are the two panels of *The Gazing Other* halves of a single image? Then why are the colors marginally different? Why are letters dislocated when they are dislocated? Is that part of a piece of currency pasted on the right edge of a painting the other half of that piece pasted on the left? Are the arrows in the same space with the knots or on the same surface with the streets or, for all we know, in the space between the canvases and us? And where is the lettering?

After a time, structures begin to reveal themselves, new puzzles emerge. Part of the meaning must reside in the irresolvability of interpretations. If you cannot return for a second look, there is to be a show of drawings, answering to the same impulses, at the Arnold Herstand and Company Gallery (24 West 57th Street) until June 15.

Arakawa is one of the few masters in the art world, where the category of the master has been forgotten and most people think of discipline as one of the kinkier outposts of sex.

· 17 ·

THE NEW PATH: RUSKIN AND THE AMERICAN PRE-RAPHAELITES GEORGE INNESS

RUSSELL STURGIS WAS *THE NATION*'S FIRST ART CRITIC. BEFORE JOINING THIS magazine in the year of its founding—1865—he collaborated with Clarence Cook (who went on to become art critic for the *New York Daily Tribune*) on a more ephemeral but equally pugnacious periodical called *The New Path*. One aim of *The New Path*—"the only periodical in the country that ventures to have an independent opinion about art," according to a contemporary comment—was to establish an informed and responsible art criticism in America. The other aim was to assure readers that a new age of American art was at hand. The prevailing schools of American painting "have given us not a single work which we care to keep," *The New Path* declared in its first number (May 1863), but now the country possessed a group of young artists ("the true men") who were bringing about nothing less than "a great revolution in art." These belonged to a high-minded body called the Association for the Advancement of Truth in Art. The group subscribed to the principles of the English Pre-Raphaelite Brotherhood, and took its artistic imperatives from the thought of John Ruskin. As The Brooklyn Museum has mounted an exceedingly scholarly exhibition of the very painters in whom my predecessor put such hopes, I could scarcely pass up the opportunity to see what the hot artists of the age were up to.

The undeniable fascination of the exhibit lies in the fact that the paintings themselves make so modest a claim on our critical attention that the distance between them and what their enthusiasts said about them is

startlingly vast. It is as though one had read an extravagant esthetic and moral manifesto on behalf of an artist and then discovered that the writer was talking about Beatrix Potter. Potter's watercolors, which are almost boisterous next to the delicate and luminous works of these American Pre-Raphaelites, would certainly be worth a trip to Brooklyn to see, but Potter would never have supposed herself the Brünnhilde of modern painting, as these artists supposed themselves to be its Siegfrieds. On the other hand, listening to the comments of the visitors who pointed out the tiny details to one another with considerable pleasure and excitement, it was plain that they were responding precisely as the painters would have wished.

What of course was invisible to those viewers was the program that painting in such detail was meant to further, and hence the meaning of the finely observed fern or fish or patch of lichen on an exactly rendered piece of bark. For that is the kind of thing these paintings and drawings characteristically show: a blackberry bush, on which the artist told a friend that he spent an entire summer; a single jack-in-the-pulpit, not fully finished; a segment of forest floor with the light filtering down through leaves to leaves; a bird's nest with three eggs and a network of individuated straws; two stems of lily of the valley; a stalk of milkweed; a stem of woodbine; four dandelions in a circle; a dead bird; three apples weighing down a bough; two acorns, alone in space with a barn in the distance; a pair of pineapples (an outdoor still life); a rock; a spill of raspberries almost opulent in its numerosity. There is a study of a solitary pine tree by Charles Herbert Moore—in my view the most gifted among this group of "little artist men," to pluralize an expression Henry James puts in the mouth of one of his characters. An anonymous essay in *The New Path* articulates part of their program in this way: "The artist who would draw trees rightly must draw a great many sprigs of three or four leaves each, and then a great many leafy boughs. . . . With such training he may *hope* to draw a summer forest at last, as it should be drawn." There are some efforts to achieve, figuratively speaking, the summer forests of that aspiration, but the typical exemplar in the show is at the level of three or four leaves, and it seems to me the deepest impulses of the movement are most palpable at this degree of particularity.

These artists referred to the photograph as something against which to measure themselves rather than as a technology that rendered their efforts obsolete; indeed they thought of themselves explicitly as instruments. "The best artist is he who has the clearest lens, and so makes you

forget every now and then that you are looking through him," Moore wrote in paraphrase of Ruskin, who had set the agenda of precise, limited observation that defined the school. Of a pencil drawing "not more than six inches long and four inches wide" *The New Path* wrote: "The amount of truth that is crowded on this small piece of paper might shame any of the old school men who yearly cover the walls of the Academy with canvases six or eight feet long." It is the effort to evacuate the space between the viewer and the subject, to present the world as it would really present itself to the disinterested eye, that precludes the presence of an artistic personality. The collective purpose was to recover through honest pictorial labor fragments of visual truth. The "Pre-Raphs," as they called themselves, had Ruskin's assurance that to be able to paint a leaf is to be able to paint anything. They drew from this the inference that in painting a leaf truly, they had painted everything. The summer forest became a remote and almost pointless goal.

I have lived through a period in which a parallel program was proposed in philosophy. First there was the thought, due to Wittgenstein, that ordinary language suffices all our philosophical needs, so that we need no idiom more technical than the language of the marketplace or the nursery. So much for the portentous vocabulary of the metaphysical tradition and the technical vocabulary of analytical thought. Ordinary language, according to J.L. Austin, contains all the distinctions it will ever be important for philosophers to draw. The task, then, was to identify these nuanced distinctions, and for a period very bright philosophers restricted themselves to minute transcriptions of the surfaces of language. I recall a dissertation which enumerated such minute distinctions that I read it through tears of boredom, though assured by the writer that philosophers up to now had never been careful enough. This was actually construed as a revolution in philosophy, and its spirit was exactly that of *The New Path*. Both movements died of their own weight. It seemed there must be more to art than phenomenological scrupulousness in getting a blade of grass right. "It is *faithful*," Moore wrote to a colleague of a landscape he had labored at all through July, "but I am not sure that it is *successful*." Comparable words were voiced by philosophers who wondered whether clarity was enough, and if the promised summer forests of metaphysical vision had not been wrongly abandoned. In the end a distinction was drawn for artists between studies and paintings, and it was not plain that the distance between the two could be filled with more and more detailed examples of the former. The superb catalogue, by Linda

Ferber and William Gerdts, on which I am gratefully dependent for the information that keeps the show from being genuinely puzzling, cites a contemporary critic thus:

> The miscalled Pre-Raphaelites of our time, exaggerating the law of fidelity in parts, and losing sight of the broader principle of effect by which particulars are absorbed into large masses, protrude upon the sight with microscopic clearness the near and the distant, delineating the tiniest flower in a wide landscape, of which, in nature, it would form, at their point of sight, but an uncertain speck of color.

Paintings in which "particulars are absorbed into large masses" is an inadvertently exact description of the work of George Inness, a contemporary and contemner of the Pre-Raphs, who spoke of their work as "puddling twaddle." The movement, he wrote retrospectively, "was false as a philosophy, though necessary as a reactionary force. It carried the love of imitation into irrational conditions." By delicious coincidence, a large exhibition of Inness's work is hanging at the Metropolitan Museum for those who wish a vivid glimpse into the style wars of the 1860s.

It is useful to recognize that America at the time was a very distant theater, and artistic conflicts here were but pale reverberations of more robust engagements taking place in Europe. And even at that, the English Pre-Raphaelite movement, like the Barbizon movement in France which Inness represented in America, were relatively minor phases in the grand sweep of nineteenth-century painting. Inness was a considerably stronger painter than the best of the Pre-Raphs, but even so he was a provincial artist who rarely responded to the native landscape as such. There are some exceptions: there is a wonderful painting of the roundhouse of the Lackawanna and Western Railroad at Scranton, Pennsylvania, but it was done in 1855, before Inness went to Europe and discovered Barbizon. After that what one sees are single figures, who might as well have been French peasants, scumbled into clotted landscapes, which might as well have been at Fontainebleau. In contrast with the artists at The Brooklyn Museum, one feels that Inness was not an observer of nature. The first painting one encounters is the *Evening Landscape* of 1862. In it a rustic trudges a road, bearing faggots, while behind him trees are flattened against a florid sky at sunset. Somehow the shadows got left out, and I instantly distrusted this painter whom I had until then always thought I

would like to see as much as possible. I even took a perverse pleasure in his incapacity to get a fallen log to lie on the ground.

Inness is a singular example of an artist who looks less interesting the more of his work one sees and for whom the large one-person show is accordingly almost fatal. For one thing, there is a great degree of repetition in the works: almost always there is a single figure, set in a meadow or a wood, at a time of day when extreme effects of light are possible: sunset or sunrise, or the coming on or passing of a storm. These are deeply sentimentalized landscapes, objectifications of mid-Victorian feelings, and it struck me at last that I was being offered a vision neither of an artist nor of nature but of a clientele. Inness was painting for patrons who vibrated to a certain mood, and who wanted their art, as they wanted nature itself, to be soft, melancholy, meditative, twilit and sweet. The Inness in the parlor assured the caller that the owner was a person of high feeling. If indeed it was such moods and purposes the Pre-Raphs supposed the art of their time was servicing, then it is easy to see why they believed their own work was dismissed as an exercise in "cold, remorseless fidelity." "How it must shake their delicate nerves to see honesty and truth," wrote one of their most militant members, Thomas Farrer.

Alas, even the heightening of their enterprise by the theories to which they subscribed and the enemies they opposed does not lift these miniaturizing canvases onto the plane of great art. Theory and virtue do not compensate for lack of genius any more now than they did in the nineteenth century. The best things in either show are by someone who had no pretense to being a professional artist at all. Four drawings at the entrance of the Brooklyn show by John Ruskin—one of them of a piece of rock Ruskin observed in the Alps, another of a twig of peach bloom —are done with an energy so exact and an authority so innate as to demand acceptance as art, even if we knew nothing of the philosophy and polemic that explains their existence.

· 18 ·

TILTED ARC AND PUBLIC ART

RICHARD SERRA'S *TILTED ARC* IS A RUSTED SLOPE OF CURVED STEEL, 12 FEET high and 112 feet long. It sticks up out of Federal Plaza in lower Manhattan like a sullen blade, and its presence there has divided the art world into philistines like myself, who think it should be removed, and esthetes, who want it to remain forever. The controversy is not over taste, since many philistines, myself included, admire it as sculpture, but over the relevance of the hostility it has aroused on the part of office workers, whose use of the plaza it severely curtails.

Esthetes insist that it does not impede but in fact metaphorically represents the human flow to and from the banal edifice it mercifully occludes. Philistines insist that artistic merit notwithstanding, the piece is in arrogant disregard of those most directly affected by its presence; to them it is an obstacle and an eyesore. Serra says that the workers "can learn something about a sculptural orientation to space and place." Philistines agree, but ask whether lessons in art appreciation ought to preempt other uses to which space and place might be put. Philistines have no illusions that the plaza will be restored to beauty now that, like Excalibur, the blade is to be removed. But they feel the issues involved to be only marginally esthetic. It is the great if unsought achievement of *Tilted Arc* to have made vivid the truth that something may succeed as a work of art but fail as a work of *public* art.

Up to now it has been assumed that the criteria for good public art are simply the criteria for good art. All a government agency charged with commissioning public art must do is commission good art for public spaces. *Tilted Arc* meets, and perhaps surpasses, current standards for good sculpture, and since it is exquisitely placed in relation to its formal

environment, it does all one could ask according to what have seemed the only relevant indexes. The furor that has resulted from its placement suggests, however, that we must build something more into our conception of good public art. What we urgently need is a criterion for public art that justifies a work's removal if it does not meet it. It is possible that a work might be good public art though bad or indifferent as art, which would then make esthetic criteria irrelevant to the matter. The possibility of irrelevance was missed in the hearings devoted to *Tilted Arc,* whose supporters supposed it sufficient to praise it as art. I want to sketch what such a criterion might look like.

First, works of art, and certainly works of public art, do not exist in interest-free environments. There is a public interest in good art, but that is not the only public interest art serves. There is ground for removing a piece of public art when its placement represents interests that the work subverts, even if the work itself is good. Let us consider some cases where these other interests can be served only if the work is good as art, so that bad art would in fact subvert them.

Although not quite public art in the full sense, corporate art is a helpful example. Consider the familiar abstract emblems set against the characteristically inhumane facades of corporate headquarters, there to assure the passer-by that whatever its reputation, the corporation is committed to higher values. The high price of good art serves as a metaphor for the high value art is supposed to connote, and success in projecting its message depends on the wide recognition that the work is of very high value indeed. It would be a genuine embarrassment to the corporation were the work found wanting as art. (Think of the embarrassment to the corporate sponsor when a major exhibition it underwrites proves curatorially defective, as did the very bad Primitivism show at The Museum of Modern Art.) This explains the preference for internationally acknowledged artists: Moore, Calder, Nevelson, Noguchi. Even a bad Picasso is a good symbol of corporate highmindedness, but in general it is plain that a choice of bad art would subvert the purpose of having art there in the first place.

The philosopher J.L. Austin identified as "perlocutionary" a class of speech acts that do more than convey information. If someone confides that his nanny loved him, he is not just conveying the simple information the sentence contains; he is letting you know that his was a privileged childhood, with parents prosperous enough to afford a nursemaid and

pretentious enough to call her a nanny. The corporate artwork is perlocutionary in this sense, proclaiming something about its sponsor beyond whatever the work itself may proclaim.

Federally funded artworks are similarly perlocutionary, and their message is much the same as that of the corporate ones: despite unpopular wars and policies, a government of, by and for the people is committed to the highest things permitted by the separation of church and state. But unlike a corporation, the government cannot look as though it spends our money extravagantly, so public artists must not be too widely recognized. This may account for the innocuousness of much federally funded art and for the practice among better-known commissioned artists, like Serra, to state plainly that they did not make a dime off their project. The last thing the Federal Program of Esthetic Perlocution required was a work like *Tilted Arc*, which transmits the message that the government puts the value of high art above the rights and interests of those who find its presence offensive. And here the very goodness of the work conflicts with the message of benignancy the government seeks to convey by funding art to begin with. The contradiction can be resolved only by removing the work, thereby perlocutionarily conveying the crucial message that the will of the public matters and that ours is a responsive government.

Consider the case of Christo, who *does* make a dime and does not cost the public a nickel. Christo's works are wholly self-financed, but he uses the political process in a way that facilitates the final acceptance of his work: the public to be affected by the work participates in its realization. Although Christo is widely admired in the art world, the art world is not his primary constituency, as it has been for *Tilted Arc*. The art world too has its interests, particularly in asserting its authority to determine which works are good art. That authority was never questioned in the public hearings about Serra's sculpture. All that was questioned was its authority to determine whether something is good public art without consulting the public. That what is good for the art world is good for the public is true only on the most paternalistic assumptions.

What, then, should be the criterion for good public art? I find Henry James instructive here, as in most of the cruxes of life. There is a passage in *The American Scene* where he records his surprised admiration for Grant's Tomb. "I felt the critical question . . . carried off in the general effect," he wrote. "The aesthetic consideration, the artistic value . . . melted away and became irrelevant." What was relevant, James goes on to say, was the manner in which the tabernacle of General Grant embod-

ied the values of a democratic society. He contrasts the monument with the tomb of Napoleon in Paris which, "as compared to the small pavilion on the Riverside bluff, is a holy of holies, a great temple jealously guarded and formally approached." His point is that these two structures project the deepest public values of the societies that built them. If esthetic values were a society's deepest values, then "the aesthetic consideration" would not melt into irrelevance unless a work failed artistically. In these two monuments, the two societies embody themselves.

I think something like this has been achieved in Maya Lin's great memorial to the American dead in the Vietnam War. And other examples are easily found. Not far from Grant's Tomb is the *Alma Mater,* in the plaza of Columbia University. Its status as public art by this difficult criterion was confirmed in the early 1970s, when students attempted to blow it up. The students were not vandals but revolutionaries, symbolically attacking the public whose values *Alma Mater* embodies, regardless of the statue's value as mere art. Courbet's demolition of the Vendôme column was a parallel acknowledgment, almost conferring value by the violence of erasure.

Public art is the public transfigured: it is us, in the medium of artistic transformation. "The experience of art," Serra argued in his testimony, "is in itself a social function." So it is. But the social is not the public, any more than the individual is the private. Private and public are dimensions of the political. So when Serra's attorney spoke of the "imposition of political considerations into Federal programs related to all of the arts," he was making a mistake of category. The public is already the political. What Serra has insisted is that the esthetic override the political, which it cannot do when the art is public.

This being his position, he ought not to object to having his work treated esthetically. A trustee of the Storm King Sculpture Center in Rockland County, New York—one of the artistic glories of our region—showed me the area in which *Tilted Arc* might stand were Serra to allow its transfer there. In a meadow, with a mountain as background, it could expand in a hospitable space. Its rusting escarpment would contrast handsomely with the green grass, with fallen snow, and would complement the brown and red harmonies of autumn leaves. Going to admire it at Storm King would be a social act. The public has an interest in the existence of museums, but it also has an interest in not having all of its open spaces treated as though they were museums, in which esthetic interests rightly dominate. The delicate architectural siting of *Tilted Arc*

in Federal Plaza ignores the human realities of the place. Were he not blind to everything but the esthetic, Serra could learn something about human orientation to space and place. Standing where it does, *Tilted Arc* is the metal grin of the art world having bitten off a piece of the public world, which it means to hold in its teeth forever, the public be damned. Now that its removal is assured, a memorial scar might be considered— a marker, redeeming the cruel blankness of Federal Plaza, the place where in furious battle the public reclaimed its esthetic rights.

· 19 ·

MARC CHAGALL

THE ABILITY TO IDENTIFY A CHAGALL TESTIFIES AS LITTLE TO ONE'S POWERS of connoisseurship as the ability to pick out a robin demonstrates ornithological competence. Even the marginally privileged child will recognize "a chagall" in the museum with as scant a cognitive effort as is required to single out a zebra at the zoo. Such instantaneous identification explains Chagall's success as an artist as well as his failure as a master, for once we know a work to be a Chagall, we seldom look further. There can be few readers of *The Nation* who have not seen the landmark murals of Lincoln Center. But try to call them to memory and you will almost certainly fail. Even so, you will be able to guess their contents without being importantly wrong: levitating lovers, bouquets of botanically indeterminate flowers, green musicians in motley, domestic animals with expressions benign enough to serve at adorations, abruptly dilated fowl, inverted villages—all deployed in arbitrary spaces and defined through a certain gorgeousness of color. How could you miss and the work still be a Chagall? How can it greatly matter that there is a lyre rather than a fiddle?

There was a time, not long past, when the Chagall reproduction was the decorative emblem of choice in the standard literate apartment, collaborating with the sling chair, the Parsons table, the Danish lamp, the Finnish rug—and, of course, last week's *New Yorker*—to express the common taste of those loosely in touch with what we now call modernism. At the same time, the Chagall mural or the Chagall window served the corresponding public function of marking a particular building as being at the acme of contemporary good taste. Easily identified, they carried the semiotic status of trademark, and the irresistible combination of cultural authority and artistic undemandingness gave Chagall a competitive edge

unmatched even by Henry Moore. And he seemed to produce Chagalls with the effortless abundance promised by one of his swollen chickens. In consequence, there exists a glut of Chagall images in domestic interiors, public spaces and collections of every degree of importance. The first critical question, accordingly, is whether this thick layer of familiarity interposes itself, like an esthetic cataract, between the work and ourselves —or whether the work is simply congruent with the multiplicity of its appearances so that seeing is all we need by way of looking in his case.

It cannot have been the primary motivation of those who organized the impressively comprehensive exhibition of Chagall's work at The Philadelphia Museum of Art (through July 21) to counteract this pictorial entropy, because, in part, they did not perceive it as a problem. Visitors, the catalogue assures its readers, "will be surprised and even amazed at the strength of imagery which explodes from canvas, glass, or print." In the curators' view, Chagall was recognized after 1948 as "the greatest living artist." The exhibition is an homage—or, because of his recent death, a memorial—to "the greatest religious artist of our times." There is no suspicion that he was, instead, the overproductive, repetitive and shallow manufacturer of Chagalls-to-order that some have judged him. There can be few artists—Dali is the other example who comes readily to mind—on whom such extremely opposed positions have been taken. At the very least, the structure of a major chronological exhibition sufficiently constrains attention to make comprehensible some of the pleasure that visitors felt forty-odd years ago, when they encountered the great postwar exhibition of his work at The Museum of Modern Art in New York City and The Art Institute of Chicago.

At least this is true of the work done in the epic period of his life, when he was a student and later an artistic commissar in his native Vitebsk, making sojourns in St. Petersburg and Paris, in Berlin and in Paris once more, then, finally, with the coming of World War II, in New York. It is plain that after he returned to France, in 1948, following the death of his marvelous wife, Bella, his output, with minor departures, settled at the level of the high-style perfume advertisement. It is true that this level defines the artistic production of the School of Paris generally during those years; and while one finds one's progress through the Philadelphia show accelerating on encountering the cloying sameness of the work from the last four decades of his life, one cannot help but wonder if his decline was due to the decline of the school as a school, or

if there were internal reasons for the falling off of his creative powers. Picasso, Matisse and perhaps even Braque went from strength to strength in those years. Why did Chagall go the way of Marcel Vertès, Eugene Berman, Christian Berard or, at best, Raoul Dufy? I think the answer must be instructive, and I offer the following speculation.

My sense is that Chagall was a vital artist just so long as he was forced to engage in the art wars of his time, when he resisted demands that he surrender a certain originary vision and paint in ways in which he did not deeply believe. Chagall's strategy, almost like the Russian response to military invasions, was to allow the enemy to make profound penetrations onto native ground and then to harass its disarrayed retreat. In each case, he accommodated alien imperatives to the point where it seemed that he had been subdued, and then, somehow, he managed to repel the opposing vision, even though his work was transformed by the encounter. There were three main waves of stylistic incursion. First was the unashamed decorativeness of flat forms, which he received from Gauguin, whose work he knew primarily through reproductions available in Russia. The second raid, very nearly victorious, came from Cubism. In *Adam and Eve* of 1912, nearly all that remains of Chagall, apart from the signature, is a yellow goat with a jaunty bird perched on its horns, and a tiny green goat gazing over his own shoulder and out of the frame, as if unwilling to contemplate the shingled forms that would, had Chagall continued to employ them, have delivered him to art history as one of the lesser Lesser Cubists. The last wave came from the austere manifestoes of Suprematism: Chagall had to fight with Malevitch for the artistic conscience of Vitebsk after the Revolution. Four small pieces in Philadelphia show Chagall literally bending to save himself from Suprematist conformity. For a style warrior, France was exactly the wrong place to be after 1948, though by then Chagall was perhaps too exalted a personage to have found the powerful aggressions of New York painting even scrutable. In any case, he mellowed out to the familiar softness in the precincts of Provence. Unlike Picasso, he evidently did not generate his own internal contestations.

This *Sturm und Drang* narrative doubtless sounds portentous and excessively heroized, so I must add a defensive word. We have been living through a curious period of art, marked at best by an ideology of pluralism, where everything is tolerated because there is no clear direction in which the art world wants to go. You, an abstractionist, go your way; she,

a minimalist, goes hers; I, an expressionist, go mine; and if someone wants to be a minimalist expressionist color-field abstract figurationist painter of *fêtes galantes,* well, that's all right too.

But this amiable laissez-faire contrasts with the intense dogmatism that animated twentieth-century art until the present slack age. There was a time on Tenth Street when abstraction was insisted on with an urgency sufficiently religious that an artist who opted for figuration did so with the stubborn conscience of a heretic. I knew an artist in the 1950s, when The Club served as the local synod of stylistic encyclicals, who insisted on doing the figure though it meant risking his soul. Then, in the early 1960s, when Pop prevailed and Abstract Expressionism sat by in astonished defeat, it occurred to him that it was O.K. to do whatever he wished. But with this came the recognition that the tensions that had given meaning to his art had dissolved that meaning with their own dissolution. He resigned from the art world and found other work in life.

Twentieth-century art has never, until recently, been motivated by formal or merely esthetic considerations. It has been religious and revolutionary and has been viewed by its makers as a means to spiritual transformation and moral redemption. To paint one way, to paint against another way, gave artists the feelings that customarily accompany a conversion rather than a decision. Chagall becomes interesting when one senses within his canvases the resistance to great and contrary artistic forces, so that even his concessions have the form of surrenders rather than experiments. If you are an orthodox Hindu, you do not choose to eat beef with the cool curiosity of the adventurous eater in SoHo, who selects guppies braised in watermelon cognac from the imaginative menu of a daring chef. But this, if true, leaves the question, What identity was Chagall seeking to preserve against the domination of other schools? What remains when we subtract the struggle? Perhaps he would have remained the brash, provincial artist the earlier work promised, which looks, folksy imagery notwithstanding, as though painted in gravy on pumpernickel panels. Perhaps the counterfactual question is wrong. As he acquired an identity through the history of his resistances, so he would have come to little had he not been tried, his being a battlefield promotion to artistic consideration. In a sense, what he insisted on was the autonomy of all painting in the face of movements that meant to swamp it.

The famous *I and the Village* of 1911 is a case in point. A peasant in a peaked cap faces a smiling cow, their eyes locked in a gaze Chagall has painted as a loopy line from pupil to pupil. The churl has a green profile;

the cow's head is full of sky, while her thoughts are externalized as the fantasy of being milked. The two brows form the upper half of an hour-glass shape in which a rustic pair is depicted, the man marching some-where with a scythe, the woman floating upside down. The upside-down woman is the unmistakable Chagall touch. I focus on her as the key to the work and, in a sense, to the corpus. For one thing, it is not literally an image of an upside-down woman. If you believed it were, you would want an explanation for why her skirt had not fallen around her neck. In fact, it hugs her ankles, and though it might be argued that in her society modesty defies gravity, the artistic moral is that images have a life of their own. The image is upside down, but it does not follow that the woman is upside down. The painting belongs in the genre of Magritte's depiction of a pipe, under which is written—truthfully, since it is only a picture— that it is not a pipe. Chagall's work is full of implicit inscriptions like that —"These houses are not upside down," or "This peasant does not have a green nose," or "This is not a village." Paintings are not in bondage to external reality; their emancipation is celebrated with a giddy infec-tious joy. I surmise that what Chagall got from the Cubists was a license to arrange forms to suit the artist's impulses rather than to depict an unperceived geometry in the world. Meanwhile, he had to resist abstrac-tion, because it does not allow the defiances of pictorial liberty.

In a momentous passage from *The Interpretation of Dreams,* Freud abandons the hypothesis that dreams stand to ordinary mental processes as one language stands to another and argues instead that a dream is like a rebus puzzle, whose solution is an unconscious desire. He writes:

> Suppose I have a picture puzzle, a rebus before me. It depicts a house with a boat on its roof, a single letter of the alphabet, the figure of a running man whose head had been conjured away. . . . Now I might be misled into declaring the picture as a whole and its component parts are nonsensical. A boat has no place on a roof, a headless man cannot run. Moreover, the man is bigger than the house; and if the whole picture is meant to represent a landscape, letters are out of place. . . . But obviously we can form a proper judgment of the rebus if we put aside such judgments as these.

Were I to ask someone whose painting the passage describes, the answer would almost certainly be Chagall's, with the possible suggestion

that it might be one of the murals at Lincoln Center. If we put aside the criticisms, as Freud requires in the case of dreams, we lose the meaning —for we can put the image of a boat on a picture of a roof in an affirmation of pictorial autonomy. We can put a space between a woman and her head, as in *To Russia, Donkeys, and Others* of 1912 (not shown here), which in life would be fatal but in art is merely expressive. Expressive of what, of course, requires a genre of scholarship to answer, though certain juxtapositions are obvious and inspired, as in the affecting portrait of himself placing a kiss on his fiancée's cheek, the tenderness of which is enhanced by the lovers' implied weightlessness. It belongs to the universal lexicon of images that Freud sought, and it vindicates James Johnson Sweeny's assessment of Chagall's contribution to modern art as "the awakening of the poetry of representations."

The death of creativity is as mysterious as creativity itself. If my explanation is wrong, I can think of no other. It cannot simply be that eventually, in combining images unanchored to reality, a deadening repetition supervenes, for surely there could be an artist who does with paint what Donald Barthelme does with words, remaining all the while driven by an inner growth. Nor is repetition itself a sign of artistic death, for there are very great painters who, like Morandi and Motherwell, return again and again to the same themes, growing deeper with each fresh address. Nor could it have been the death of Bella, for Chagall went on to do the scenery for *The Firebird,* which I count as his masterpiece. It is as though, having struggled to retain freedom, he had nothing to do when freedom was unchallenged. When the struggles stopped, the meaning went, though the painting went on and on. There was then only the war with the market, which he seemed only too glad to lose.

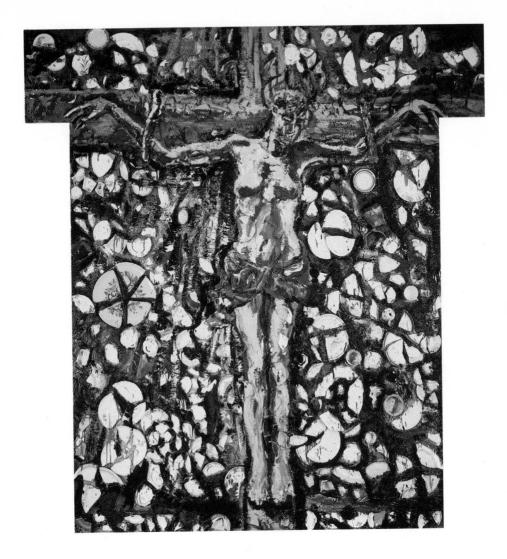

Julian Schnabel ▪ *VITA* ▪ **1984**

The crucified yellow woman amongst broken plates may just be oppressed womanhood nailed to the cross of domesticity. But the sharded crockery make it as gay and primitive as the Watts Towers. *(Photo courtesy The Pace Gallery, New York)*

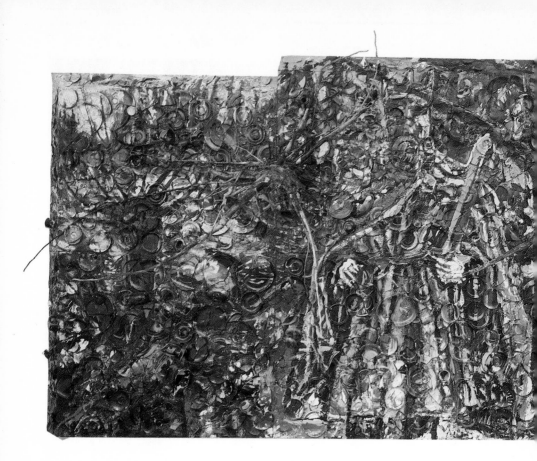

Julian Schnabel ▪ *KING OF THE WOOD* ▪ **1984**

The Hot Artist, in order to underline the fact that he has made an Important Painting, must deposit evidence of creative frenzy on the very surface of the work: smearing, scooping, dripping, squeezing, gouging, scraping. *(Photo courtesy The Pace Gallery, New York)*

George Sugarman ▪ *C-CHANGE* ▪ **1965**

A funny and ingratiating work, a zig-zag harlequinade of silly Cs evolving up some kind of vertical climax 114 inches above the floor. It is impossible not to smile each time one reads it. *(Photo courtesy Robert Miller Gallery, New York)*

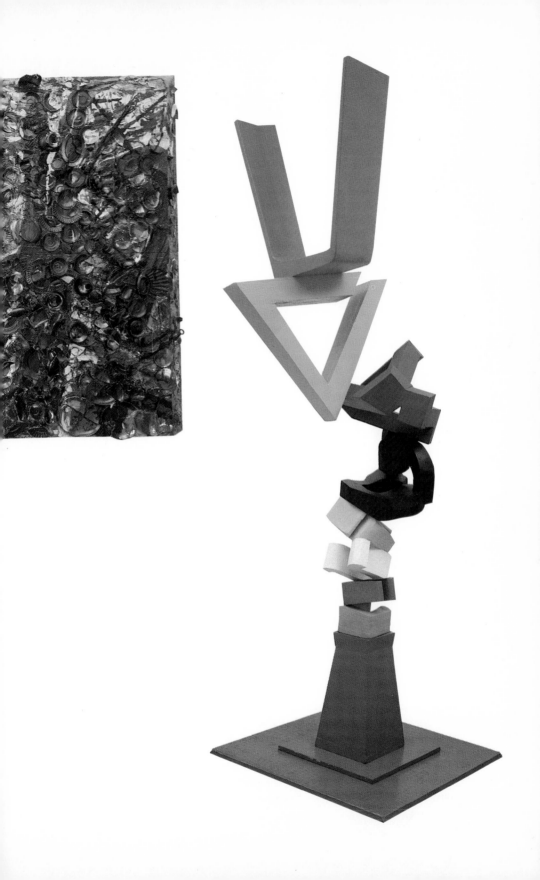

Willem de Kooning ▪ *PAINTED TOILET SEAT* ▪ 1947

Beyond question, de Kooning dripped the paint on this toilet seat. He has thereby compounded a natural comedy and put sufficient pressure on the borderline between artwork and curiosity to raise a question at once about the status of the artwork and the firmness of the borderline itself. *(Photo courtesy Joseph S. Lada)*

Jonathan Borofsky ▪ *2,845,325 THE DANCING CLOWN* ▪ 1982–83 (detail)

The impression of having wandered into an exuberant toyland is overwhelming on first entering the show. The dominating figure is this dancing sort of doll with a clown's face and a female torso. This androgynous figure turns his/her toe to the familiar strains of—naturally—"I did it my way." *(Photo courtesy Paula Cooper Gallery, New York)*

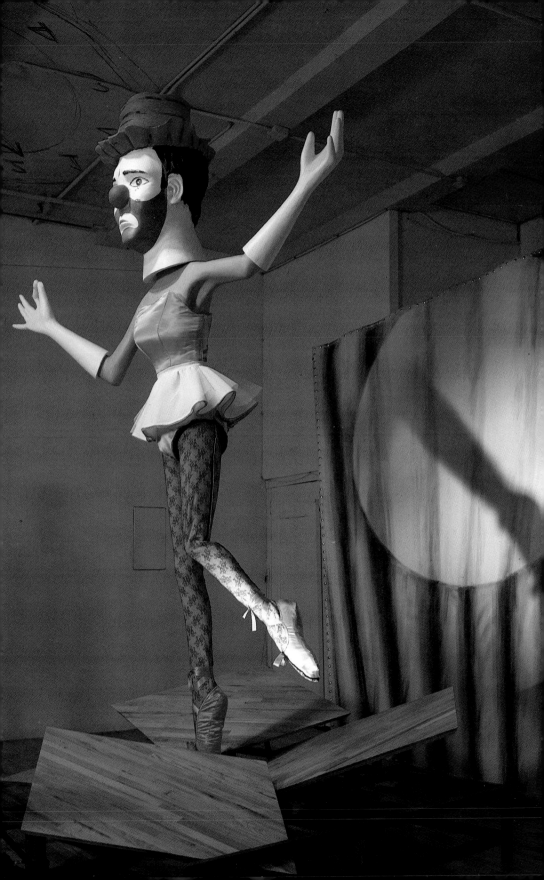

Jennifer Bartlett · *RHAPSODY* · 1975–76 (detail)

Her motive was to make a work that "had everything in it." So stupendous an ambition has seldom been pursued since the god Haphaestos forged the shield of Achilles. Since *Rhapsody* is composed of 988 squares, an analytical and synoptic program was required to achieve Bartlett's global aim. *(Photo courtesy Paula Cooper Gallery, New York)*

Robert Motherwell ▪ *ELEGY TO THE SPANISH REPUBLIC NO. 34* ▪ 1953–54

I know of no paintings by a contemporary more moving than the *Spanish Elegies*, and their power to move us must somehow be explained by the power of that feeling in Motherwell that he has managed to objectify, and which has driven him in an obsessive way to redeposit much the same array of forms as the effect of this compelling reality. *(Photo courtesy Robert Motherwell)*

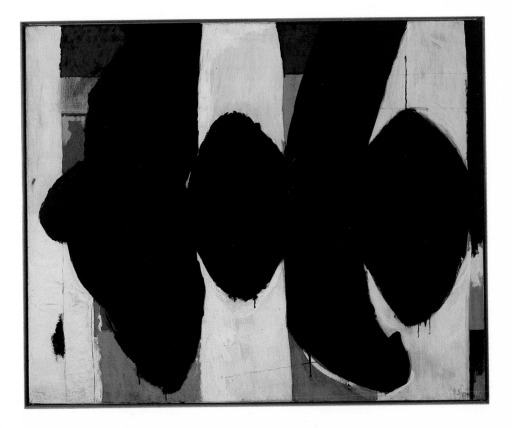

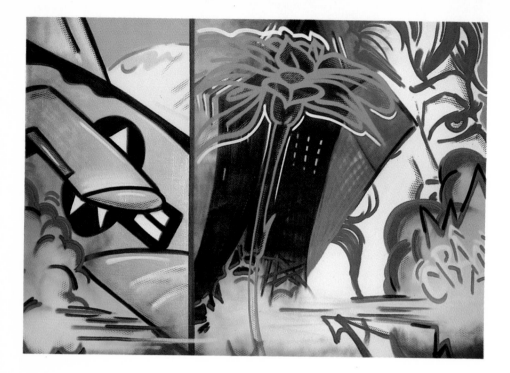

CRASH (John Matsos) · *SHATTERING OF... IMAGES* · 1985

As graffiti writers, DAZE and CRASH are good to very good. But as gallery
artists, they are, for all the vividness of their imagery and the phosphorescence of
their coloratura, pretty feeble. *(Photo courtesy Sidney Janis Gallery, New York)*

DAZE (Chris Ellis) · *COTTON CLUB* · 1984

The forms of graffiti are vestigial in this work, which chiefly shows, luridly,
images of street people executed in adolescent colors such as sick greens and
stammering reds. *(Photo courtesy Sidney Janis Gallery, New York)*

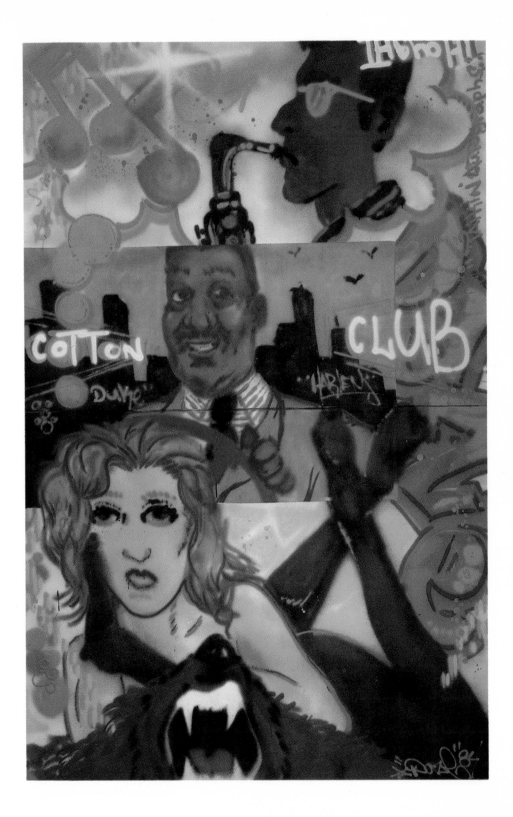

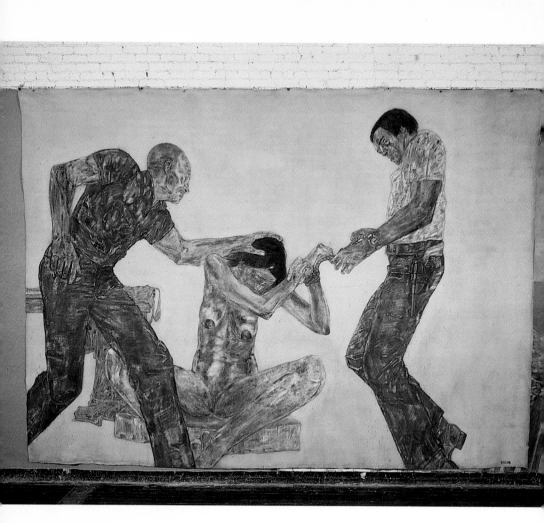

Leon Golub ▪ *INTERROGATION III* ▪ **1981**

All the figures, perhaps even the victims if we knew their histories, are moral monsters, and the inhumanities are quite unredeemed by comparison, say, with the depiction of martyrdoms and certainly by none of the purposes politics is supposed to serve. *(Photo courtesy Barbara Gladstone Gallery, New York)*

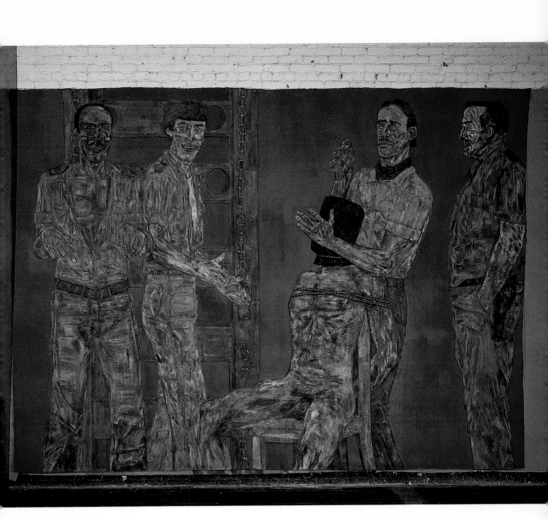

Leon Golub ▪ *INTERROGATION II* ▪ 1981

The artist engages with these persons as one who has somehow gained their confidence. It is as though he were there in the same terrible space as victims and tormentors. The power of the works derive from their moral optics. *(Photo courtesy Barbara Gladstone Gallery, New York)*

Arakawa ▪ *PORTRAIT OF HELEN KELLER OR JOSEPH BEUYS* ▪ **1985**

Arakawa's panels need participatory viewers if they are to be fully realized, for their truth exists in the space between them and us. For all their size and intellectual energy, the new works are very quiet, and the imperatives they project all but inaudible against the raucous music of the art world. *(Photo courtesy Ronald Feldman Fine Arts, New York)*

Paul Cézanne ▪ *STILL-LIFE WITH PEARS AND APPLES, COVERED BLUE JAR, AND A BOTTLE OF WINE* ▪ ca. 1902–1906 (watercolor over black chalk)

Composed less of apples and pears than of pear contours and apple vibrations, this is a work of such compelling luminosity that only the etiquette of how to look at an exhibition inhibits one from dashing across the room to gluttonize it. *(Photo courtesy E.V. Thaw)*

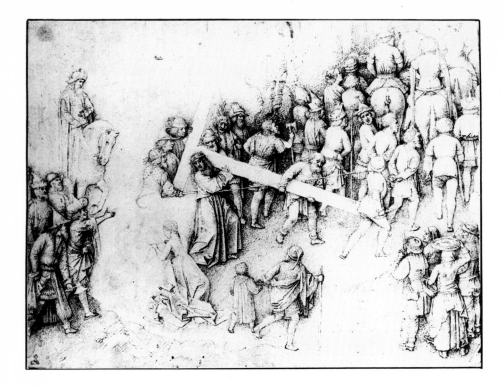

Netherlandish Master ▪ *THE CARRYING OF THE CROSS* ▪ ca. 1450–60

The cross is the color of the paper, a pure blank. But it takes on a radiance that does not belong to the paper outside the area of the cross. The cross is hardly drawn; the spectator completes it through what psychologists call subjective contours. *(Photo courtesy Graphische Sammlung Albertina, Vienna)*

Caspar David Friedrich · *THE JACOBIKIRCHE IN GREIFSWALD AS A RUIN* · ca. 1829 (graphite, pen and gray ink, brown wash on wove paper)

The color of the paper remains the same, but the color it implies varies in intensity—pale as sky, luminous when seen through the broken windows. *(Photo courtesy E.V. Thaw)*

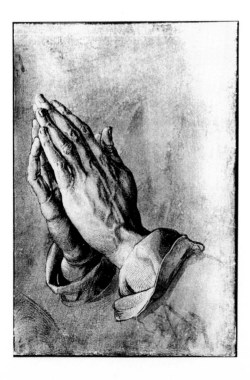

Albrecht Dürer · *PRAYING HANDS* (Study for an Apostle) · 1508

In the lower left corner is the vestigial indication of a shoulder that Dürer evidently saw no reason to go further with. A drawing is finished when the artist stops, but in Dürer's time this could not have been true of paintings: an unfinished painting would have to be of an unfinished reality, of which there can be none. *(Photo courtesy Graphische Sammlung Albertina, Vienna)*

Richard Serra · *TILTED ARC* · 1981 (Cor Ten Steel, Federal Plaza, New York)

This photograph shows Richard Serra's *Tilted Arc* as majestic, authoritative and exquisitely placed. What it fails to show is its conquest of a public space and the reason it has become so controversial as to call the concept of public art into question. *(Photo © 1986 by Don Hamerman)*

Maya Lin · *THE VIETNAM VETERANS MEMORIAL* · 1982

A memorial is a special precinct, excluded from life; a segregated enclave where we honor the dead. With monuments, by contrast, we honor ourselves. *(Photo courtesy UPI/Bettmann Newsphotos)*

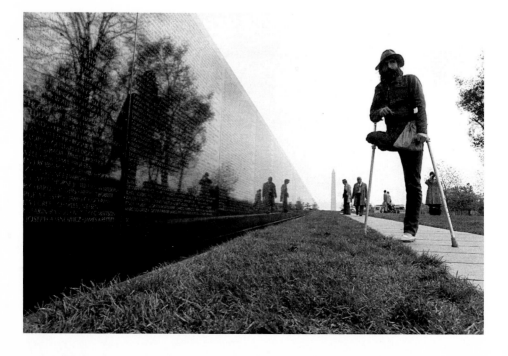

· 20 ·

KURT SCHWITTERS

WHOEVER HAS VISITED ANY REPRESENTATIVE COLLECTION OF MODERN EURO-
pean art, and especially of the paintings of the 1920s, will have encoun-
tered—and remembered—two or three of Kurt Schwitters's unmistakable
collages, or *Merzbilder,* as he called them. They are memorable in part
because they are composed of fragments of things commonly so sub-
merged in the transactions of daily life as to be beneath notice: who
remembers what a bus transfer really says, or a movie ticket, or a parking
stub, or the receipts from cash machines which we check out only to
confirm our incapacity to balance our accounts, and then crumple? Such
bits and pieces form the compost of our goings and comings. Were we
to retain each of the ephemeral scraps we jettison—the tissues and wrap-
pers, the receipts and tickets, the bills and memos, vouchers, coupons
and chits, the stubs, butts and inches of paper tape, the leaflets advertis-
ing sordid services, not to mention the business cards, front pages of
glimpsed newspapers, napkins sanitary and unsanitary, disposable con-
tainers, paper cups, matchbooks printed with meretricious enticements,
the carefully crushed and torn carbon interleaves of credit-card pay-
ments, and all of this made thicker by lost buttons, broken shoelaces,
toothless combs, fallen bobby pins, sprung rubber bands, plastic spoons,
wooden stirrers, soda straws, small change, tokens, emptied tubes and
wasted condoms—we would have the mute inadvertent autobiography of
anyone at all on a day like every other.

There is more to the *Merzbild* than the aggregated anonymous and
unconscious memorabilia of Schwitters's contemporaries, but one's ini-
tial sharp impression is that he has made into a form of art the compul-
sive, almost journalistic snatching up of unconsidered trifles. How much
more there is to him, and how much more complex, accordingly, the

interpretation of even a single collage must be, might never have been evident to more than two or three scholars of the interchange between Dada and Russian Constructivism without an exhibition as remarkable and inspired as the retrospective on view at The Museum of Modern Art in New York City (through October 1). Few can have been prepared for the oceanic ferocity of his creativity, or for the sustained polymorphism of his single artistic—or, more accurately, his single philosophical—idea. The name he gave that idea was *Merz,* partly to insist that his impulses were not to be assimilated to those of the Dadaists but more exactly to designate not so much a philosophy of art as a philosophy *as* art, of which he was more or less the sole practitioner. So closely did he identify with this philosophy-as-a-form-of-art that he said, in an important apologia of 1919, "Now I call myself MERZ." The idea sustained him through decades, while, true to his obsession with banality, he sought to live, almost as an act of artistic will, an irreproachably bourgeois life in a period marked by inflation, depression, social upheaval, cultural cataclysm, political oppression, exile, decrepitude, loss and death. In order to understand *Merz,* it is critical to see that it was more than an avant-garde prank, vintage 1920. It was, in fact, nearly a religious calling.

There exists, alas only in a grainy snapshot, a work whose title is *HAUS MERZ.* It consists of a wooden base in which "HAUS MERZ" is incised, together with a date—20—and the initials K.S. Signature, title and date are part of the work, testifying that it is a work of art. Mounted on the base is a tiny model of a church, with a toy top as spire, a nondescript block of wood as the tower it completes, and a button for the clockface. Behind is an open nave, composed chiefly of some clockwork gears, under a roof that looks as though it may once have been a blade of some sort from a scraper. It is not a typical *Merz* work because of the transformations: the button is displaced by its role as a clock, the block as tower, the top as spire, the blade as roof. These are the sort of visual puns we are familiar with from Picasso, who made a chimpanzee's head from a toy automobile and a goat's body from a wicker basket, and who drew a woman's breasts as a pair of teacups. Such metaphoric transformations, in which something is shown as another concrete object while retaining its identity as a button or a top, are unusual for Schwitters. Customarily, in *Merz,* an object, keeping its identity to be sure, is transformed only into part of an often quite abstract work of art. But *HAUS MERZ* is a work made up of puns—"the lowest form of humor"—and it is essential to interpreting the work that something as low as a pun should

be perceived as the substance of something as elevated as a church, let alone a work of art. The title/inscription is itself a pun: "HAUS MERZ" plays on *"Ausmerz,"* which would mean something that has been culled. The verb *"ausmerzen"* means to cull out, and the term *"merz"* occurs only in compound words, such as *"Merzschafe,"* a culled sheep, or *"Merzvieh,"* a culled piece of livestock. It implies rejection, as of something picked out because it's not up to the mark. *"Merzhaus,"* if the expression existed, would designate a faulty house. On Long Island there is an eating place actually called The Cull House, which, if it lived up to its name, would serve culled seafood: lobsters with missing claws, clams with broken shells, fish of the sort that fishermen throw back as having no commercial value.

It is striking that Schwitters's first use of *"merz"* was cut out of the printed word *"Commerz,"* an anglicized German expression that means "commercial," as in "commercial bank." (In fact, he cut it out of *"Commerz- und Privat-Bank."*) But since he was using in his collages only such words as could be culled out of newspapers, posters, handouts, labels and the like, there was probably no way he could have found *"merz"* save as part of *"Commerz"* (or perhaps *"Merzurizaten,"* "mercerization," if that process was common at the time). The verb *"merzen"* is obsolete and can be found only in large, expensive dictionaries, a circumstance inconsistent with the concept of *Merz.* The word *"Commerz,"* if you wish, is an instance of *Merz* which also contains the latter as part of itself, though not as part of its meaning. (Think of the way "cat" occurs as part of the word "cattle" or "she" as part of the word "sheep," without in either case being parts of the meanings of the words that contain them.)

Now the irony of *Merz* as practiced by Schwitters is that it is an act of including those things that have been excluded by culling: it is like a club made of those who are not members of other clubs, a *salon des refusés,* or, paradoxically, a class whose members have no other class in common —a kind of classless society. How appropriate, then, how quintessentially Christian, that a church should be a *Merz Haus,* a congregation of nobodies, of the outcast and downtrodden, the despised and rejected, of those who are so poor as to slip through the eyes of needles with room to spare, the last who shall be first, the inheriting meek. It is not surprising to learn from the densely documented catalogue by John Elderfield, director of the Department of Drawings at MoMA, who organized this show, that the unpretentious assemblage of loose parts that is *HAUS MERZ* should have been described by a friend of Schwitters as "the cathedral." Not a humble

building made of humble building materials but humbleness itself raised through an act of artistic transfiguration to a structure for which we need the loftiest expression the language affords. Although it is untypical of Schwitters, for all his love of jokes and artistic fun, to have induced the Picasso-like transformation, here it is important that a discarded and unusable clockwork should fill the space of holiness. Usually in *Merz,* the tram ticket or candy wrapper remains itself while transfigured into art. I am impressed by how marvelously *Merz* succeeds where Christian iconography fails. Commonly, in the latter, the elevated are shown on clouds, the vestments of poverty stripped away in favor of celestial garments, the Christian artist having forgotten how central to his message lowness is and how it must be retained in any suitable transfiguration. I knew a woman who daydreamed as a girl in Russia of joining her family in America where, to be sure, she expected to scrub floors—but in a silk gown. A proper Christian representation should have figures bearing not the emblems of spectacular martyrdoms but those of grinding common labor: the scrub brush, the diaper, the skillet, the spade and pickax, the short hoe.

Schwitters claimed that a work of his specifically called *Das Merzbild* because of the occurrence in it of the fragment MERZ was the first of the genre of works he went on to call *Merzbilder.* According to his account it was called that simply because of the fragment it contained, the way another picture is called *Das Undbild* because of the occurrence in it of the word *"und."* I doubt it can be as simple as that, because *Merz* has the antecedent meaning I have described, which the subsequent *Merzbilder* all more or less exemplify, being made of culled detritus, and because *Das Merzbild* is already made up of culled bits, including the fragment MERZ. Like *HAUS MERZ,* the *Merzbild* vanished, and the snapshot in which it holds a suitably banal immortality is too indistinct for us to be able to make out what its components were with any confidence. But there is an unmistakable piece of torn netting and what may be a shred of lace from what had been a veil or an undergarment. There may also be a comb. And, who knows, once MERZ was glued in, the artist may have been driven to complete what perhaps began as a routine abstract collage by seeking other objects to vindicate the title and the concept.

Whatever the case, the *Merzbilder* after that take their names from scraps they contain, often but not always a word, and it is difficult to suppose that any of them refer to what the word itself refers to. I doubt that many of them carry much external reference at all. But the scraps

themselves are referential in that each exemplifies the concept of nonde-
scriptness, of what would have been waste had it not been redeemed by
and for art. The natural locus of these scraps is the ground on which
unheeding heels will pound them into dust. Schwitters has lifted them up,
one feels lovingly, and placed them as though precious in arrangements
of great formal elegance and haunting beauty. The pictures are like
heavenly choirs composed of waifs and strays, down-and-outs, odd balls
in even holes, each allowed its own voice which then combines with the
others in a surprising harmony. It is one of the most moving exhibitions
I have ever seen.

What is even more moving than the work itself is the manner in which
Schwitters is transfigured before our eyes into one of the great artists of
the century. The transfiguration of the transfigurer could only have been
achieved through an exhibition on this scale, in which the full range and
reach of *Merz* is arrayed. Much has been lost. The *Merzbau,* for example,
which was a kind of interior transformation of his home in Hanover,
comprising vaults and columns and grottoes, was bombed into what I
should like to term "schwitters"—fragments of worn and shattered real-
ity past any uses save those discovered by this artist as his art. He rescued
banal expressions for literature, banal gestures for drama, and built for
himself a life of banalities made precious by the surrounding collapse.
Had the extent of his achievement been widely known, much of twen-
tieth-century art would have been unnecessary, since it had already been
done by him. He found forms and ways of combining forms that many
have rediscovered but none have employed with anything like the vision,
the abstract power, the charity, humanity and grace of this great soul.
One gets a glimpse of what Kandinsky must have meant by the spiritual
in art.

· 21 ·

WORKS ON PAPER

I AM UNCERTAIN OF JUST WHEN IN THE RECENT PAST THE EXPRESSION "WORKS on paper" entered the art world's lexicon, but my sense is that it was initially a dealer's term, intended to segregate a wide and heterogeneous class of artworks from paintings proper. The new term then underwrote the practice of charging higher prices for works done on canvas, panel or any support less paradigmatically fragile than paper. As a material, paper connotes cheapness, disposability, ephemerality: it is what we employ, as Kurt Schwitters appreciated so profoundly, for things meant to be used and thrown away. The *New York Times,* for example, is referred to as "the paper," but despite its reputation and authority, no one hesitates to use it for starting fires, wrapping garbage or training puppies. And perhaps these connotations carry over into art: with canvas or gesso panels, let alone actual walls, there is a presumption of permanence which goes with a prejudice for eternity that has become associated with art since Platonic times. So an artist must be supposed to have serious motivations indeed when she or he commits an image to these seemingly more enduring surfaces. If it is to be a joy forever, a thing of beauty is not to be placed on surfaces of metaphorical mortality, even granting that the ancient soil of Greece is dense with shards of shattered urns.

For just these reasons, perhaps, work being on paper licenses a certain experimentalism, a recklessness, audacity, even a certain frivolity, as though it does not ultimately matter what one does, since it is supposed not to last. So the genre of works on paper began to take on a life of its own, and paper became the favored substance for artists in their more playful and intimate moods. Ours is not the first time in the history of art that perishability has accompanied experiment. In the eighteenth century, the fireworks display gave free rein to architects, who used the

occasion to work out ideas that were too chancy to commit to masonry or that might as well be extravagant, since they were destined to go up in smoke and dazzle. Today something like this is true of beach houses in the Hamptons, where the immanence of hurricanes and uncontrolled seas transform the fragile coastlines into an architectural laboratory. It is this antic holiday spirit, then, that marks the true work on paper, a certain openness and looseness to which paper liberates us.

It would be wrong, however, to designate certain artworks as works on paper, even though they are indeed works and are in fact on paper, like the scrolls of China or the screens of Japan. In part this is due to the fact that anything might have been a metaphor for ephemerality in those cultures which set no particular premium on inalterability in their philosophies. To be sure it could be argued that the fact that they used paper so widely in their art was itself an expression of their metaphysical celebration of the fleetingness of things. But in these Oriental cultures paper was appreciated for its beauty and paper workers appreciated for their skill in regimenting so fragile, so naturally insubordinate a stuff. Nor would we designate as works on paper etchings and lithographs, though literally this is what they are, because the mediation of considerable technical prowess fits awkwardly with the spontaneousness insinuated by the new term.

There *is* an inclination to use works on paper as a trendy synonym for "drawings," but apart from the fact that drawing is done on a wide variety of surfaces—sidewalks, the walls of caves, as well as on panels and stretched canvas, our emblems of eternity—it would be quite improper to speak of the drawings of the old masters as works on paper, even if as a matter of artistic psychology the circumstances of being done on paper had a liberating effect.

Consider the drawings of Théodore Géricault, recently exhibited at The Morgan Library in New York City. Many were sketches and studies, to which paper lends itself by its nature, but Géricault's manner of address is too serious to fit consistently with the connotations I am seeking to identify. Many of them were preparatory sketches for *The Raft of the Medusa,* a work which condenses so much human agony, caused by unleashed nature and the cruel indifference of those in power, that the tragedy of his concept transfers to the studies. Moreover, Géricault drew the things he took most seriously in life—horses, battle, death and sex—and sought through his drawings to work out the internal contradictions of style that made his own artistic personality so difficult and that defined

the polarities of nineteenth-century art in France. The nobleness and intensity of artistic purpose stifle the qualities about paper that give rise to the animation and caprice of work on paper. These very qualities, the ones which make paper the appropriate material for parties and celebrations, make work on paper so central to the contemporary spirit and lead one to speculate whether painting itself implies values that belong to another, more solid, period of art. Works on paper exactly suit an art world defined by perishability and fashion.

It was inevitable, then, that the actual presence of paper should finally become so marginal to the concept of works on paper that an exhibition of them, New Work on Paper 3, on view at The Museum of Modern Art until September 3, should consist of work on materials quite other than paper: aluminum sheets, fiberglass and in one instance a kind of scrim. This might not matter greatly if all the works were drawings and the synonym held, but in fact they are not. Robert Morris's work on fiberglass looks like a mold of some shallow pit taken for archaeological or forensic purposes, since it shows human bones among the oddments. One work, by James Rosenquist, is distinctively a paperwork, like a non-folded origami, but there is no work on the paper itself to justify the name. And the cautious, elegant modifications of metal sheets by the minimalist Robert Ryman could as easily and perhaps more accurately be thought of as painting rather than drawing. Since neither drawing nor having been done on, as opposed to with, paper is essential to the definition of "works on paper," it is clear that we are dealing with a novel genre of art, one whose criteria remain to be worked out. The term itself therefore should be used with implied quotation marks.

The show exemplifies the adventuresome indefinition of its contents, as does the curiously suitable catalogue, which announces "Works on Paper" on its *plastic* cover and then proceeds to subvert the ordinary purpose of catalogues by reproducing and describing *none* of the works shown. In candor, it is difficult to determine what is being described in the so-called narrative portion of the text, which attempts to discuss mimesis by imitating prose. The author, Bernice Rose, achieves a singular autonomy of art writing (to use a term I believe coined by David Carrier)—a dense curtain of typography through which we can darkly intuit a possible meaning, much as we are able to make out some words through the opaque plastic of the cover. As a work on paper in its own right, a *part* of the show rather than standing outside it, the book is

sufficiently unhelpful to qualify as a work of art. The one useful piece of information it gives is that none of the works exhibited were done when the book went to press, which shows that the curator took the same sort of chances that works on paper are supposed to take, hoping for the best. Meanwhile Rose assures us, by listing the pedigrees of the invited artists —their educations, one-person shows, important group shows—that it was not a completely aleatory enterprise, even if the catalogue was written and sent off before there was a single work to ponder. And, as sometimes happens when great risks are run, the show is an experimental success.

The catalogue does contain, by happy accident, a sketch for the paperwork by Rosenquist referred to earlier: a kind of disk, with an elegantly deckled circumference. It is suspended by threads from the ceiling and hangs, or rather floats, parallel to the floor. Called *Table,* it defies the customary uses of tables. But so do pictures of tables defy these purposes, unless we use the canvas they are painted on as tables, and I thought this work a witty comment on the boundaries between art and utility.

I was also struck by the virginal whiteness of the paper, and speculated on the problems of preservation it must present: How was it to be kept free from dust and humidity? The catalogue sketch is accompanied by the inscription "paper disk or table to collect dust," and I suddenly realized that the act of preservation would be contrary to the spirit of the work, intended to accumulate dog hairs and fly drippings, dust and flying ash, meanwhile buckling under the onslaught of gravity and damp, until it achieves the end state for which it was intended—a domestic eyesore, imposing on its owner a conflict as to whether to preserve it as art or cooperate in its destiny by throwing it out as, after all, a piece of soiled paper, like a Kleenex or a Pamper. It is a kind of performance, incorporating as part of its meaning the forces that would threaten it were it to defy them instead.

Rosenquist's more conventional entries are displays in virtuosity, deeper of course than demonstrations of artificial marbling but seriously illusionistic in that they look as though a drawing had been torn into shreds and pasted over another drawing, visible between the shreds. The illusion consists in the fact that it is all one drawing with a certain internal discontinuity: one is able to pay attention to only one of the drawn images at a time, either the overlaid or the overlaying one, as in a classical optical

illusion. But whether there is an internal reference between the mutually disrupting images and what the iconographic total comes to belongs to a review of Rosenquist rather than here.

And so with what I would want to say about the work of Robert Ryman, apart from the observation that his work is anti-illusionistic by direct antithesis to Rosenquist's. The presence of Ryman's hand is detected only along the edges of the pieces, making those edges real and, by that same gesture, making real the shiny surfaces of the metal sheets he works with. Any mark he made on the sheets would have to have been on the surface rather than in an illusory pictorial space, and the restraint he demonstrates in not touching the surfaces induces a conceptual tension within the works. So does the fact that all the connotations of works on paper are present through negation. Whether they would be present were the works hung in a show of their own is a nice question, and if, as I think, the answer is no, that shows something about what an exhibition can contribute to its constituent pieces.

The work I most admired consisted of some very large and very heavily worked sheets of unframed paper, on which Pat Steir conveys, with an intense and athletic energy, the feeling of immense waves of the sort that threaten the beaches of Westhampton. The drawings refer explicitly to famous works by Hokusai and Courbet, though those artists' waves are, respectively, breakers and rollers, and Steir's drawings seem closer to the latter, consisting of circular movements of pencil and crayon, repeated and repeated until a sort of dense helix is scribbled across the distressed paper. On the upper edge of each she has lettered in, loosely, the line from Rilke's *Duino Elegies,* "Beauty is nothing but the beginning of terror." The adjunction of these words to those images restored for me what I realized had been a lost dimension of the great Japanese print *The Great Wave Off Kanagawa.* That is one of those pictures standardly used to illustrate eye movements and formal relationships, as though it were an abstract pattern of reciprocating curves. Formalist analysis, as usual, blanks out content, and in looking again at that marvelous woodcut I saw how much terror must begin with the beauty of the breaking wave, how nearly as anguishing as being exposed on the raft of the Medusa it must have been to be in those podlike boats in the awesome trough, Mount Fuji all the while standing tranquil and quiescent in the distance. I think some of this affect is present in Steir's works, which alone justifies a visit to the show.

Bruce Nauman's work is merely turgid: one recognizes from it how

much the properties of neon tubing, luminous and linear, contribute to the work in words, his trademark product. And Robert Wilson's pallid doodles require more energy to describe than they possibly could have cost to inscribe, though their limp and skimpy character might enhance by their weakness the diaphaneity of the scrim that sustains them when, as in the pretentiously darkened room they are shown in, it is lit from behind. Robert Morris's *Blind Time* drawings, executed while blindfolded and with both hands, inspire speculation about vision and proprioception too philosophical for inclusion here. But they encapsulate, as we learn from the appended legends describing the exact circumstances of their execution, precisely that openness to risk that belongs to this brash genre of contemporary expression.

Bernice Rose took just such risks in putting the show together, but next time she should leave the writing to some of the clever hands in the department of public relations. Now that genres are up for invention, I look forward to the first show at MoMA of work-in-wood, with its giddy confections of aluminum, hemp, feather, leather, plasticine, rubber and, of course, paper.

· 22 ·

THE VIETNAM VETERANS MEMORIAL

WE ERECT MONUMENTS SO THAT WE SHALL ALWAYS REMEMBER, AND BUILD memorials so that we shall never forget. Thus we have the Washington Monument but the Lincoln Memorial. Monuments commemorate the memorable and embody the myths of beginnings. Memorials ritualize remembrance and mark the reality of ends. The Washington Monument, vertical, is a celebration, like fireworks. The Lincoln Memorial, even if on a rise, presses down and is a meditation in stone. Very few nations erect monuments to their defeats, but many set up memorials to the defeated dead. Monuments make heroes and triumphs, victories and conquests, perpetually present and part of life. The memorial is a special precinct, extruded from life, a segregated enclave where we honor the dead. With monuments we honor ourselves.

Memorials are often just lists of those killed. Herodotus describes a megalith that carried the names of all 300 Spartans slain at Thermopylae in a defeat so stunning as to elevate their leader, Leonidas, to what Ivan Morris once called the nobility of failure. Lists figure prominently in the hundreds of Civil War memorials, where the names of fallen townsmen bear the iconographic significance that those who were lost meant more than what had been won. The paradox of the Vietnam Veterans Memorial in Washington is that the men and women killed and missing would not have been memorialized had we won the war and erected a monument instead. Among the specifications for the memorial's commission was the stipulation that it show the names of all the U.S. dead and missing (the battlestone of Thermopylae only memorialized the Spartans, not their Theban or Thespian allies) and that it make no political statement about the war. But just being called a memorial is as eloquent as not being

called a monument: not being forgotten is the thin compensation for not having participated in an event everyone wants to remember. The list of names, as a collective cenotaph, situates the memorialized war in the consciousness of the nation.

The Washington Monument is an obelisk, a monumental form with connotations of the trophy in Western art. Augustus carried obelisks to Alexandria, whence they were in time borne off to London and New York; Constantine brought one to Rome, where it was appropriated by Pope Sixtus V for San Giovanni in Laterano; Napoleon was obliged to cart an obelisk to Paris. The Lincoln Memorial is in the form of a classical temple, in which Lincoln is enthroned like a brooding god. It is a metaphor for sacrifice and a confession of the limits of human power. The Veterans Memorial carries no explicit art-historical references, though it consists of two symmetrical walls, mirror images of one another, right triangles sharing a common vertical base, which point, like a pair of long wings, east, to the obelisk of triumph, and west, to the temple of submission. Everything about it is part of a text. Even the determination to say nothing political is inscribed by the absence of a political statement. A third stipulation for the memorial was that it harmonize with its surroundings. It does more: it integrates the two structures it points to into a moral landscape. Because the two wings form an angle, the Veterans Memorial together with the Washington Monument and the Lincoln Memorial compose a large triangle, with the long reflecting pool as a segment of the base.

The memorial was dedicated on November 13, 1982—Veterans Day —when there were only the walls and the names, each wall composed of seventy granite panels, with about 58,000 names and room for several hundred more. Two years later a bronze statue of three servicemen, done in an exacting realism, was added to the site. Their backs are to the axis that connects the Monument and the Memorial, as though they are oblivious to the historical meanings to which the walls return us by pointing. Like innocents who look at the pointer rather than that to which it points, they see only rows and columns of names. They are dazed and stunned. The walls reflect their obsessed gaze, as they reflect the flag to which the servicemen's back is also turned, as they reflect the Monument and the Memorial. The gently flexed pair of walls, polished black, is like the back of Plato's cave, a reflecting surface, a dark mirror. The reflections in it of the servicemen, the flag, the Monument and the Memorial are appear-

ances of appearances. It also reflects us, the visitors, as it does the trees. Still, the living are in it only as appearances. Only the names of the dead, on the surface, are real.

The reflecting walls constituted the Veterans Memorial at the time of its dedication, but before they were in place a concession was made to a faction that demanded figurative realism instead of what it perceived as an abstract monument to the liberal establishment. Thus the bronze servicemen. Those walls could have stood on their own, artistically, but the bronze group could not have. As a piece of freestanding sculpture it is intrinsically banal. Its three figures belong to obligatorily distinct racial types: a black and someone vaguely ethnic—a Jew, perhaps, or some Mediterranean type—stand on either side of a Nordic figure. The central figure has a holstered pistol, but the end figures carry more powerful weapons—though not held in a position for use—and there are no empty spaces in the cartridge belts: fighting is suspended. The garb and gear of this war are precisely documented: visitors will learn how many eyelets were in G.I. boots and that soldiers carried two canteens. More realistic than the military figures that guard the honor rolls in Civil War memorials, they look too much like specimens for a military museum, at least when considered alone. But they are greatly enhanced by their relationship to the great walls. In a way, the harmonization of their presence in the triangle generated by the walls is a monument to the triumph of political compromise rather than a memorial to artistic strife. The dead are remembered in their gaze, even when there are no living to look.

The walls are the design of Maya Ying Lin, who won a competition against 1,421 contestants when she was 21 and a student at Yale University. An Asian-American from Athens, Ohio, she was a child at the time of the memorialized conflict, too young to remember the tumult and the protest, which for her are simply history, like the War of Independence or the Civil War. The bronze group was done by Frederick Hart, a Washington sculptor, who was, ironically, a demonstrator against the Vietnam War. The irony is that artistic realism was associated with patriotism and endorsement of the war in the minds of those who insisted on figuration. They regarded the walls as a symbol for peaceniks. "A wailing wall for liberals"; "a tribute to Jane Fonda"; "a degrading ditch"; "the most insulting and demeaning memorial to our experience that was possible": these were among the nasty things said. The walls are nonfigurative, of course, but they are deeply representational, given the textual nature of memorial art (of all art, when it comes to that), and the question

of the meaning of Lin's text was acknowledged by those who rejected what they took to be its supposed representation of reality. Its being black, for example, was loudly read as a sign of shame until a black general brought an abrupt end to that effort to pre-empt the language of color.

The winning design was the unanimous choice of a panel of eight experts, and it was accepted by the group that pushed the idea of a memorial as an expression of the feelings they wanted to have objectified. It gave a form to those feelings, as public art is supposed to do: the issues are never solely esthetic. It was accepted by 150,000 participants at the dedication. No one has defaced it, no one has tried to blow it up, though there was a threat of this once. It has been accepted by the nation at large, which did not even know it wanted such a memorial. It is now one of the sites most visited in the capital. Still, it was wholly appropriate that the design should have been put in question when a schism opened up, that intense emotion and antagonism should have raged, that terrible and foolish things should have been said by everyone. Lin mounted the same high horse favored by artists whose work is publicly criticized and accused the critics of sexism. Even so, her design held. It was not replaced by a monument, as though the tacit rules that govern the distinction between monuments and memorials finally prevailed. Those who wanted realism finally got their mannequins, not exactly where they wanted them, with the walls to their back and a proud flag flying at the vee, but off to one side, up a gentle slope, and at a certain distance, with the flag still farther away. By a miracle of placement, Hart's shallow work has acquired a dignity and even a certain power. The complex of walls and figures reminded me of a memorial sculpture of Canova, in which a single figure sits in white silence outside a pyramidal sepulcher. A dimension is even added to the triangular walls, wonderful as they are. The entire complex is an emblem of the participation of the public in the framing of public art. It did not, to paraphrase Richard Serra, cost the government a dime. More than 275,000 Americans responded to the call for funds with contributions in small denominations—those bearing the faces of Washington and Lincoln.

Lin's instructor told her that the angle where the walls meet had to mean something, and I asked myself, when I pilgrimed down one hot Tuesday in July, what its meaning was. A writer in the "Talk of the Town" section of *The New Yorker* described it as "a long open hinge, its leaves cut vertically into the ground, which descends very gradually toward the

vertex." The hinge is a powerful symbol—we speak of "the hinge of fate" —and it has the mysterious property of opening and closing at once. Still, that is something of a misdescription. A hinge 140 feet long sounds too much like Claes Oldenburg, who might, consistent with his *oeuvre,* have submitted the Vietnam Veterans Memorial Hinge had he entered the competition. The *New Yorker* writer does better on a nearer approach: "a little like facing a huge open book with black pages." The book lies open now that the episode is closed and all or nearly all the dead are known. A book of the dead. And that would fit with their being listed in chronological order, from the first one killed in 1959 to the last one killed in 1975, when the remaining Americans were evacuated from Saigon as the Republic of Vietnam surrendered, on April 30.

This brings me to my chief criticism of Lin's work, which concerns an incongruity between narrative and form. An effort has been made to make the slight angle meaningful by having the narrative begin and end there: RICHARD VANDE GEER is at the bottom right of the west panel and DALE R. BUIS is at the top left of the east panel on either side of the joint. As though a circle were closed, and after the end is the beginning. But a circle has the wrong moral geometry for a linear conflict: the end of a war does not mean, one hopes, the beginning of a war. As it stands now, we read from the middle to the end, then return to the other end and read again our way to the middle. This means that the terminal panels, architecturally the most important, carry one name each, but the end points of the walls are not the end points of the list. If the first were first, we would read through to the last, from left to right. The panels grow larger, which is to say the space in which the walls are set grows deeper, as we approach the center. So there are more names on the central panels than on the rest. But that exactly reflects the shape of the war itself, our involvement being greatest in the late 1960s. So the angle could represent a high point and a turning point. And you would leave with the Monument before you, as you entered with the Memorial behind you, and the whole complex would acquire the direction of time and, perhaps, hope.

You can read a chronicle of the making of this singular work in *To Heal a Nation,* by Jan C. Scruggs and Joel L. Swerdlow (Harper & Row). The memorial would not exist without Scruggs, a veteran of that terrible war and a man of great vision. I like to think that the voice of the book, optimistic, enthusiastic, conciliatory, is his, whoever did the writing. It also contains some photographs, but there is really no way to imagine the

memorial from them, or from any pictures I have seen. For that you must make a visit. If you know someone who was killed, an attendant from the National Parks Service will help you locate his or her name. They are all listed alphabetically in directories near the site.

Be prepared to weep. Tears are the universal experience even if you don't know any of the dead. I watched reverent little groups count down the rows of a panel and then across to the name they sought. Some place a poignant, hopeless offering underneath: a birthday card, a flag, a ribbon, a flower. Some leave little notes. Most photograph the name, but many take rubbings of it on pamphlets handed out by the Parks Service. You can borrow a ladder to reach the top names. The highest panels are about ten feet high—or, more accurately, their bottom edges are about ten feet below ground level. Someday, I suppose, visiting it will be like standing before a memorial from the Civil War, where the bearers of the names really have been forgotten and, since the theory is that the meaning of a name is its denotation, the names themselves will have lost their meaning. They will merely remain powerful as names, and there will only be the idea of death to be moved by. Now, however, we are all moved by the reality of death, or moved by the fact that many who stand beside us are moved by its reality. I copied down two of the names of which rubbings were made:

EDWARD H. FOX
WILBUR J. MILLER

· 23 ·

PUBLIC ART AND THE GENERAL WILL

THE TWENTY-EIGHT ALDERMEN OF ST. LOUIS ARE PONDERING THE PROPRIETY of a referendum on whether to remove an allegedly controversial work of public sculpture by Richard Serra. In terms of substance (rust-clad steel) and scale, there are unmistakable parallels between *Twain,* as the work is called—doubtless in reference to the author of *Life on the Mississippi*—and *Tilted Arc* in New York City, whose removal is imminent without benefit of referendum. But there the resemblances stop. *Twain* is iconographically rich—it makes a second reference to the great river through its deltoid shape—and appears almost ingratiating, in that its punctuated walls offer entry into a sheltering enclosure on a landscaped city block set aside especially for it: a quiet and contemplative space in a largely blighted downtown area. *Tilted Arc,* by vivid contrast, was perceived as hostile and confrontational, a disenhancing presence too much at odds with the uses of the site it seized and sought to hold. The decision to remove it must have suggested an attractive precedent to St. Louis's eager aldermen, but the similarities are in fact too slight to justify a similar eviction.

All serious art, our cultural commissioner Bess Meyerson observed at the hearing on *Tilted Arc,* is difficult. And so it is. But one is obliged to distinguish those difficulties due to compositional complexity and interpretive density, as in Michelangelo's *Last Judgment* or Picasso's *Les Demoiselles d'Avignon,* from those that would be caused by the construction of a visionary work proposed by the artist J and called *Angry Co-ordinates,* to consist of 70,000 sharp spikes embedded, point upward, the entire lengths of Fifth Avenue and 42nd Street. *Twain* appears difficult in neither sense—it is accessible in every sense—and its case seems somewhat urgent, before all the rusted walls of public art fall like dominoes down

the slippery slope about which the defenders of *Tilted Arc* warned us. Since I strongly favored the removal of *Tilted Arc,* it is gratifying to be able to defend the placement of a second work and to amplify my views on public art.

There is no problem with the idea of an artistic plebiscite as such. One of the great failures in our public art programs, as dramatized by the strife over *Tilted Arc,* is that the public has been radically underinvolved and all the main decisions have been left to panels of "authorities." The assumption has been that art is good, so it must be good for people to have it, without anybody making much of an effort to translate the goodness of works that are not self-evidently good into terms people can grasp and respond to. If art is as irreducibly difficult as defenders of serious art have maintained, a considerable barrier exists between it and the public it is supposed to benefit. A referendum on removal is certainly one way of involving the public, but a vote will count as an esthetic mandate only if the electorate is esthetically informed. Of course, even if the work in question is clearly understood to be good art, there may remain other grounds for its removal. But there are no such further grounds in the case of *Twain.*

A referendum on *Tilted Arc* would have been in order, because few New Yorkers were unaware of the issues surrounding it. For some months, intense conversation about the work usurped the place usually occupied by real estate at dinner tables throughout society. I participated in two academic conferences mainly given over to the issue, and I knew of many more. Newspapers and newsmagazines editorialized, reported and gave valuable space in letter columns to Serra's work, and "The Today Show" considered opening one of its programs to the debate. An actual vote, of course, is a simple aye or nay, but there must be considerable discussion, argument and clarification before a decision as to which lever to press can constitute a rational choice. We are, after all, called on to decide by referendum matters of the greatest intricacy and moment.

Gustave Harrow, Serra's counsel, has, it seems to me, a genius for misrepresenting the issues raised by his client's art. Putting artistic matters to the voters, he contended in an interview with the *New York Times,* "is precisely the thing that would force art to be judged by a common denominator, which art cannot be." If Serra's work is that distant from the common denominator, its candidacy for public commissions must be seriously compromised. Clearly there could be scant justification for placing, at public cost and in public space, a work that means nothing to the

public beyond the fact that those who are supposed to understand such things insist upon its excellence. But not too many blocks east of *Twain* is the austere *Gateway Arch* of St. Louis, by Eero Saarinen, one of the most successful examples of public art in the country. Whatever controversy may have surrounded its selection and ultimate erection, it really just *is* St. Louis today, and in explaining it to their visitors or to their children, the people of St. Louis articulate the consciousness it has come to objectify. It is unimaginable that the public would countenance its removal or that it would not raise funds to restore it if necessary. The Vietnam Veterans Memorial came into being in an atmosphere of the most intense artistic and moral debate. Even after it was in place, Maya Lin, its designer, was subjected to bitter abuse and condemnation. Yet by this date no public work is more highly esteemed or widely admired, and a mandate for its removal would be unthinkable. Abraham Lincoln insisted that work continue on the Capitol's dome as a palpable symbol of continuity and hope during the agonized years of the Civil War. That cupola, like the dark stone wings of Maya Lin's memorial and the exquisite trajectory of Saarinen's arch, are paradigms of high art that are also public art, because the public has invested them with its feelings, beliefs and values. They in effect *are* the public in the medium of art.

That much may be said on the appropriateness of a referendum on public art insofar as it is public. But whether something is good art, or art at all, cannot be left to electoral determination, though this is evidently the question the St. Louis voters are being asked to decide. According to Thomas Zych, president of the Board of Aldermen, a number of his colleagues have "somewhat silently said, 'I don't like it but who am I to judge what art is?' Now some are saying that these pieces of iron are not art." They ask themselves whether they can, in good conscience, expend public money on the maintenance of mere scrap metal. Especially when—and it is this that makes one suspicious—the rusting plates occupy "a valuable piece of property that should be developed." Aldermen as a class are not noted for a disposition to reflect on the ontology of art, but one's cynicism is not stilled by Zych's assurances that monetary considerations are not at issue. It is only "the pure controversy over what is art." Now, if these legendarily smoke-filled rooms have indeed been given over lately to meta-esthetic disputation, then surely the solution is to treat the matter just as aldermen would treat problems of sewage or air quality or budgets—call in an expert, in this instance a philosopher of art. Addressing the general will as philosophical oracle is of course as inappropriate

as consulting it on the technologies of sanitation or traffic flow. So, pleased to waive my fee for philosophical consultation, I offer instead a few observations that may persuade the aldermen to quash an ill-considered referendum.

Until the very late nineteenth century, the question of whether something was a work of art would have raised few cognitive difficulties, even if there was no widely accepted definition of what art is. Such a discrepancy is not philosophically uncommon. St. Augustine famously said he knew what time was until someone demanded a definition, which he could not give. Most people know the difference between right and wrong conduct, as between just and unjust rulings, even if a general theory of morality or of justice remains to be given. With works of art there have been problems at the borderline—Japanese prints and, later, primitive sculpture had to be argued into artistic status—but as recently as Wittgenstein it could be maintained that no theory of art would make us wiser, or better able to pick out works of art than we already were.

This situation has not been precisely reversed, but it is no longer possible to suppose that we know what are the artworks, even if we do not know what is art. Since Duchamp and Schwitters, Warhol and Lichtenstein, it has been clear that something can be a work of art and yet resemble, in every outward particular, a quite ordinary object—a snow shovel, a bicycle wheel, a soup can, a soap box. When things belonging to deeply different kinds resemble one another as much as things belonging to the same kind, then the alderman's "Who am I to say?" becomes vivid and universal. Who does have the right to say of one thing that it is art and of something quite like it that it is not? Decisions about arthood become as inscrutable as the distribution of divine grace according to the Calvinist teaching. In any case, the public cannot be supposed capable of such discriminations, all the less so when it is readily imaginable that ten plates of steel found in a steelyard and arrayed to look like *Twain* would have no claim to the status of art at all. It would be just a bunch of iron, as the aldermen say in their hearts that *Twain* is.

The incapacity to discriminate between such pairs is less important than understanding those transformations in the concept of art that entailed defining art as something that doesn't meet the eye. Without being privy to those transformations, one really knows neither what art is nor how it matters that one cannot say which is an artwork. One gains access to this knowledge by participating in the discussions regarding the nature and enfranchisement of artworks. That is the business of the art world.

ARTHUR C. DANTO

The art world is not a clique but a widely dispersed community of artists, collectors, historians, critics, curators, art buffs and cognoscenti, concentrated in New York and London, Paris and Milan, Zurich and Berlin, Los Angeles and Tokyo—with branches in Chicago, Düsseldorf and many other places, St. Louis surely included—who read and contribute to journals, attend or participate in panels, attend shows and read about what they cannot attend, and discuss, comment and carp endlessly. The Institutional Theory of Art, whose most forceful spokesman is Professor George Dickie of the University of Illinois at Chicago Circle, insists that the identity and existence of works of art is inseparable from the interventions and determinations of the art world as just characterized.

Art worlders are not, of course, experts in the ordinary sense of the term. You would not lug an otherwise indeterminate object into Dickie's office to see whether it really is an artwork, the way you would go to a specialist to find out if something is an original or a copy, a genuine or a fake, a Rembrandt or a Ferdinand Bol. No one takes out a tape measure or a magnifying glass, submits something to radiography or chemical test, draws your attention to catalogues and inventories in order to ascertain whether something is an artwork. The best you can do is find out why something is an artwork, if it is one. A few years back, when Hilton Kramer, then art critic for the *New York Times,* claimed Judy Chicago's *Dinner Party* was not art, you certainly could not hope to prove him wrong with a printout from an empirical investigation of some sort. That would require reasonings, arguments, analyses, interpretations and analogies of a kind Kramer is familiar with as a member of the art world. Of course, the question of whether something is an artwork is seldom addressed as such. The more usual question is why something is art, what makes it art. Anyone can join the discussion, but without having joined it, one has little of interest to say.

Not everyone will join, of course. Busy aldermen have other priorities, so all they need to do is consult those who have gained the interest and the understanding. In doing so the aldermen will quickly discover that the "pure controversy over what is art" is settled definitively in the case of Serra. That was never the issue with *Tilted Arc,* though many supposed it was and insisted that Serra was a master and *Tilted Arc* perhaps a masterpiece. Being a masterpiece, however, was not enough, as we know, because of the severe perturbations that the work set off. But nothing like that applies to the work in St. Louis. It really does reduce

to the question of whether that St. Louis block should be devoted to art or should be "developed." I know how I would vote.

It is possible to imagine a "Save the *Twain*" movement springing up, with bumper stickers, T-shirts, vigils, teach-ins, posters and petitions. Not the sort of thing Serra has been accustomed to, of course, but just think of glimpsing *Twain*'s celebrants between the steel plates, chanting, holding candles which cast dramatic shadows against the warm rust, the public voice carrying out, past the arch and across the dark waters of the wide Mississippi!

· 24 ·

THE THAW COLLECTION

GOTTLOB FREGE, THE FATHER OF MODERN LOGIC, ONCE PROPOSED THAT A word has meaning only in the context of a sentence. It is reckless, perhaps, to press as an analogy to this deep thought that a work of art has meaning only in the context of an exhibition. Everyone will allow that the circumstances of display often vest a work with qualities it does not possess in its own right: when a museum exhibits a painting in a room by itself, with velvet barrier and guards, something is being said about rarity, importance and value that the painting scarcely could say about itself. But that Frege would dismiss as mere "coloration," a matter of rhetorical force. I refer, rather, to the fact that when we discuss a work, whether as critics or art historians, we tend to surround it with other works which illuminate features of it that might remain invisible when the work is examined in isolation. Each critical or art-historical article implies an exhibition in what Malraux has termed "the imaginary museum." To understand a painting, then, is to know what other works it would go with to form a coherent show. And this, pretty much, is what Frege wanted to say about words: to understand a word is to know how to combine it with other words to frame a coherent sentence. But to the degree that the analogy holds, the conclusion is inescapable that exhibitions have meanings that are implied by their component works.

It is rare, of course, that the meaning of a work will be given through a single exhibition. Works are characteristically richer than that; and it might be argued that the richer the work, the more exhibitions it implies, which is one way of making explicit the claim that a given work is capable of myriad interpretations. It has sometimes been true, especially when exhibitions are institutionalized and official, that the meaning of a work is exhausted by the context for which it was intended. When the Salon

dominated French painting, few artists could afford to paint in a manner unacceptable to a Salon jury. Renoir, for example, was diverted from his natural creative bent by the need to conform to Salon criteria. And since the costs of alternative exhibition, with his fellow Impressionists, say, were simply too high for him to bear, his work hovers uneasily between what was officially required and what the urgencies of his original vision demanded. Géricault, though financially independent, painted on the scale he did, with subjects as dramatic as that of *Raft of the 'Medusa,'* because he meant his work to go into the Salons, which favored paintings in the grand manner on dramatic historical themes. He even allowed the semiotics of those exhibitions to determine, to its detriment, where a particular work was to be hung: for *Raft* he chose a high position on an important wall when it should have been set at eye level to draw viewers into its vehement action. That painting, of course, survived and transcended the context of its exhibition, but the bulk of its companions in the Salon of 1819 were so congruent with that exhibition that they cannot be seen without generating a vision of an arid, meretricious and academic society of works. If you wish a counterpart in our era, think of last year's terrible inaugural exhibition at the made-over Museum of Modern Art. The works looked exactly as if constructed to go with one another in just such an exhibition, and as with the *grands machines* of France's Salons, it is difficult to imagine them as having a meaning apart from their context. Much the same thing may be said about the recent Whitney Biennials.

In any case, an exhibition has the structure of a text one must learn to read. In recent years, a special category of art criticism has emerged which tacitly takes the exhibition to be the basic unit of artistic meaning, much as Frege supposed the sentence has primacy over the word. Perhaps this "exhibition criticism"—or *Ausstellungskritik,* to give it the German name it is destined to bear once scholars become conscious of its existence—has its beginning in Diderot's brilliant analyses of the Salons of his time. Whatever its credentials, one finds oneself responding to works in terms of the meaning exhibitions have conferred on them, drawing attention, as critic, to latencies of form and reference the assembled works release in one another. For someone of my temperament, the overwhelming temptation is to identify some of the axioms of *Ausstellungskritik.* But on this occasion I shall instead offer a limited illustration of it, by discussing the elegant show that provoked these speculations.

The exhibition, preponderantly but not exclusively of drawings, from the collection of Eugene and Clare Thaw at The Pierpont Morgan

ARTHUR C. DANTO

Library in New York City (until November 10) is one of the most intox-
icating and delightful shows I can recall. Each of its component works is
of a certain quality, but the sum of their individual values cannot account
for the spirit of the show itself, which is one of lightness, gaiety, piquancy,
pleasure and civilized excitement. That spirit has to come from the works'
juxtaposition and mutual enhancement. For whatever the unquestioned
quality of the exhibits, few of them belong to the same class or have the
same depth. Indeed, for certain of them, such as a series of watercolors
of the interiors of nineteenth-century rooms—the *Dressing Room of Ludwig
I of Bavaria, 1836,* for example, by Franz Xaver Nachmann—the category
of depth has no application. But there is a wonderful, abrupt refreshment
in seeing that painting hung in the same show with Mantegna's *Three
Apostles* and Rembrandt's *The Rest on the Flight into Egypt.* To get such
internally distant works to vibrate to one another would have been impos-
sible had the show consisted simply of these three works. It would be like
a meeting of Einstein, Saint Bernard of Clairvaux and Gypsy Rose Lee
in the Elysian Fields. What could they have to say to one another? So one
has to have selected just the right other works to mediate the disparities
until, by some miracle of taste and audacity, something quite unexpected
and amazing emerges. A bit of Fragonard, a Watteau, a Cézanne or two.
Why not Goya? A Max Ernst? Some Picassos? The talent called on to
form such a singular complex is the sort that goes into the design of a
marvelous meal, or a party in which the most unlikely pairings induce
unimaginable harmonies, or a piece of interior decoration in which things
one would have supposed antithetical display affinities no one could have
expected. It is a talent for experiment and generosity.

 As one enters the main exhibition space, one sees some unmistakable
Cézannes, one of them a watercolor of pears and apples—of pear con-
tours and apple vibrations—a work of such compelling luminosity that
only the etiquette of how to look at an exhibition inhibits one from
dashing across the room to gluttonize it. (Some cleverly interspersed
display cases subtly discourage so headlong a plunge.) So one begins,
responsibly, at the beginning, where one sees, immediately, Mantegna's
Apostles; a portrait of a bearded personage, ambiguous as between dignity
and foolishness, by Hans Sebald Beham; and a giddy Mannerist drawing
by Goltzius, titled *The Sense of Smell* and composed of a confectionary girl
smelling a flower while her dog, rapturously as an Adoration figure,
smells another flower, this one stuck provocatively in a fold across her
pubis. The passage from the austere sobriety of Mantegna to the oblique

eroticism of the Goltzius, through the characterological indeterminacy of the Beham, defines the esthetic transits of the show. Each drawing deepens something vaguely present in the others, reveals an aspect in its companions that cannot be generalized and leads one to expect that a fourth and fifth drawing is going to enrich what one must carry now in memory. One must look, for metaphor, to the way great dancers augment one another's gifts or conversationalists prick one another into flights of brilliant outrageousness. And one realizes that working one's way to the Cézanne is not going to be a matter of serial responses, a quantum of appreciation and on to the next thing. Rather, one goes to the next thing with an increased anticipation: What can possibly come next? And one is never let down. It is like opening presents, each at once suitable and surprising.

But let me describe what one meets en route to the pears and apples. A mother and child by Jordaens, mouths agape in some indeterminate emotional transport. A landscape by Claude, a world of air and water, with feathery trees and a distant gray basilica submerged in washes. The mentioned Rembrandt, but also one he drew, with calligraphic bravura, of a scholar whose nose and brows are done with two decisive strokes. A youth by Watteau, executed in his *trois crayons* manner. An Oudry in grisaille of a rat trapped by an oyster, intended as an illustration for La Fontaine's *Fables*. Now six drawings by Fragonard for Ariosto's *Orlando Furioso*—disciplined froth, casual exactitude, gestural mastery. And one is only halfway to the Cézanne, with, among other things, a sketchbook of Degas to relish. Each piece is crazily perfect. It is all treats.

The unity of the exhibition is such that one wants the show to materialize in the mind in its entirety, so one is driven through to the end. After that one wants to go back to favorites. I returned to a Piranesi, an astonishment in blots and scratches out of which the portrait of an artist emerges, holding a sketch board. The color on which the figure is drawn and the color of the paper on which he is about to draw are, of course, the same, but the latter is opaque and solid, while the former has the transparency and impalpability of the atmosphere. The sky, in a crisp drawing titled *The Jacobikirche in Greifswald as a Ruin,* by Caspar David Friedrich, is the color of the paper, whether seen above the broken pillars of the church or through the shattered mullions of its windows, but it is luminous through the windows, while pale above the pillars. Two translucent pears by Odilon Redon. An uncanny airless drawing of a boy asking alms of a mounted squire, casting surrealist shadows, done by Wilhelm

ARTHUR C. DANTO

von Kobell in 1831. In a way, everything was the favorite, most particularly the Cézanne, which draws one in and to which an entire review could be devoted. You will leave the show happier than when you entered.

Eugene Thaw is well known as an art dealer and a connoisseur as well as a collector. A memorable exhibition of the collection he and Clare Thaw formed hung at the Morgan in 1975, before it passed into the library's collection. The works exhibited here were acquired by the Thaws in the intervening decade. Or "accumulated" by them, as Eugene Thaw prefers to say, "because no specific program has motivated this assemblage and, consequently, it unfolds as a much less systematic survey than the collection we showed ten years ago." So it does. But the use of the word "unfolds" is revealing. Unfolding is not something exhibitions often do, and the Thaws' exact taste gave rise to an assemblage that must be useless for the didactic or crass purposes that generate so many exhibitions. Even so, it is instructive to the student of *Ausstellungskritik.* "We hope," Thaw writes, "that some of the enjoyment [the works] have given us continues to emanate from them." Of course it does and will, but even more, I think, the pleasure of collecting them, of coming upon wonders one would never have counted on getting, is transmitted through the show itself.

Sooner or later, all these works will find a place in the Morgan's drawers and portfolios, and occasionally in its cases or on its walls. But the exhibition is unlikely to be repeated. Pleasure is not an esthetic category much in philosophical prominence these days. Infrequency is not be confused with irrelevance, however, and the effervescent recollection of this show may sustain you through the heavy season ahead.

· 25 ·

|NDIA!

THE EXCLAMATORY SHRIEK IN THE TITLE INDIA!—AS IF IT NAMED AN ILL-
considered musical based on the *Mahabharata*—is doubtless intended to
express the excitement with which visitors are meant to view the franti-
cally designated exhibition that will remain in sullen and inert splendor
at The Metropolitan Museum of Art until January 5, 1986. But in English
punctuation the exclamation point has other senses more appropriate to
the reality of the show. It marks, for example, the expression of a wish:
"India!" meaning, "If only it were a show of Indian art as marvelous as
the one that went instead to The National Gallery in Washington earlier
this year!" It can also transform the word it emphasizes into a scornful
quotation, so that "India!" might well be a one-word criticism of the
entire enterprise: "If *this* is India, then . . . !"

The museum's press release characterizes the intended extravaganza
as "a comprehensive exhibition of the art of India from the fourteenth
through the nineteenth century." It consists, certainly, of work done in
India, in some instances by Indians, but done for the pleasure and to the
taste of the Islamic conquerors of India. Imagine, for analogy, a show
called Mexico! which devoted one small room to various pieces of pre-
Columbian art, with the remaining seven or eight galleries filled with
Hispanic altarpieces, portraits of landed proprietors and their families
and servants, fragments of hacienda architecture, some ornamental fire-
arms and flamboyant ironwork and, of course, a certain number of ob-
jects of *vertu*—of the gold and silver that brought rapacious conquista-
dors to the halls of Montezuma in the first place. Mexico! would naturally
exclude those twentieth-century artists—Rivera, Oroszco, Siqueiros—
who sought artistic community with forms of expression stunted and
diverted by ruthless oppressors. The present show represents the imposi-

tion on Indian sensibilities of an alien culture, a fanatically insisted upon religion and a different ordering of artistic values. To call the first gallery, with its sparse display of genuinely Indian art, The Great Tradition is merely sardonic. The vast bulk of objects displayed in succeeding galleries have as little connection with the few great bronzes we see in that first room as an early Bible, printed in the city of Pueblo, might have with a Mayan codex from Cichen Itza.

Now there is nothing intrinsically wrong with the idea of an exhibition of Islamic art from India, with its emphasis on the esthetic preferences and artistic patronage of the Mogul sultanate. Nor can it be denied that Islam is and has been part of India since the Moslem invasions of the thirteenth and fourteenth centuries, the agonies of partition notwithstanding. But it is inconsistent with the alleged pedagogical aims of a museum of the Metropolitan's stature to mislead visitors, whose grip on Indian history, let alone on the principles of Indian art, is not strong, into believing that it is being given the very essence of India (!) in a show which all but leaves that essence out.

The show is, in fact, vulgarity through and through, all stridency and hyperbole. A hanging from Andhra "has never been seen outside India" —as if that were artistically relevant. There is a carved emerald two inches across (!) and weighing 232 carats (!): "There is no likelihood of material of this size and quality ever again being mined," the catalogue ecstasizes. But if you did not know it was an emerald (!) you would not be much affected by the green lump crudely incised with an inappropriate depiction of trees. The paradigm exhibit is a palatial tent from the reign of Shah Jahan, twelve feet high and twenty-four feet square, made of gold-embroidered red velvet. It is a sumptuous curiosity, a glimpse into a state of mind on which cost exercised no constraints. And so are the jeweled daggers, the jade hookahs, the nephrite inkpot with the gold mounting, the ceremonial spoon set with rubies, emeralds and diamonds, the gilded palanquin of Rajasthan and the pearled Baroda carpet. "Dazzling!" is the catalogue's adjective of choice for items in an exhibition that looks as though the Met's gift shop had been moved upstairs. And since museums today tend to be gift shops surrounded by the objects of which the gift shop purveys reproductions, even the gaudiest and rarest of the displayed *bibelots* and bric-a-brac look like reproductions of themselves. The transition from the final gallery into the convenient boutique of pertinent souvenirs is indiscernible. All that is missing is a barker got up in a turban and curled slippers to drum up trade.

THE STATE OF THE ART

India! presents itself as the focal point in a nationwide Festival of India, which began last June with a brilliant exhibition of Indian sculpture in Washington. The finest pieces in the Met's show—a Shiva and a Parvati from Vijayanagar, and the museum's own magnificent nursing Krishna, all three in bronze—typify the level of artistic achievement attained by every piece, and transcended by many pieces, in the Washington show. The grace, warmth, intensity, exuberance and spirituality of the great works of Indian sculpture shown there were enhanced by the chaste surroundings and the gray light of The National Gallery's east wing. The objects in New York are seen as in the darkness of a treasury, and one feels like a tourist allowed in to gape at priceless frivolities rather than, as in Washington, a pilgrim in the presence of divinities. The New York show coincided with a parade on Fifth Avenue, augmented by elephants —naturally—which the Sunday *New York Times* showed on its front page. The *Times* devoted no fewer than five articles to the show during its opening week, culminating in a nearly full-page hymn to its wonders by the chief art critic. It was almost as if our major newspaper had become an annex of the overheated publicity offices of our major museum. Whatever the reality, the impression was one of desperate oversell.

"The best exhibitions," John Russell wrote in his best stardust prose, "are acts of love, and 'India!' is one of them." Not even The Beatles could seriously have supposed that all you need is love: the best exhibitions are based on ideas and are acts of intelligence. "The zestful curator of 'India!,' " to quote the headline of another *Times* piece, seems to have had the idea of negotiating into exhibition space as many extravagant ornaments of Indo-Islamic craftsmanship as he could, of superimposing upon them a desultory chronological order and prefacing the jumble with a grudging room of truly Indian art (The Great Tradition)—and leaving the show at that except for a misguided and perfunctory gesture in the direction of education, the inclusion of some objects chiefly of anthropological interest from villages and tribal outposts. The lavishly illustrated catalogue he produced reads like a flyer from Banana Republic. Under the rapturous prose, to be sure, it transmits a lot of information about the individual objects. What it and the show fail to do is to enable the objects to release artistic information in one another. The show is merely the sum of its precious parts.

Stuart Cary Welch, the zestful curator, sounds as if he knew better. "You have to see works of art as an aspect of culture," he declared in the *Times* interview. "If you don't know the other parts of the culture, you see

less in the works of art. Your eyes see more when you know more." I concur. I also concur with the corollaries: if you know nothing your eyes see nothing; and if you know nothing about the other parts of the culture, you know nothing about its works of art. Welch doubtless knows so much that he can see the whole of India, or at least India!, in each of its displayed fragments. But that knowledge is not transmitted through the objects alone, and an intelligent curatorship must establish the cognitive context for artistic appreciation. This he has failed to do.

Consider, for example, a beautiful wine cup in white nephrite. Its handle has the form of a goat's head bent back to contemplate its body assuming the improbable shape of a flower. One's eyes trace and retrace the astonishing gradients of metamorphosis as the goat swells into the voluptuous petals. The impossible, even hallucinogenic fusion of animal, vegetable and mineral could hardly have belonged to anyone but its owner, the great Shah Jahan, fifth Emperor of the Mogul dynasty. That wine cup encapsulates the whole of Shah Jahan's stupendous vision, but how is one to see it in that true light if one cannot connect it with the Taj Mahal, which Shah Jahan built as the tomb for a beloved wife; if one does not see it in the immense astronomical devices he built in Shahjahanabad (now New Delhi), which stand like a complex of gigantic sculptures; if one has not been awed by the image of a Shah Jahan's own unachieved tomb, a duplicate of the Taj Mahal but in black marble, across the Jumna River from its white counterpart; if one is ignorant of the perfect simplicities of the Pearl Mosque of Agra? The viewer is given none of this; the object stands in isolation in a glass case with a factual label. The catalogue says soupily, "The goat bleats plaintively, appreciative of Shah Jahan's sadnesses earlier in life, and lamenting painful times to come." This is false, silly, useless. It is art writing at its characteristic worst. It is crap. And a magnificent opportunity is sacrificed, for the wine cup is not surrounded by the photographs or engravings that would enable one to see it as infused with the spirit of architecture. Shah Jahan was one of the great builders of history.

And so was his grandfather, Akbar the Great, whose tomb at Sikandra, near Agra, swarms today with irascible green monkeys, and whose long deserted city of Fatehpur Sikri is a sculptured world in rose sandstone. That city, with its gates, its mosques, its divan, its palaces and battlements, its vast square marked in such a way that Akbar and his queen could move the women of the harem from position to position in games of backgammon, is a metaphor for Akbar's mind and the culture

he fused out of disparate elements and imposed on the world he domi-
nated. He was a lavish and enlightened patron of the arts, a military and
administrative genius, but there is no way one can grasp the unity of his
singular achievement from the confusion of objects lumped together
here. I was not surprised to see visitors wandering from display to display
with none of the excitement a great exhibition arouses. They were quietly
puzzled. On occasion, someone would murmur, "How exquisite!" before
some object, an opium cup, for example. That cup is truly exquisite, with
ruby petals and emerald leaves edged in gold and set into a calyx of
polished jade. But the depths of meaning locked in that exquisiteness are
left to languish.

Naturally, there are some rewarding moments: a watercolor in roll-
ing perspective of a harem garden with filigreed pavilions, ornamental
birds, regimented flower beds, elegantly scarved women with stringed
instruments and hookahs; a study of a resting tiger from Punjab; a poppy
from Rajasthan which Ruskin could have endorsed. A luminous portrait
of a rani's monkey holding its red leash in its witty tail and looking like
a Buddhist monk. These are the little openings into ways of seeing and
feeling that it is one of the joys of art to share for a moment. It is gratifying
to see that their modest power stands up against the surrounding arro-
gance and sultanic indulgence.

One thinks of the immense enterprise that went into the assembling
of all this—the trips to India, the lucky finds—and all the money. And
then the failure of nerve in simply spilling it out without enough structure
to give it life, and the lapse of taste which is emblemized in the hateful
exclamation point, the hoopla and elephants, the Barnum disdain for
rubes. There is a kind of Mogul dimension to the show itself, opulent and
decadent, imperial but with a fatal lassitude. In that sense the show
becomes symbolic of its subject. But it gives the framers of the museum
too much credit to suppose they are making that sort of point, succeeding
through dramatic failure.

· 26 ·

GEOMETRICAL ABSTRACTION

A MATHEMATICIAN I ONCE KNEW USED TO TAKE AN IMPISH PLEASURE IN pretending not to understand what artists meant by "geometric form." All forms, he tirelessly observed, were indifferently geometric. And he explained, with aggressive patience, the uncontested facts of analytic geometry to the sullen painters in his company. In point of pedantry, he was infuriatingly right. Every point in a plane has a unique pair of real numbers as coordinates, and since every form is a locus of points, any form, however loopy to the eye, can be represented by an equation. No form, accordingly, is especially more geometric than any other so far as algebraic method is concerned. So why especially paint squares and bars and circles when the lush presence of the visible world—young girls, flowers, the surging sea, grazing cows, and dancers at the Bal Tabarin— are no less geometric? Why, in the name of geometry, cut oneself off from the myriad shapes of the world as it is?

The artists before whom he laid these impeccable reasonings were uncomfortable and finally unimpressed, and they were right to be so. It would be perverse to designate the *Last Judgment* of Michelangelo or Turner's *The Slave Ship* as geometric paintings, even if one could point to hidden trapezoids and obvious diagonals. The term "geometry" invokes, in even the most modestly informed, austere scenarios enacted by circles and spheres, by polyhedrons and polygons of unimpeachable regularity, which chastely intersect one another or submit to the bloodless martyrdoms of being cut by planes or inscribed by lines. The entire lore of cones, cubes and cylinders, triangles and pyramids, parallelograms and rhombohedrons had assumed mythic status in Western consciousness long before the introduction of coordinate analysis by Descartes in 1637. The use of pyramids to house the preserved bodies of pharaohs, the fact

that the altar of Apollo at Athens had the form of a cube or that the heavens were believed composed of crystalline spheres in harmonic relationship to one another, were not semiotically innocent choices. They were comprehensible in terms of a language of forms which Kepler drew upon only a few decades before Descartes's discovery, when he exulted, alas without foundation, at having found the key to the solar system in the five regular Euclidian solids that marked the spaces between the planets. Only such a geometrically ordered universe would be worthy of a Perfect Designer, Kepler supposed; he was disgusted to discover not long afterward that the planetary orbits were ellipses rather than the circles celestial perfection would recommend.

Confronted by such facts, my friend would raise his circumflex eyebrows in mock surprise. "Oh," he would say through the perfect circle his lips formed on such occasions. "But I thought geometrical art was supposed to be *modern.*" And there he would have a point. There truly is a paradox in the fact that once liberated by the possibilities of abstraction from the need for perceptual replication, painters reverted to forms they had learned to construct as schoolchildren with tin compasses and ink-stained rulers. Why should geometric forms carry the cachet of modernism from the first decade of the twentieth century down to the present? Why should postmodernism seem to consist in postgeometricism?

There is no single answer to the first question, since succeeding generations of geometric painters responded to very different artistic imperatives. The Russian Constructivist Aleksandr Rodchenko, for example, programmatically employed geometric forms generated by such instruments as compass and straightedge specifically to obliterate personality. A circle executed by a compass and another executed freehand by an artist with the exquisite reflexes Giotto is said to have possessed might be perfectly congruent, or at least indistinguishable to the unaided eye—but the circumstances of their execution carry an invisible meaning. The submersion of personality, in that overheated period of artistic utopianism in Russia, went with a natural celebration of the community, of the mass, of what anyone with the right tools could draw. Rodchenko meant to present himself as subservient to this. But for Giotto the circle was a signature, almost a gesture of arrogance, declaring that no one but he could have made it.

Consider some further examples. There is a drawing of about 1922 by El Lissitzky showing Rodchenko's great contemporary, Vladimir Tatlin, working on his visionary—and unrealized—Monument to the Third

International. Tatlin's face is featureless, but there is a compass protruding from his right eye socket, his head is framed by a circular arc suspiciously like a halo and he holds a straightedge with the authority of Prospero displaying his staff. The Monument to the Third International rejects figuration as roundly as Rodchenko rejects personality. Tatlin would have been agonized to see the heroized worker-and-soldier monuments that came to dominate the open places of Soviet cities. He instead favored an impersonal ordering of geometric solids almost like that of the universe according to Kepler: the lowest story of his monument was to have been a cube, the second a pyramid, the third a cylinder topped by a hemisphere. The stories were given over to different functions and were to rotate at different velocities; the whole complex was encased in a scaffolding reminiscent of a powerful telescope. It was to be a place not of contemplation but of agitation, and you, as visitor, should "be mechanically taken up, carried away against your will." It was a lesson in submission to forces as overwhelming as social metaphysics could imagine.

The famous *Black Square,* shown by Kasimir Malevich in a turbulent exhibition in St. Petersburg in 1915, carries another meaning. That simple shape was dense with the intended erasure of the whole of Western art. It went beyond representation, since it was *in fact* a square, not the representation of one. It went beyond illusion, since it was not in pictorial space but coextensive with the canvas. It was hung across a corner rather than conventionally on a wall, declaring a whole new concept of exhibition. The black could have been a gesture of defiant mourning for the death of all previous art. It was conceived as a radical beginning, and as such conveys an altogether different meaning from any we might ascribe to squares done by Joseph Albers or Ad Reinhardt, or by some more recent Minimalist. It was an icon of revolutionary consciousness, not a symbol of artistic distillation.

The Russian Modernists are featured in a show of seven decades of geometric abstraction called Contrasts of Form, on view at The Museum of Modern Art until January 7. The exhibition is in acknowledgment of a generous donation to MoMA of the extensive and deep Riklis Collection of the McCrory Corporation. This collection is, according to its curator, Celia Ascher, largely Constructivist in spirit. MoMA has responded by placing it in the format of a chronicle of geometric art from 1910 to 1980, augmenting it with examples of relevant art already in the museum's collection and prefacing the whole with certain Cubist and

THE STATE OF THE ART

Futurist works from which the Russians made their severe projections and reductions. I was not happy with the format, nor for that matter with the title, since it is not the forms that contrast so much as the meanings of forms, which may themselves be quite similar. Before offering some arguments for critical disquiet, however, I want to return to the sort of historical concerns that Constructivism and its immediate predecessor, Suprematism, express.

Standing in the gallery where these fragile, small, somewhat empty and faded objects hang in their protective light, looking almost like specimens of tissues preserved for an obscure scientific purpose, I could not but wonder what the casual visitor, unaware of the passionate social and esthetic controversies which brought them into being, might see in them. They were, in effect, the product of an antiesthetic esthetic, a repudiation of beauty and pleasure, of grace and elegance, of suavity and feeling. The traditional values of art were held at bay by works that were almost constituted by the tension of not yielding to them. Painting as it was known was declared obsolete. Inevitably monochrome, deliberately dulled, the little works took on the puritan drabness, the antidecorative utilitarian blankness, of communist architecture and city design—or even costume, as in the blue workclothes of the Chinese. The materials are as consistently countertraditional as possible: a scrap of burlap, some wrapping paper, a bit of tin, some string. This was not in the exuberant spirit of French collage, which inspired Apollinaire to write, "One can paint with whatever one likes, with pipes, postage stamps, postcards or playing cards, candlesticks, pieces of oilcloth, detachable collars, wallpaper, newspapers." Nor was it in the spirit of redeeming base materials for artistic transfiguration, as in the work of Kurt Schwitters. My mathematician friend might, consistent with his position on form, have observed that since any material could be used, why not gold leaf, marble or bronze? And the answer is that it was precisely such materials that had to be rejected as bourgeois: one professed proletarian solidarity by using the simplest of industrial materials to constitute the most mechanical of forms in the most modest compositions on the least prepossessing scales.

Everything that gives these eviscerated objects force and structure is present by exclusion, but it is invisible to the historically uniformed eye. It is a mockery of their intensity of artistic purpose to treat them formalistically, or as exercises in pure design, to be graded by criteria students at the Bauhaus had to meet. It is demeaning to see them as other than allegories of a hopeless revolutionary consciousness, destined to be

blown sky-high by forces those who created them could not have anticipated. The galleries here are suffused with the weight of political tragedy and, if you like, artistic exaltation. It is against the doctrinaire condensations of this advanced art that we can, finally, appreciate the early Chagall, whose boisterous colors, vivid fantasy, poetry, wit and opulence constitute a gesture of defiance as flagrant as, say, Marilyn Monroe in full glamorous regalia at a workers' meeting of the hydroelectric plant of Tientsin. In the willed desert of principled Constructivism, Chagall was magnificent.

And this is what bothers me about the exhibition. Only at the most superficial level is there much community between these works and those which, in a formal or material way, influenced them or were influenced by them. The efficient and final causes of history are missing here. The linear chronology dissolves the meaning of geometry by treating the works merely as stages in the steady stream of abstraction. But Mondrian's geometrizing arises out of different passions from Tatlin's, Moholy-Nagy's forms arise out of a different theoretical atmosphere from those of Sol Lewitt, Kandinsky's out of a conception of spirit alien to van Doesburg. The exhibition could only have been illuminating had it broken the continuity and related the impulses to geometry to the different domains of thought that produced them.

The catalogue, by Magdalena Dabrowski, is immeasurably better than the exhibition it illuminates, just because it does furnish the kind of information the works cry out for. Walking amid the circles, rectangles, grids, diagonals and squares, I felt like Odysseus among the bodiless spooks of the nether world. Odysseus is able to communicate with them only by giving them blood he has brought along for the purpose. The thirsty spirits, momentarily transfused, revert to something like their former vibrant selves. Some of the blood these paintings and constructions so desperately require is furnished by Dabrowski's exemplary text. In the rooms devoted to "The Paris–New York Connection: 1930–1959," filled with paintings that seem robust by comparison with the withered membranes of Constructivist art, it is useful to know that "for the generation of the 1930s, geometric abstraction became a style rather than a philosophy." Had this been printed in large letters on the wall, the differences would have come to life. All modern painting before the 1930s was held erect by philosophical belief defended with nearly religious enthusiasm and intensity. It was the age of manifestoes, and the idea that painting was something one might do independently of a fervent and utopian

project was all but unthinkable. In 1925 Mondrian broke with De Stijl because of van Doesburg's insistence on the diagonal. Diagonalists, if I may characterize them thus, differed from Perpendicularists as Catholics differ from Protestants on the topic of Communion. Here is the way van Doesburg preaches the diagonal:

> The purest and, at the same time, the most direct means of expression of the human spirit, which recognizes neither right nor left, neither symmetry, nor statics, nor the exclusively Horizontal–Vertical but is always in revolt, in opposition, to nature.

It is a standard criticism of laboratory science that the world beyond the sterile walls of experimental space is so rich and complex that what is found within them can rarely be projected outward. Such criticism is most convincing in connection with living things, and the injunction to study them ethologically, in their natural atmospheres, becomes more compelling as their behavior becomes more nuanced and reflective. Something like this should be true of works of art as well. It is a premise of formalism that they stand on their own, containing in themselves all the information we require to understand them. An exhibition of geometric abstraction is a crucial test for such views, just because the works seem most amenable to formalistic analysis. But this is an illusion. The current show fails to comply with the simple direction laid down in Celia Ascher's prefatory remark: "Collecting should follow a defined path of exploration and scholarship, rather than the willy-nilly road of the eclectic contemporary." This show, for all its marvelous contents, is willy-nilly eclectic. All a work needs to get in is some sort of geometric credential, plus the right date and place of birth. The curatorial mind is fixated on chronology and influence but blind to the philosophy that animates art and ought to animate its intelligent display.

Riklis believes, rightly, that his collection is "of significant esthetic and educational value." But the esthetic access is blocked by educational negligence, and if it were not for Dabrowski's catalogue, the show would have been a failure. Without it, the scraps and bits of geometry are puzzling and mute—scarcely the bare beauty on which Euclid is said to have looked.

· 27 ·

RALSTON CRAWFORD

I HAVE ALWAYS FELT A SPECIAL COMPASSION FOR ARTISTS WHO GROW UP under one set of artistic imperatives but are prevented from a normal development because they reach their artistic maturity under a contrary set. When Abstract Expressionism came to an abrupt end, for example, a number of young careers were simply blasted by the fact that the reflexes and attitudes that made for painterly abstraction were unsuited to the cool cynicisms of Pop. The masters, whose reputations were secure, were allowed to continue painting in the accepted style, even if it was considered slightly archaistic. But the second-generation Expressionists had to make shift or perish, for the market was no longer favorably disposed to gigantesque canvases clotted with swipes of energized pigment. The adoption of a painting style is, after all, not a casual matter: it can have the quality of a religious commitment as one becomes persuaded that a given direction is the right one, that it alone is where art must now go. Since our beliefs define our worlds, we do not change them easily for the same reason that we do not easily exchange one world for another. The artist beached by the tides of historical change is tragic in the sense of having been robbed of his reality.

Sometimes change is so cataclysmic that even the masters are beached. Our century is almost perfectly bisected by an event that had the most momentous consequences for American art: around 1950 there was a reversal in the direction of artistic influence so total that it might be mathematically represented as a catastrophe flip. Painting in New York stopped taking its stylistic orders from Paris and began instead to issue its own. The inversion was sufficiently dramatic to give rise to the paranoid interpretation that New York had "stolen" the idea of modern art for sinister imperialist ends. However it is explained, it is incontestable

that at midcentury New York became the engine of artistic manufacture, pumping forms, manners, attitudes and values through the conduits of high culture to the studios and galleries of the world. This meant that American painters were, perhaps for the first time in history, in a position to be world figures rather than simply leading Americans.

But what of those artists who had been leading Americans, and whose lines of development were now merely tangential to the orbit of world art? From the time of the Armory Show, the major artists of the United States had sought to adapt European, particularly French, ideas to American reality. This was true even of those who turned their backs on Europe in the name of regionalist authenticity. But now European artists were scrambling to accommodate American discoveries, and American artists with established reputations in the use of the superseded European mannerisms became redundant. It was as though one could no longer simply be an American painter: one painted to the world or not at all.

Ralston Crawford (1906–1978), to whom The Whitney Museum of American Art has devoted a respectful and dignified exhibition, continued to be an American artist with French tastes long past the time when this combination was considered suitable. He seems, as much from his paintings as from his biography, to have been a loner. But for a certain period, his image and manner promised to define a new American landscape—one not so much geometric as stylized along geometric lines—as he regimented to a severe and purified manner the industrial motifs that would have been appreciated as quintessentially American. His major reputation was established in 1939 with *Overseas Highway,* a sharply abstract representation which instantly became as famous an American emblem as Grant Wood's gothic Americans, Whistler's mother, Washington crossing the Delaware or the Spirit of '76. Crawford faltered after his success, but before he was able to recover, functional oblivion settled over him; and though it may be argued that he achieved a vision that might otherwise have charted the great march forward of American art, he remained its only standard-bearer.

Crawford was fortunate in having a well-to-do wife, so he was able to live something of a swell's life. And he seems to have been blessed with a cast-iron ego and an unshakable confidence in his own artistic significance. Nevertheless, *Overseas Highway* seems to have been the metaphor for his existence—a highway to nowhere, unswerving, empty of traffic, with no exits and no place to stop or turn around. Only if American art

had remained American could Crawford have had a future. He did not so much fail; circumstances thrust failure upon him, which vests him with a tragedy he did not altogether deserve. My own sense is that his would have been a solitary road even if the path of art in the twentieth century had remained linear, though this might have been disguised by the surfaces of his paintings, which made it seem that he was one of the throng.

Crawford was never an abstract artist as such but a representationalist whose pictures increasingly took on the look of abstractions. In this, I suppose, he bears comparison with the Cubists, whose fiercely fragmented and faceted surfaces remain sufficiently tethered to visual reality so that if one finds the formula, one is able, in effect, to exchange them for still lifes, interiors or even portraits. There is always, in Crawford, an implicit function which will take you to a specific piece of reality from a surface that looks arbitrary and abstract. "I never painted anything I did not see," he once remarked, and Barbara Haskell, who curated this show and furnished it with its scholarly catalogue, located photographs taken by the artist which enable one to solve the equations of artistic reference. *Fishing Boats #6,* for example, painted in 1956, has precisely the appearance of an abstract work, with flat, moderately geometrized areas, the paint laid on smoothly, almost blandly, as if for a poster. But a photograph enables us to see that the thin white vertical rectangle, just off center, is the illuminated side of a ship's mast, while the adjacent black rectangle is its shadowed side. The circles and diagonals refer to items of maritime gear—ladders, ropes, net-rings, floats. Because the photographs are in black and white, it is difficult to know what visual reality corresponds to the colors of the canvas, but there are enough cues to suggest that they, too, are purified representations of actual colors. Probably, Crawford invented nothing but simply reduced what he saw to patterns that pleased him. Hence I suspect this must be true of color as well as of shape. The neat blues on the upper right of the canvas must refer to the color of water, while the silver fragment just left of the mast must depict some path of light across the surface of the calm harbor.

It is conceivable that the transformation from visual reality to what appears to be an abstract deployment of flat and angular shape is to be explained by certain feelings the reality invoked in the artist. I dare say Crawford would have endorsed such an account. But there is something so chilly in Crawford's work that I find this standard expressionist thesis unsatisfactory in his case. Instead, one has the sense of some analog mechanism breaking down the visual input into a graphic display as

output. There is a taste for mechanical objects in Crawford's work, but the artist himself seems also to be a kind of mechanical transformer, and his landscapes convey the sense of reality replaced by a color-coded chart of itself. There is more human feeling in Malevich's *White on White*—once taken as the pinnacle of Suprematist purification—in which a white square almost dances on one of its corners than there is in Crawford's collected works. So it is less a matter of emotional response, I think, than of the imposition of an implacable artistic will. Crawford paints from a position of visual domination, replacing the jumbled face of things with an almost frightening, almost totalitarian order.

The icy will of these paintings is made particularly palpable when one comes to realize that often they are of subjects that might ordinarily elicit powerful emotions. There are, for example, tombs that Crawford frequented on his many visits to New Orleans. His *New Orleans Still Life* of 1951 is of a tomb, and "still life" thus becomes a morbid pun. Its dominant form is a rust-colored cone with a smart white band across it, geometrically similar to an adjacent shape that looks like a triangle with its corners broken off, which is in blue and black. To the right is a vertical bar, from bottom to top of the canvas, then a trapezoid and next to that a circle, all three shapes in ultramarine. From the photograph we learn that the cone is a kind of vase, doubtless rusted, set in a ring (the white band). The mutilated triangle is its shadow. The bar is the shadowed edge of the next tomb over; the trapezoid is the shadow of a tablet; the circle is a metal fastener. The epitaphs have been erased. Nothing tells you that it is a tomb—the painting looks like a suave abstraction in white, blue and gray with a daring touch of rust—but knowing what it is, one is struck by the fact that Crawford viewed it in terms of its formal opportunities.

And there is something frightening about an artist who prowls through cemeteries looking at the tombs as entities to be exploited for purposes of design. In *New Orleans #7,* of 1954 to 1956, a number of jagged and wavy lines superimposed on forms that look like pieces of torn paper in a collage might, on formal grounds, suggest reference to the swags and drips of Pollock and certain familiar *papiers collés* of Matisse, say from his *Jazz.* But in cold truth they are representations of cracks in the plaster or patches where the stuccoed face of the tomb had fallen away. They are snappy pictures of decay. Monet once wondered what sort of a monster art had turned him into when he realized, sitting by the body of the wife he was supposed to be mourning, that he had been fixated on the purple of her eyelids. Crawford seems to have moved through life that

way, a human constructed on the principle of a mechanism for computer graphics. So if there are feelings, they are powerfully suppressed.

These conjectures regarding his artistic personality are reinforced by two further sets of paintings, one of a wrecked bomber, the other of the atomic bomb tests at Bikini, which Crawford observed as an officially appointed artist. "My work is usually charged with emotion," he wrote once. "I realize this comment is quite at variance with many responses to my pictures, but I am never concerned with a pictorial logic to the exclusion of feeling." Well, if there is feeling, either it is not what ordinary people experience or it is poorly communicated. Of the paintings of Bikini, Haskell cites contemporary criticisms which verify the blank insufficiency of Crawford's forms to transmit sentiments appropriate to the event. One critic deplored the "startling indifference to the drama of the events depicted." Ad Reinhardt harshly asked, "Do crooked shapes and twisted lines represent painting's adjustment to the atomic age? (NO)." The perversity of the situation is that Crawford seems almost to have sought out charged motifs as an opportunity for displaying indifference. After all, he did not paint flowers, guitars, gardens, people strolling in the Bois de Boulogne, nudes, pitchers or self-portraits. Or perhaps the forms he settled on for his paintings were simply inadequate to the charged realities, so that he was racked by the tensions between what he felt and what his vocabulary allowed him to express. That his vocabulary was in large degree a kind of emotional carapace is suggested by the surprisingly affecting photographs he took of the jazz makers of New Orleans, for whom he must have had feelings uncharacteristic of his artistic persona. He stipulated that he be buried to the music of jazz bands. So death was perhaps always on his mind, and suppressing the feel of tombs may have been a way of keeping fear at bay.

Crawford was a fine photographer, but he ranked this art a low second alongside his painting. Such feeling as the paintings express—as opposed to suppress—seems at best to be global and in some sense abstract. He was a communist when that was the thing to be, and he became a Catholic toward the end of his life. My judgment is that the works he made during his radical phase were his best, just because style and subject were then perfectly suited to each other. These were studies of factories, which he regarded as America's counterparts to Europe's cathedrals. His long career of stylization begins here. The factories are as silent as cathedrals—there is no grime, no smoke, no sign of—well—industry. And in particular there are no workers, or human beings of any

THE STATE OF THE ART

description. Instead, there are storage tanks, fences, pipes, condensers, electrical wiring and buildings flattened into the design and rhythm of their architectural parts. The skies are inappropriately blue for industrial reality, with the kinds of clouds preferred by angels. The buildings are set down in some nonnatural light which, like a religious illumination, casts no shadows. Or he has erased all the shadows that do not work as forms. There is no foliage, no animation, no movement, merely the bloodless clarity of forms robbed of their productivity by their role in a ruthless pattern.

Only at the end of his life, when he was a Catholic, do human beings enter Crawford's paintings, and then only to the extent that their humanity is concealed beneath the robes and hoods of the *penitente. Blue, Grey, Black* of 1973 could be read as an abstract composition of elongated triangles softened into curves. But it is, in fact, the subtracted residue of a scene with *penitente,* in conical headgear, photographed a year earlier in Seville. It is a sobering confirmation of the dehumanizing nature of Crawford's forms that he could deal with persons only when they became identified with shapes he knew how to handle. For all one knows, he seized upon such shapes in order not to have to deal with a more spontaneous reality. Factories without workers, robes without celebrants: these are the termini of his curious eliminativist career.

Unless you had something to do with the art world of the 1940s, Crawford will be unknown to you. In the exhibitions of that time, his paintings were familiar presences, part of the general effort to Americanize the language of European art. I always sensed in them a certain frigidity which marked them off from the abstract art his work so resembled. Abstraction could be boisterous and warm, but his painting had a mummified quality, as though the fluids of life had been drawn out and replaced by something alien to the forms it sought to preserve. I am accordingly grateful to the Whitney for this instructive show. Everyone supposed Crawford dead long before his actual death. Somehow it fits that he should finally have had a spectral connection to the art world, haunting its edges. His place in the history, realized and unrealized, of American art is as unresolved as ever. But one has a clearer picture of what he was.

HENRI DE TOULOUSE-LAUTREC

GEORGE SANTAYANA, WHEN HE WAS A YOUNG PHILOSOPHER, ADVANCED THE thesis that beauty is but pleasure objectified. Beauty, in this view, exists only in the beholder, as gratification caused by the forms and colors of things. But by some trick of psychology, the beholder is incapable of believing that there is no more to beauty than that, and spontaneously projects the pleasure outward, onto the things that cause it, henceforward treating it as one of their resident features. It is an ingenious theory, with an irresistible tang of paradox which insures that it will be disputed in esthetics seminars forever, though its author abandoned it almost immediately. Paradox or not, the forced conjunction of an inner state and an outer reality characterizes to perfection the heady atmosphere of Paris in the final decade of the nineteenth century, the Belle Epoque. Pleasure was palpable in the life of the boulevards, and it remains palpable in the depictions of that life in the great graphic work of Henri de Toulouse-Lautrec, on massive display at The Museum of Modern Art.

One cannot enter the galleries that house the famous and familiar posters without feeling, almost as a physical presence, the dense effluvia of sensual pleasure they distill: champagne, absinthe and dubonnet, rice powder and patchouli, dancers in frilled drawers and black stockings executing the manic steps of the quadrille, sports and *boulevardiers* in frock coats and opera hats, white-aproned waiters rushing heavy trays of foie gras and oysters to debauchees, the abandoned cadences of drums and violins, tipsy girls and whirling couples of various sexes, racehorses and bareback riders—a brothel world of infinite ecstatic promise. The chemistry of Lautrec's spicy imagery confirms the celebrated discovery of Marcel Proust that an entire reality stands latent in even a dish of tea, ready to be unfurled to consciousness and memory. The posters,

his masterpieces, after all participated in the reality they also represent, which is perhaps why they bring, along with its arabesque forms and chromatic dissonances, the sounds and smells and even some of the kinesthesia that defined that era. The harsh gaslight of dance halls or theaters seems to cast pools of decadent luminescence on the antiseptic floors of the museum's chill interior, a false but welcome warmth.

This was, after all, advertising art, plastered against the walls of *fin de siècle* Paris, on its kiosks or behind the bars in its brasseries and cafés, and was meant to arouse appetite and awaken desire. So even today, seeing the spectacular poster for the Moulin Rouge which brought Lautrec overnight celebrity in 1891, we want to go there, to see with our own eyes La Goulue flashing her magnificent behind, while her perfect partner, physiologically improbable, claps an appreciative rhythm. Even the lettering is seductive: "Moulin Rouge" repeated three times in the upper left corner, like a drum beat, in red letters against the pale, intoxicating chartreuse tint of watered pernod. The name is repeated once more, lower down, this time describing a sweet curve, almost dancing with La Goulue, whose complicated white underwear now forms the background. And just above that, in tinier letters, like a naughty whisper, "Tous les soirs" points to the V between her sexy legs. In the farther distance are silhouetted patrons in night-life headgear—toppers and feathered hats—forming a circle which curves forward to include us as part of its circumference. So we are, in a sense, half there already, inside and outside the picture at once. La Goulue dances her abandoned fling wherever the poster is shown. It obliterates, or at least makes ambiguous, the space between depicted viewers and real viewers. And the pleasure is made present in the art that objectifies it.

The poster is inherently an evanescent form, not intended to outlast the event that occasions it—an exhibition, a performance, an appearance, a fete. It is perfectly emblematic that the painter of pleasure, itself inherently evanescent, should have chosen for his most characteristic statements surfaces as fleeting as the sensations they advertised. It must have been a marvelous thing to awake one morning to iterated effigies of La Goulue all along the Boulevard Montmartre or the rue de Clichy, fresh from the bill-sticker, urging you to hasten to the Moulin Rouge, forming an escort. It is with Lautrec as with those short-lived species that spawn prodigiously and survive by sheer force of numbers. If one is going to work in ephemera, lithography is the medium of choice, facilitating vast

editions with minimal degeneration of impression, and insuring that some exemplars have a chance of making it to the shores of the future. Posters, but also theater programs, menus, announcements of art shows, leaflets with various functions, album covers, throwaway entities all, have somehow defied their natural condition of gay brevity to be preserved for connoisseurs of graphic art in its highest embodiment. The line between high and commercial art, between utilitarian and contemplative art, is boisterously erased in the radiance of Lautrec's achievement. It democratizes hedonism.

There is an invitation which Lautrec designed for a famous party thrown in February 1895 by Alexandre Natanson, publisher of *La revue blanche,* summoning his wide and arty acquaintance to partake (the invitation is written in English) of "American and other drinks" at "8 h. ½." Lautrec was barman on that remembered evening, wearing the American flag for a waistcoat, and with his head shaved. According to the wonderful biography of the celebrated Misia Sert (whom Lautrec loved to draw) by Arthur Gold and Robert Fizdale, he "invented monstrous cocktails in layers of bright green, red, and yellow liquors." They extract this passage from a contemporary account:

> Lautrec's imagination was inexhaustible. After a series of drinks which had to be swallowed in one gulp, there followed a gamut of pink cocktails, undreamt of concoctions which had to be sipped slowly through a straw.... He also compounded substantial cocktails of sardines in gin or port: he would set these aflame in a long silver dish, and before long they would be scorching the throats of the unwary. . . . There were also prairie oysters, their palatability unimproved by cayenne pepper.

That evening Lautrec served 2,000 fiery drinks to three hundred crumpled guests, all of them on the Natansons' floor when the bar finally shut down. For me, this episode expresses his artistic personality totally: a witty concoctor, a demonic juxtapositioner. Gold and Fizdale speak of "the great colorist running amok at the bar." He ran amok, in just that way, over the immense stones on which he drew his images. Bright green, yellow, red: these were the colors of his world, migrating from the bright bodices of the Moulin Rouge to the cocktail glass to the lithographic stones to the brilliant sheets which would be pasted all across the city the next morning. He is present, as such, in each of his works.

THE STATE OF THE ART

Consider, once more, the Moulin Rouge poster, and our privileged view of La Goulue's behind. The shown bottom is universally recognized as a gesture of mildly obscene defiance: I once read that the women of Lagos lifted their skirts and aimed their aggregated behinds at the governmental palace as an unmistakable gesture of contempt. So he has lifted the dancer's skirt and placed her as he has in a spirit that must be seen as impudent and provocative, establishing an instant complicity between himself and us. The poster is a cocktail of sly signals, and ripples with suppressed laughter. The lettering, like regimented balloons, goes with the comic topknot on La Goulue's head; with the foolish polka dots like clumsy bubbles across her blouse; and with the salient Adam's apple of her dancing partner, Valentin Le Desossé ("Valentin the Boneless"), a man so skinny as to verge on insubstantiality, allowing Lautrec to flatten him into a prancing shadow. In the *Divan Japonais* poster, he slices off the face and features of Yvette Guilbert, whose long gloves suffice to identify her, and puts us in the loge with Jane Avril, tapping her fan to the music. In the drawing *Poor Streetwalker!* of 1893, the client is reduced to a mere hand, leading the resigned woman, with her pathetic fur piece, out of the picture. In the lithograph based on that drawing, the hand is restored to its owner, but he loses his face and half his hat to the edge of the sheet. The cropped form, the poignant edge, the meaningful angle of vision, the improbable proportion, insinuate a language of commentary and observation between the image and us. To master the language is to learn what we are meant to feel and how we are meant to see the subject. He is manipulating it for himself and for us, and we are always conscious of him: he has made himself invisible to the subject in order to make the subject visible to us.

This is particularly the case with his pictures of prostitutes. He is known to have lived for various periods in whorehouses, something I suppose easily arranged with the infinitely accommodating madams of those establishments, prepared to cater to stranger preferences on the part of their moneyed clientele. As a fellow tenant, he became at last so familiar to the women that they paid him as little attention as they would a maid, or a pet, or a lover they had come to take for granted. Before Lautrec's gaze they were, simply, themselves. He represents them in unguarded moments, when they are vulnerable and unbuttoned, bending awkwardly over a tub, or unfastening a corset, or vacantly combing their hair, or sleeping deeply with their undefended breasts exposed, or gazing into a mirror wondering how to restore enough of their looks to turn the

next sou, or lying, exhausted and used, after having turned the last one. I love the painting, not shown here, of the salon on the rue des Moulins, where the women are chastely deployed on hassocks and ottomans in the garments of their trade, facing the implied entrance, awaiting custom. "They loll about on sofas like animals," he once commented, but it was a kindly, affectionate remark, for he adored animals and adored drawing them, and the women have the inextinguishable and hopeful patience of dogs. In one of the prints a stately proprietress, wearing a look of great wisdom and acceptance, carries breakfast things from the bedside of a young girl, clearly now the star of the establishment, who grins wickedly past her at the artist. In another print the same two women face one another across the length of the bed, like two stages of the same woman facing herself across the waste of years. It would have been simple for Lautrec, who had a caricaturist's malice, to make the heavy woman look ridiculous or hateful. So we are aware of the restraint, and hence of his humanity and compassion.

But sometimes he lets an expression stand which it would have been merciful to alter. In an 1891 painting on cardboard La Goulue is shown in the Moulin Rouge, supported on either side by a woman friend. Her bodice is disheveled, and she wears a look of dissolute stupidity. Her eyes are crossed, her mouth sour. She is perhaps too drunk to see the artist facing her. In showing us La Goulue with her defenses down, he is not showing us a defenseless woman, as in the feminine intimacy of the whorehouse pictures, which are so movingly tender. "Look at her!" the artist seems to say. Lautrec is always pointing things out to us, for our amusement or edification.

Lautrec constructed his compositions as he built his cocktails. He counted on different viscosities, in the latter case, to keep colors from bleeding into one another, and on some corresponding chemistry of optical display to allow the undiluted intensity of colored planes to work together. He functioned like a sort of prism, refracting pure hues out of the chromatic jumble that meets the eye. The oil sketch *The Englishman at the Moulin Rouge,* of 1892, shows the subject in full-dress regalia, his florid complexion set off by the poisonous green behind his head, his frock coat made up of blue-green strokes in the manner of late Impressionism, his red lower lip protruding so aggressively that the red-haired cocotte seems to be recoiling from it. The entire atmosphere is of flickering lights, artificial and cruel, and of a certain boozy vagueness. In the lithograph of the same year for which this vibrant painting was a study,

there are more severe separations and reductions. The Englishman is now an undifferentiated plane of mauve, like a fragment of Tiffany glass. The wall of the dance hall has become a plane of chrome yellow, like another such fragment. The image has the bold reductiveness of stained glass; and while there can be little doubt that the procedure echoes the separation of colors required by lithography—one color per stone, more or less—Lautrec may have taken a step, in treating the subject as so many planes of color, in the direction of what became Cubism. When Cézanne said, abruptly, in regard to the relative merits of Lautrec and Degas, "I prefer Lautrec," it was because he saw in this artist an enterprise of formal analysis kindred to his own.

Of all the modalities of pleasure objectified in this exhibition, none is greater than the intense pleasure the artist took in his own extraordinary powers, in the unparalleled gifts of reflex and grace his aristocratic forebears discharged in the form of sword-play. He combined an unsurpassed draftsmanly touch with a perhaps unique visual understanding. Lautrec knew how to show anything from any angle; he had a gift for perspectival transposition analogous to a musician's gift for transposing melodies from key to key. It is as though he could rotate a scene in his mind's eye until just the angle he required turned up—and then draw it from memory. After all, as he stood over a stone, the scene he meant to depict was far away or vanished. There is a famous set of drawings he did in 1899, in a sanitarium, to demonstrate that he was in control of himself and *compos mentis:* thirty scenes of circuses, with rearing horses and poised riders, animal tamers and acrobats, all made as an exercise in perfect visual recall. He simply knew how things had to look, from above or below, in order to be convincing, and though we too may have that competence, since we *are* visually convinced, no one else has had the power of drawing with the certainty and courage that is his signature. Beyond that there is the immediacy with which he swept an image onto the surface of the stone and, after having laid down his initial statement, found a way to fit the rest of the scene around it, cropping ruthlessly, condensing severely, augmenting in that manner the energies of the central figure. In one poster, the entertainer Caudieux fills a space too small for his flailing limbs, forcing all his energy back from the edges of the sheet. My favorite work is a poster of 1896 showing the troupe of Mlle. Eglantine: four dancing women in superb hats, five and a quarter purple legs sticking out of a cascading sweep of petticoats as urgent as the great *Wave* of Hokusai. Alongside Lautrec, every artist looks static.

There is more energy in a square inch of his drawings than in any six square blocks in Soho.

Of course he was tethered to an inadequate body: dwarfed, ailing, alcoholic, syphilitic, homely, drooling. He lived through breakdown, the collapse of his powers, and he met an early death. Anyone who feels that is the whole story is blind to the wit, the good nature, the motor ecstasy of the work. The world of the happy man and the world of the sad man are not alike, Wittgenstein remarked. This is the world of the happy man. The show is pleasure, objectified.

· 29 ·

TRANSFORMATIONS IN SCULPTURE

IN THE WORLD ACCORDING TO BARNETT NEWMAN, SCULPTURE WAS CHARAC-
terized as what you bump into when you back away from a painting to get
a better look. So what do you bump into when you back away to get a
better look at a piece of sculpture? At Transformations in Sculpture, the
display of the last forty years of European and American sculpture at The
Guggenheim Museum until February 16, you bump into The Guggen-
heim Museum itself. This means you get the look permitted by the con-
straining bays of that unaccommodating helical gallery, whatever the
sculpture itself might demand or you might require.

This may not matter particularly when the sculpture happens to be
one of Andy Warhol's facsimiled packing cases: it would be a caricature
of esthetic refinement to imagine someone standing back for an exquisite
appreciation of his replica of a Heinz ketchup carton. But it is antipathetic
to seeing the Giacomettis, with which the show begins. Giacometti was
a deeply optical artist, who dealt in vanishings. He once told me that his
project was to represent the world as it would appear to someone without
a sense of touch, whose experience of distal objects was accordingly
purely visual. He also remarked that his pieces were justified by the
shadows they made possible, and shadows, after all, are intangible enti-
ties. Experiencing a Giacometti is a complex optical transaction, as Sartre
established in a famous essay. At too distant a range his pieces vanish into
stick figures, at too close a range they disappear into their own textures.
There is an optimal position from which shadow, texture and image
synergize magnificently, which of course will vary from viewer to viewer.
The glum institutional lighting of the Guggenheim is grudging with
shadows, and its cramped spaces are inhospitable to the delicate adapta-
tions of sight and meaning needed to liberate these works from their

material embodiments. And this is almost tragic with an artist like Giaco-
metti, whose remarkable sculpture is obscured by the thick glaze of over-
familiarity, and by a heavy grime of morose existentialist interpretation.
Far from objectifications of *Angst,* his pieces are light and nimble and
radiant with philosophical intelligence and visual wit. There is a technol-
ogy for restoring works assaulted by physical degeneration, but when the
mind of the viewer is separated from the work by layer upon layer of
deadening belief, it takes great curatorial initiative to dissolve the psychic
oxides and make the work fresh again. But such initiative is hostage to
the severe parameters of the Guggenheim's architecture.

Perceptual inertness is only one of the indignities to which sculpture
is subjected in this ruthless space. Another is the indignity of bodily
misorientation. Certain works of sculpture have verticality as part of their
meaning, but all works of sculpture have verticality as one of their prem-
ises. So, for the matter, do paintings, for whether or not we are to
respond to the upward vectors of their images, as in an Assumption,
everyone will be disturbed by a crookedly hung work. Louise Nevelson's
characteristically imposing wall-piece *Sky Cathedral — Moon Garden + One*
makes three vertical references in its title, and certainly it conveys, as part
of its esthetic, a sense of vertical ascent that would be subverted were its
base allowed to sit naturally along the downward slope of the Guggen-
heim's coiled ramp. For then diagonality would be thrust by physical
circumstance on what was required to be plumb. The Guggenheim in-
stallers have therefore slipped in a prosthetic wedge, giving the piece a
platform on which to stand erect. Since Nevelson's work exemplifies
Diane Waldman's claim that one distinguishing mark of contemporary
sculpture is the way it has climbed off its implied pedestal to join us on
the ground, the wedge is inconsistent with the thesis the piece is meant
to exemplify. Beyond that, it gives the impression of shoddy craftsman-
ship, like a book shoved under the short leg of a tippy table, as if Nevelson
were incapable of getting her things to work. And finally, though the work
is given an artificial rectitude, *we* have become diagonal, and as we lean
this way or that to get in touch with the work, the work starts to lose its
balance.

Maintenance of bodily orientation is not something we can choose
to do or not: it is one of the modules of our sensory system. This, coupled
with the presuppositions of viewing sculpture, induces a sense of sus-
tained esthetic discomfort with such works as Nevelson's, in any case
crowded into an imprisoning corner and poorly illuminated. It can even

cause a certain indeterminacy of interpretation. I was unable to tell, for example, whether Barnett Newman's *Here I (to Marcia),* consisting of two elongated bars rising upward from a base, was slightly canted, or if I was imposing my own involuntary imbalance on an objectively vertical structure. I inferred verticality, partly from the fact that the museum had slipped one of its compensatory wedges, like an angular coaster, under the piece, and partly from my knowledge of Newman's zips, which the bars seemed to resemble: zips don't lean like Pisan towers. But such inference occurs at the wrong place in one's experience of the work: if it is vertical, one should experience its verticality, not derive it as the consequence of a spatial syllogism. As it stands, it is like trying to guess the notes in a piece of music occluded by static.

The architecture interposes obstacles to appreciation at every step, even where, as it were anticipating that he might someday be exhibited in the Guggenheim, Carl Andre has sought to achieve maximal flatness. His *Lead Piece* consists of 144 lead plates, each one foot square, laid like a protective floor in the radiation laboratory. But of course the ramp tips it at an angle, making it look foolish. The only piece that somewhat profits from the slant is Richard Stankiewicz's *Untitled,* which takes to the slope like an expert skier. The work consists of a column of steel slanted so that it rests on its lip. The angle of the column is opposed, chiefly, by a sort of horizontal drum. So it leans against the inclination of the floor, gaining an accidental energy. But suppose it had been rotated to lean the other way? Then it would feel positively dangerous, its angle of lean amplified by that of the floor.

The exhibition is a kind of chronological anthology of sculpture that has been important through the past four decades, and this format imposes an indignity of its own. For it wrenches each piece out of any context that might give it meaning, imprisoning it in a time cell to correspond to the spatial cells in which the visitor keeps hopeless company with the sculptures until the downward urging of the ramp moves him to the next thing. Chronology is the weakest of temporal structures, and at the same time the most reductionist, for it only situates things in terms of before and after. Chronology does not deal with beginnings and endings, only the ordinalities of time. There is no question that in terms of chronology, Giacometti should stand at the earliest position in the anthology. But it is far from clear that he belongs to the same history as the rest of the show. If anything, he marks the culmination of another history, pointing back to Etruscan art and to Surrealism, or to the Beaux-Arts

paradigms of sculpture his discoveries subvert. Giacometti said, "After me, there will be no one to try to do what I am trying to do," and while this is perhaps false, it requires a degree of historical interpretation to see why it might be so. This requires more knowledge than chronology can disclose.

It might, on the basis of certain visual analogies, be argued that the unfortunate statuary of de Kooning refers to Giacometti as a source and even an inspiration. Both men worked with clay on armatures, and in both cases we are aware of the moves and gestures of molding: the clay retains the traces of its having been formed. But in fact de Kooning's lumpy mannequins refer us less to the history of sculpture than to the impulses of his painting—and this is what, in a way, he shares with Giacometti, who regarded himself primarily as a painter who resorted to sculpture as an alternative exploration of parallel effects. The most striking feature of the show is how many of the artists were (or are) primarily painters: Rosenquist, Lichtenstein, Johns, Kelly, Youngerman, Warhol, Giacometti, de Kooning and Newman himself. And it is as though sculpture, for them, was less a mark of versatility, as with Michelangelo or Leonardo, than it was a necessity and a consequence of internal transformations in the concept of art. This is the history to which Giacometti does not belong, even if it is true that for him sculpture was to be appreciated in terms appropriate to painting.

When Newman put sculpture down as what you bump into when trying to see painting, he expressed an ancient snobbery common to painters. This snobbery was connected with the social ascent of painters in the Renaissance, who were anxious to put as much distance as possible between their art and the practices of manual laborers. The sculptors' atmosphere was one of dust and dirt, mud and plaster, mallet taps and hoarse shouting. But the painter, in his velvet biretta, could discourse with poets and philosophers as he touched the surface of his tableau with the delicate point of an elegant brush. Painting, like poetry, sublimated the matter of its art in favor of the illusions of imagination, while the sculptor was imprisoned by materials. Newman made his remark just at the moment when a complete reversal had begun to set in. For one thing, the illusions that seemed to exalt painting to a higher realm of the spirit had begun to be suspect. Definitions of painting were abroad which saw it in terms of pigment: painting was the physical process of depositing physical substance on physical surfaces. And there was, at the same time, a transformation in social attitude toward physical toil, which was vested

with a certain proletarian dignity. Both transformations were reflected in the standard artist's costume of Newman's era: the paintstreaked overalls, the dirty jeans and muddy boots and smelly flannel shirt of the laborer implied a certain honesty, while the monosyllabic grunts of the Dumb Artist, seasoned with obscenities, became the affected discourse of very clever men and women. How could Newman resist turning to sculpture, despite his Renaissance prejudices?

By insisting that painting was nothing but a physical act with physical objects, the boundary between painting and sculpture was *already* crossed, and the logical next step was to liberate painters' forms from the necessarily illusory space that kept them from being real. Newman's *Here I (to Marcia)* consists in the transfer from painterly space into the three real dimensions of his zips. One of the zips has molded painterly edges, the other has clean linear edges. It was like Pygmalion breathing life into fantasy, turning art into something one could bump into. And through the 1960s, sculpture seemed to have become a means of conceptual jeering at painting, though painting itself was often a kind of jeering at the axioms of an art theory that made the move to sculpture a *reductio ad absurdum* of itself. Lichtenstein's portraits of brush strokes is a case in point. It is as though this artist pretended to understand the Expressionists' claim that painting itself was the subject of painting in such a way that one was now making paintings of painterly acts, the way artists used to make paintings of Madonnas and saints. The show is full of such jokes. George Segal constructs, with mock literalness, a three-dimensional counterpart of a mildly Cubist drawing by Picasso, as though Picasso had done a highly representational study of what happened to be some real fragments—a chair back, a wet mop, a rubber ball—of a woman uncertain of how to make some order out of the jumbled interior of her life. Rauschenberg dribbled some paint over the hapless muzzle of a stuffed goat, as though taking the Expressionists at their word that paint was to be considered reality itself: Why bother using canvas? Why not a goat? Or a quilt? Or any convenient thing?

This is certainly a main dimension of the history. The other main dimension comes from the fact that sculptors, as if themselves infected with the Renaissance prejudices, had sought to advance their art by assimilating it as much as possible to the condition of painting. This was certainly David Smith's project, with whom the history might properly have begun. Welded sculpture in the 1940s and 1950s was explicitly described as "drawing in space." Smith's *Steel Drawing 1* uses sheets of

steel like sheets of paper, and his acetylene torch like a kind of stylus. The work has the character of a three-dimensional picture. So what painting bumped into when it stood back from itself in order to become like sculpture was sculpture backing away from itself in order to become like painting. This double backspring, in which painting and sculpture pass each other on the way to becoming each other, makes a very comical narrative: the sculptural painter now may contemplate himself as a painterly sculptor, as in a mirror. And vice versa.

The Guggenheim is beginning to look shabby. The highest ramp is filled with pieces of stowed paraphernalia, as though it had been turned into a kind of attic. It is a very ill-considered perversion of architectural intentions. The light is so bad one feels the management is trying to save money on electricity. The wonderful reflecting pool with which the great slow spiral used to end has been cemented over, inducing a terrible opacity where light was once captured by water. The walls are dirty. In an exhibition, as in a meal, presentation counts for something. This is a graceless show. What could have been an exhilarating experience has been turned into a dull textbook of modern sculpture. Both times I visited the show I left depressed.

· 30 ·

THE SCULPTURES OF GEORGE SUGARMAN

"PURITY OF HEART IS TO WILL ONE THING" IS THE TITLE OF ONE OF KIERKE-gaard's *Edifying Discourses.* It would have pleased this witty, driven man to know that a natural rhyme in English would yield an artistic imperative close to the homiletic one of his sermon. He would doubtless have inter-preted "Purity of Art Is to Will One Thing" as a celebration of the single-minded artist who labors to no ulterior and distracting purpose, as in the case of the needlewoman with whom he begins his discourse, who makes an altar cloth as a form of prayer. But I have in mind instead the artwork as the locus of severe purgations undertaken to reveal the pure essence of art. The history of modernism may be read as a linked sequence of spiritual exercises, undertaken in compliance with what the Apostle James repudiated as "double-mindedness." The subtraction of subject matter is only the most obvious reduction, but even Kandinsky, who discovered abstract art, also wrote a treatise on art and spirituality. Some deep historical explanation is necessary to understand why the studio should have replaced the monastic cell for the practice of austeri-ties, and why art and asceticism should be so closely linked in our century.

Kandinsky did not go far enough, the single-minded would murmur. He retained pictorial space, leaving room for illusion and hence the danger that art should be damned to the status of appearance. Painting must be identified with surface; flatness is the saving virtue, everything else is excrescence, is corruption, no matter how long it has been as-sociated with art. The rejection of any save primary colors, as in the work of Mondrian, leads to a further elimination in favor of pure white or pure black, or better still the blank, textureless, hence textless, panel. The rejection of diagonal, not to speak of curved, lines makes room for the erasure of lines altogether and finally for the erasure of forms, since

forms bear the stigma of boundaries, and so on until one has arrived at pure stains and washes, and finally, once more, the untouched canvas dense with the history of its resistances. It would be difficult to comprehend the undertaking of this renunciatory itinerary but for the promise that less is more, and its corollary assurance that the least must be the most. Minimalism, as the logical destiny of the enterprise, would look pretty arid but for this transfigurative formula.

Construed as an agenda of progressive divestiture, modernism petered out sometime in the early 1970s. Its demise accounts in part for the fuddled state of art criticism since that time, for with each purification, a platform was established for criticism of everything else on grounds of esthetic bulimia. These platforms collapsed in the general spirit of permissiveness or pluralism that seems to follow, as a matter of historical necessity, periods of puritan sublimity. It is still all right to be a minimalist, but on grounds more of preference than duty: the art world has its Jack Sprats, but it also has its Ms. Sprats, who, like Joseph Beuys, see no harm in fat. Purity today remains only as a nostalgic concept. Those who have attained their majority in the present period of artistic tolerance would have great difficulty imagining what life was like in the times when one resisted this or that injunction with that sense of defiance with which Kierkegaard's father roared blasphemies while striding the Danish marches. It was a challenge to the universe.

The sculptor George Sugarman likes to say that there are no longer any dirty words, which means, I suppose, that the possibility of impurity has vanished with the possibility of purity, leaving a normatively unstructured space in which a term like "baroque," once an epithet, is now merely descriptive. His sculptures in wood, on view in the Lobby Gallery of The Whitney Museum of American Art until February 9, were executed in a period—from 1961 to 1965—during which they must have deserved most of the dirty words that composed the critical vocabulary of the era. Consider, for example, the injunction to respect the integrity of materials—the woodiness of wood, the stoniness of stone. This defines the instant limits on sculptural intervention, and condemns as trespass any manipulation of materials deemed disrespectful of its natural properties. When Jasper Johns painted bronze to look like the familiar stamped tin out of which cans of Savarin coffee were fabricated, he was violating a commandment that went back perhaps to Winckelman. Part of what made his *Savarin Can* of 1960 so intoxicating was its naughty disregard of the purism of materials. For Sugarman, sculpture as such was an

unnatural use of natural materials: "The natural capacity of wood," he said, remembering his Aristotle, "is to be a tree." So if we are to give it a shape that deflects it from its own natural fulfillment, why stop there? "It is," he said, "just another substance for making sculpture."

There are a dozen works on display, and as a group they violate, one might say systematically, most of the esthetic prohibitions thought to be essential to sculpture in the early 1960s. I do not suppose they were made specifically to breach a commandment, as demonstrations that one can —imagine!—indulge in polychromy without the heavens opening. Rather, I believe, Sugarman saw the prohibitions as impeding the realization of his sculptural concepts, and I shall explain how polychromy is a response, in his case, to problems that evolved in the natural course of his work. The typical piece, in any case, is a concatenation of wooden elements, each a kind of crazy form, painted in the bright enamel colors of the toyshop—the colors of wooden soldiers, rocking horses, tops, jumping jacks, blocks, roly-polys or jacks-in-the-box—and patterned like objects required to be insistently visible in order to be instantly differentiated, like fishermen's floats, signal flags, the costumes of jockeys, the blazons of jousting knights. They are a world away from the rust or leaden tonalities of severely minimal forms so appealing to a different sculptural temperament. "Less is less," he wrote in 1968, contradicting Mies's paradox with a tautology, though not quite willing to endorse the complementary tautology, "More is more." More just "has a chance of being more."

Visitors to the exhibition may wonder whether in his case more really is more, but perhaps that will be only because they have brought with them proscriptions mastered in art appreciation courses, which render them unprepared for the merry impetuosity with which Sugarman spills one set of misfit forms across the floor, or gathers up another set to compound some integral assemblage. In a way, the pieces look like a prodigal child's putting together of the elements of a magnificently eccentric Lego set. It is this sense—that the integral pieces could be taken apart and put back in the box, to be taken out and played with on another occasion—that perhaps gives the impression of not being quite the "more" we have in mind when less is said to be more. Whatever meaning there is, of course, it is clearly not the meaning borne by archaic torsos of Apollo or Pietàs or dying Gauls or horny saints pierced by arrows. The meanings seem more the kind borne by gaudy figureheads, by cigar-store Indians or Uncle Sams, or wooden Punches. It comes as no surprise, for example, that Sugarman should on occasion make actual toys: there was

a flower on wheels by him at the Vanderwoude Tananbaum Gallery which you could have given (for fifteen grand) to the child who has everything last Christmas. It would be hard to picture a toy by Richard Serra, unless in a nursery by Charles Addams. But Picasso made marvelous toys, infused with the same spirit that went into *Guernica,* and Matisse's decoupages were masterpieces that arose from the same impulses as paper dolls. So be sure, before dismissing them from consideration, that you are not demanding purity of heart at the cost of an alternative sculptural virtue.

C-Change, of 1965, is a good piece for thinking through Sugarman's enterprise. Its thematic element is the letter C, and the work consists of C's adventures in seeking to escape its basic geometry. It is a vertically oriented work, so begin with the base, an elongated pyramid resting on two flat squares, which changes its mind before attaining its apex by widening out to support the first C. This is a nice, thick, squarish C, like a shoe for a cubist horse, painted orange. Atop it is a bright raspberry C, fat and round, as C's should be, tipped at an angle. Then comes a swollen white C with thickened extremities, expressing an ambition to assume the shape of a lyre. The next C closes its lips, rather too fiercely, and looks like a claw from a yellow lobster—or a C-clamp. Cantilevered out is a complex form, painted black, which could be two C's, or one C with a shadow, or a single C split in two.

Let me pause at this point to discuss the matter of color. This doubled, or angled, C is clearly meant to be read as a single element with a complex anatomy, as the single color indicates, rather than as two adjoined elements, like the bottom two C's. And there would be no way of understanding this difference were it not made plain by the differentiating use of color. So colors here are punctuational, marking the boundaries between forms. When dealing with familiar or natural forms, like flowers or human or animal bodies, we have independent, real-world knowledge as to which the parts are and where the joints are: legs, petals, heads, stems, necks, leaves, arms. A sculpture of such an object, therefore, can either dispense with color or use it more or less descriptively: a sculptor who painted arms a different color from trunks would be making a witty observation on the philosophy of parts and wholes, a kind of color-coded demonstration model for extraterrestrial tourists. But Sugarman's forms have, as a general rule, only a distant resemblance to natural or familiar forms; he is an abstract artist (though not a nonreferential artist). So novel are his forms that it is a serious question as to whether we have come to a new form or simply an unexpected part of an

old form. And color helps us decide that. These observations, needless to say, explain the use of color without explaining the choice of color. Color itself becomes descriptive when form becomes referential: the green of a form that refers to a tree helps fix the reference of the form, allowing the sculptor great freedom. But that leaves open the choice of *which* green to use, and at that point color becomes expressive rather than merely referential. Since the letter C has no natural color, the colors of Sugarman's antic C's describe a mood or feeling. And the choice of lollipop colors pretty much singles out a sector of relevant feeling: there is no hermeneutic license for connecting *C-Change* to something terrible or tragic.

Arising from the black form is a blue form so thick and angular that only the pressure of its peers enables us to recognize it as a wayward C. And poised at the very edge of this anomalous C is a rebellious form which almost closes the gap essential to C-hood, to become a triangle. It is the color of limes. And balanced on its upper leg is the largest C form of all, triumphant in its identity. It spreads its coral arms as a singer who has reached, well, high C. It is a very funny work, reversing the title of Wallace Stevens's poem so that it becomes *The Letter C as Comedian.* It is, as its title requires, something rich and strange, a zigzag harlequinade of silly C's evolving up to some kind of vertical climax 114 inches above the floor. It is impossible not to smile each time one reads it.

Inscape, of 1964, is a horizontal aglomeration of heterogeneous forms spread out at the entrance to the Whitney's restaurant. A white serpentine form wiggles, like the Loch Ness monster, alongside a crinkled expanse of green wood, which, if it is a stream, flows into a four-armed trough, which sluices it into a peach-colored lozenge, which may be a pool. This identification is made difficult by a stack of wooden slices laid on its side, which then connects with a slinky S—which may be the monster's svelte companion—which either touches or turns into a sort of chain, which forms a bridge over what might be a glacier if the forms between it and the serpentine have a geological identity: mountains or boulders, or perhaps huts, painted blue and eggplant and the color of yolk. It has the air of a miniature golf course. Or it could be the model for a marvelous playland of bright, kind forms to climb over or crawl under or creep through or slide down. On either scale, as sculpture or environment, it radiates a generosity of invention and objectifies a certain innocent glee.

In view of these essentially benign connotations, it is a dark tribute

to the paranoia of our time that Sugarman's work should have become associated with the terrors of the contemporary world. Sugarman approaches the public space from the Samaritan perspective with which people bring toys to very sick children. Since the spaces he is commissioned to enhance are terminally bleak, why not fill them with shapes that refer to the green world of waterfalls and bowers, of sweet streams and cool forests, where office workers and bureaucrats can enjoy the privileges of nymphs and shepherds as they spoon yogurt or listen to headsets on their lunch breaks? In 1975 he set about constructing, in a plaza in Baltimore that makes Red Square look like the Parc Monceau, a sort of arbor of leafy forms, under the auspices of the General Services Administration Program for Public Art. The chief judge of the United States District Court in Maryland moved to quash the project, saying it afforded shelter to muggers and molesters, "persons bent on mischief or assault on the public." It was even argued that it would convert to instant shrapnel were a terrorist's bomb detonated within its dangerous space. The political and legal ordeals the work had to undergo from maquette to monument give it a heroic dimension somewhat at odds with its pastoral intentions, to become a lesson in the politics of purity of heart.

A show of Sugarman's later style, of thin washes of sheet metal given a certain rococo lightness and flamboyant energy, will have closed at the Robert Miller Gallery by now, but two good examples of it can be seen, one on 60th Street and Fifth Avenue, the other on Third Avenue near 53rd. I like the wooden work at the Whitney best. What strikes me is how difficult it would be to be untrue to the essence of wood after all. Cut it up into screwy shapes, paint it up in any color you choose, the woodiness of wood is irrepressible. In the end I was reminded of the great sixteenth-century limewood sculptors of Germany, who celebrated wood by shaping it into elaborate drapery, into intricate weavings and plaitings, plant-forms and animal-forms of astonishing realism, the convulsings of martyred flesh, the liquefactions of blood and tears. There is a message here regarding the moral metaphysics of matter, which I leave to the reader to draw as an exercise.

· 31 ·

JENNIFER BARTLETT

EVERY EVENT IN THE HISTORY OF MODERN ART HAPPENS TWICE—THE FIRST time in the studio, the second time in the nursery school. Hardly had Jackson Pollock broken the ice by flinging arabesques of paint across a horizontal surface than neat rows of dripped paintings could be observed drying outside schoolrooms from coast to coast. Since the first thing many infants see when they open their eyes to the world is a mobile dangling over the bassinet, making mobiles in kindergarten is now as natural as fingerpainting. The collage was almost instantaneously trans-mitted from Montmartre to the day-care center. The parent who criticizes an artwork by murmuring that his child could do that is confessing that he or she is out of touch with the child's education. The appropriate Johnsonian riposte is, "Sir, she already has." To be sure, few such mur-murs are to be heard in front of Raphael's *Transfiguration* or Poussin's *The Death of Phocion.* But that only means that most of what pertains to modernist art never meets the eye. A formula for beginning to think about such work is to subtract whatever a child in fact can do; the essence of the work resides in what is left over. And this—a body of thought—if not altogether inaccessible to a childish intelligence, must be transmit-ted in some way other than by requiring her to imitate with her hand that portion of the total work accessible to her eye.

When I visited the immense retrospective exhibition of the work of Jennifer Bartlett at The Brooklyn Museum, I shared its galleries with groups of schoolchildren. As the teachers were obliged to speak above the engaging tumult of their charges, I was able to overhear a fair amount of well-intended pedagogy from educators who clearly did not find this artist as difficult as I do. So I listened in order to determine what to subtract, to learn how to gain access to those inner thoughts that give

meaning to the outer portion of the work. One group was seated in an unruly semicircle before a segment of Bartlett's celebrated *Rhapsody*, which was the primary object of my visit. Begun on Long Island in the summer of 1975 (not very far, in fact, from where Pollock discovered the drip) and exhibited the following year at the Paula Cooper Gallery, where the artist herself saw it for the first time completely assembled, *Rhapsody* consists of nearly a thousand enameled plates, each one foot square, regimented (with one exception) to form a grid seven squares high, in rows 141 squares long. The modules are separated from one another by one precise inch. Each module is overlaid with a silver grid silkscreened on, reminiscent of that system of squares an academic artist will impose on a drawing to facilitate transfer to the larger surface on which the final work is to be executed. Or, more consonant perhaps with the industrial connotation and provenance of the modules, the overlay could be viewed as a graph. The upper left module, where one begins to read the work, is left untouched, but across the vast expanse of *Rhapsody,* as though it were an abstract comic strip of epic dimension, Bartlett has deployed a number of images. Some of these take up several of the squares. Some take up just a single square. Some of the squares are, in a way, their own images and hence self-referential, for squares are among the things the work is about. It is a rich and demanding piece of art, and I was naturally interested in how it was to be explained to minds untouched by the art world, in no position to ask whether this is art, any more than it could occur to them to raise such questions about the objects in The Brooklyn Museum's Egyptian collection or its galleries of primitive art, which they had doubtless visited on other excursions.

They were given sheets of graph paper and instructed to fold them into twelve squares. Then they were told to draw something in each square, but always something different from square to square. Since they were being taught to be creative in the newest way, they were cautioned not to look at one another's work, though Bartlett herself has clearly peeked over every shoulder in the history of art. My aim is not to scold the teachers, who had a hard enough time collecting the sheets they had handed out, but rather to reflect on what instruction I would give children were it my intention to move them toward an understanding of this work. To be sure, it is (very) roughly true that Bartlett has drawn something in each square and something different from square to square. But whatever it was that she undertook that summer, she achieved something that these children were asked to duplicate only in the most external way. It would

not have helped had the children been terribly privileged and been told to do the same thing with 988 enameled metal squares. A better instruction would have been this: get everything in the world in twelve squares. Bartlett's own recorded motive was to make a work that "had everything in it."

So stupendous an ambition has seldom been pursued since Hephaestus forged the shield of Achilles: "He made the earth upon it, and the sky, and the sea's water, And the fireless sun, and the moon waxing into her fullness." Achilles's shield has considerably greater human content than *Rhapsody,* which reduces that portion of "everything" that expresses human reality to a very minimal house. But as Achilles observes when his mother lays the shield before him, no mortal could have made it. Nor could a child have made *Rhapsody.* But a child might have made something that incorporates part of the work's spirit by trying to comply with my imagined directive, for a set of choices and a certain kind of thought would be required were "everything" to be expressed through twelve images. The child would have to exercise powers of abstraction, universalization, reduction and symbolization before putting his or her felt-tip pen to paper, and would have to be prepared to situate his or her decisions in a structure of justification and explanation. Each of the chosen images would have to be condensed and would stand for a wide class of things—as the house expresses the entirety of human reality—and in seeing how to do this, the child would reenact the kind of thought I believe animated this singular object.

Having decided to house everything in a single work of art, Bartlett was committed to an analytical and synoptic program. She says she chose the first four things that entered her mind, but the very structure of the program meant that these had to be very elemental things. What occurred to her were: mountain, ocean, tree and house. She then decided on three geometrical components: circle, triangle, square. This, I surmise, means that *Rhapsody* exists on two levels, corresponding, in a way, to what natural philosophers of the seventeenth century would have distinguished as primary and secondary qualities. The primary qualities are the quantifiable properties—space, time, shape—to which her lexicon of geometric forms perhaps answers. Secondary qualities are those of sense and feeling—the colors and textures of the world as we see and touch and live in it. The world of secondary qualities is composed of such things as mountains, oceans, trees and houses. But a mountain is a triangle; a house, a triangle set on a square; a tree could be a circle set on a

column of squares. The phenomenal world resolves into the geometrical world, the world of geometry is actualized in the realm of what we sense.

If one were programmatic and determined, one might seek a set of formulas through which whatever is sayable could be translated into the vocabulary of mountain, ocean, tree and house, and this then translated into the deeper language of geometry. Nothing quite so constructionistic was intended by Bartlett, I dare say, but she did mean for the work to have the structure of a kind of conversation, in which certain topics recur in different contexts—so the house reappears in different forms. It is possible to imagine that there are, perhaps, four voices in the conversation, four styles of representing the basic elements of the work (and the world). There is a lyric voice, which depicts the world in lush brush strokes; an analytical voice, which construes angles and modulates abstract forms; a child's voice, exemplified in some of the deliberately infantile ways in which a mountain or a tree is drawn. And there may be a philosophical or mystical voice, which objects to the plurality even of Bartlett's restricted vocabulary and demands, in the manner of Thales of Miletus, who argued that everything is water, a final monistic reduction. Eighteen columns of *Rhapsody* are given over to the ocean, which might be read as stringently minimalist except for the great range of distinct blue hues with which it is painted. But there is a lot of water throughout the work. One segment, a square of squares, forty-nine in all, is given over to a loosely brushed landscape dominated by two cascading trees, more or less in the shape of poplars or cypresses, behind which runs an unmistakable stream. Another such square, in an analytical notation, the dots of a computer graphic, is almost fully occupied by the house in its most compelling manifestation.

Rhapsody is a four-part invention and an absorbing work. I do not know what its intended shape is, whether it was meant to be a wall but has compromised for the exhibit to become four walls (with a door), to form a kind of room. I thought it suitable that it should be installed that way, surrounding the viewer with what is, after all, the whole world. I was grateful when the room-work emptied out, as the children were shepherded on to the next thing, leaving me to ponder what might have been said to them. I do not know the degree to which children consciously think in terms of levels or parts and wholes or themes and variations, but those would be among the things I would try to get them to see in the work. Then I would ask them to see the same elements in the other works that composed the exhibition, for just as the four elements emerge and

reemerge in *Rhapsody's* different discourses, they appear and reappear, over and over again, throughout the entire retrospective, almost obsessively. It is as though the corpus produced thus far by this exceptionally ambitious artist were a continuation of the conversation of *Rhapsody*. And much as that work must be taken as a whole and not sold plate by plate or section by section, the body of Bartlett's output has the quality of a single work produced over fifteen years. It is as though "everything" were the least (hence only) relevant unit of her enterprise, as though it were to be taken as an evolving whole. Once one sees each style as but one of the voices in the conversation, one realizes that she uses styles rather than has a style. She uses them as she uses her elemental things. And just as she might need to augment her spare vocabulary, she might take on further styles as required by the global demands of the work.

An axiom system in mathematics defines a kind of universe. Its axioms are meant to be the basic truths of that universe, from which all further truths follow as a matter of logic. Naturally, one seeks for the smallest set of axioms possible, but sometimes a truth one thought one could prove turns out to be basic, and the axioms must be expanded to include it. Each such system also has a set of basic terms or concepts, through which everything else in that universe can be defined. But the idea is to express everything with the fewest terms possible. Bartlett has been obliged to extend her basic vocabulary over the years. She has added swimmers and boats, each of which enables the conversation to take up matters that cannot be expressed in the spare language of mountains, oceans, trees and houses. The swimmers are perhaps too amoeboid, pink disks quivering in watery media, to succeed in carrying an explicit humanity into the work. But the boats interact with the houses to define two fundamental moments of human life: security and adventure, stability and exploration, possibly masculinity and femininity. A single boat in a painting by Monet carries a brooding lesson on the solitary meaning of life. "Single swimmers in a waste of waves"—a line from Virgil—was used by Schopenhauer to symbolize philosophical thinkers. Boats and swimmers are marvelous symbols.

The boats and houses have acquired a kind of three-dimensionality in the later work, often standing in front of paintings that show blank shapes in the midst of brush-swept landscapes, as though marking the places they quit in order to take up residence in the real world. There was a whole room in which such actualized shapes stood in front of the paintings to which they belonged. The boats are quirky in material and

construction. There was a brick boat, a boat made of cement, another boat made of sheets of copper. Some had plaid sails. It is easy to see why it seemed a natural exhibition to bring children to. The round area under the rotunda became a kind of marina, with toy boats moored here and there around the shore, on which stood the toy houses, behind which were those paintings with their singular emptinesses and florid brushwork. The effect was somewhat ghostly, and I do not know quite what these works try.

Jennifer Bartlett is an artist about whom there are strongly divided opinions. I know many who despise her, who find her work empty, factitious, pretended, facile and self-absorbed. I have become one of her enthusiasts. I could not find reasons for everything she did, but in some way I felt, immediately upon entering the exhibition, that I was in the presence of an exceptional creative force and an unmistakable authenticity. The brushy trees in *Rhapsody* have become more and more central, especially in her paintings of gardens. In the next-to-last gallery were three paintings of an ornamental pool with a banal figurine of a peeing boy, set in an abandoned garden under heavy shade. The garden is dense with shadow, the trees stirred by a melancholy wind. Each painting shows the pool from a different vantage point, three glances, each slightly different but not deeply different. They are very beautiful, full of the moody and urgent brush movements of someone who could be a major painter were that her goal.

Organized by Marge Goldwater at The Walker Art Center in Minneapolis, the exhibition completed its sojourn at The Brooklyn Museum, alas, on January 6. It will travel to The La Jolla Museum of Contemporary Art and after that to The Museum of Art of the Carnegie Institute in Pittsburgh. I would make a serious effort to see it if you are within striking distance of either of these institutions. Meanwhile, if you missed the show at the Brooklyn, you can experience *Rhapsody* through a fine book, *Jennifer Bartlett: Rhapsody*. Published by Abrams, it has a very useful introduction by Roberta Smith, who contributed as well to the exhibition's excellent catalogue, which will give you some sense of the other work.

· 32 ·

FRANÇOIS BOUCHER

PASTORAL FANTASY SURVIVES VESTIGIALLY IN FRENCH CONSCIOUSNESS chiefly, I think, in the name *Folies-Bergère* and in the language of that institution's costumes and entertainments. The frilled and feathered garments of its prancing vedettes are vulgar descendants of the ribboned improbabilities that shepherdesses wore in eighteenth-century paintings, where they also chose to show their pretty bosoms and to dance and sing away the cares and hours of life. These shepherdesses' follies have no iconographic connection with the sheep-tenders prominent in Barbizon painting in the nineteenth century—honest agrarian toilers shown bent against the wind or standing under stormy skies, watching over the sources of wool and mutton on which they depended for their marginal if picturesque livelihood. Such follies as the Barbizon shepherds may have been capable of would have had to do with colic, lambing, foxes or the propensity of their dim charges to stray, but certainly with nothing that could be classed as frivolity, which defines the insubstantial essence of the comely personages shown with token lambkins in the characteristic eighteenth-century pastoral landscape. Those same personages, in different costumes and with different attributes, also turned up as godlings and goddesses in mythical allegories by the same painters for the same clients. But it is the fantasized bucolic landscape, with rosy shepherdesses and fluffy sheep, that epitomizes the high art of the reign of Louis XV. It says something profound about that civilization that its leading official artist, François Boucher, should have served as purveyor of such largely innocent images to as dissolute, cynical and opportunist an elite as the world has ever known.

Boucher's patrons lived the lives ordinary people fantasize about: lives of luxury, power, sensual indulgence, elegance, distraction, leisure

and wit. What they fantasized about was a distant innocence: the carefree existence of living dolls frolicking with happy animals through feathery groves, by clear waters, under blue silk skies with clouds as soft and white as toy sheep, in sweet landscapes punctuated by the romantic melancholies of classical ruins—picturesque reminders of the transience of worldly power. There is not even much eroticism in these Arcadias, but an almost virginal sensuality: a ballet of indolent flirtation in a setting of curls and flowers. Plato defined the despot as one who seeks to live out in action what but haunts the dreams of ordinary persons. It is clear that he believed despotism a form of madness, which after all consists in an incapacity to keep reality and fantasy distinct. That Marie Antoinette, in the next reign, sought to enact the fantasies her predecessors only contemplated in tapestries and tableaux—that she and her attendants should have pretended they were milkmaids—is a sign of her power and instability. But even so, it is a startling inversion of values that the Queen of France could aspire to the life and being of women who might have tried to soften harsh realities by imagining what it would be like to be a queen. The Queen's dairy at Rambouillet is a Rococo grotto embellished with milk jugs fabricated by the royal porcelain works of Sèvres, with little correspondence to rustic reality. I suppose even the lambs and kids were shampooed, though the courtly eighteenth-century nose was used to rude aromas.

Now one cannot pretend that pastoral yearnings figure much in the fantasy life of present times, and visitors to the celebratory exhibition of François Boucher at The Metropolitan Museum of Art until May 4 (and at The Detroit Institute of Arts May 27 to August 17) are certain therefore to find the work paradoxically difficult for a painter otherwise so accessible and concerned to give pleasure. Perhaps the first thing to realize is that even in its time Boucher's world was appreciated as a make-believe one—the representation of a universe connected to the actual universe only by repudiation. It strikes me that his are among the first works of pure imagination in Western art, for while painters had always been required to imagine the scenes of sacred history, they had no doubt that these were part of real history. In any case, it would be wise for the visitor to hold the fantasies, for a moment at least, at a distance, and concentrate on what in Boucher is immediately available to contemporary appreciation: the extraordinary manner in which he handled paint. One can find one's way into the painting through the paint itself, for Boucher's touch is unparalleled in the history of art, and the movement of his brush

emblemizes the visions he was able to transact in the spaces of the imagination. The surfaces give tangible promise of the sensuous possibilities behind them.

Compare him, to begin with, with Watteau, whose paintings he engraved when a young artist, and of whom he executed a portrait believed to be imaginary, since there is no evidence that the two men ever met. Then compare him with his prize student, Fragonard. These three define three moments of a period of remarkable artistic expression that began with the death of Louis XIV, when the court was transferred from Versailles to Paris under the Regency and when the dour austerities of official painting, dense with the absolute authority of its patron, gave way to something more interior and more intimate, more sinuous and more sensuous, suited to a life where frivolity was elevated to a cosmic principle and pleasure became the duty of power. To be sure, the country had to be run: solutions had to be found for its fiscal desperations, treaties had to be negotiated, wars fought, marriages arranged. But the imaginative tapestry of life in the Tuileries was of dancing and picnics, boating parties and tennis games, the interchange of secret notes, whispered amours and confessions to one's lady-in-waiting, the pampering of flossy dogs, kisses stolen behind the garden statuary, the flying skirts of squealing girls on high, garlanded swings, serenades and stifled giggles, the circumvention of chaperones in a leafy world of rosebuds and grapevines, lakes and pergolas, trellises and Italianate niches, achingly gentle lawns and bowers soft as beds. This period came to its end when the celebration of domestic virtue, as in the paintings of Chardin and Greuze, implied a different private morality, and when public morality began to censure voluptuousness through the classical severities of Jacques-Louis David, which announced the revolution and the new era of rectitude to come. The spirit that ended the Rococo expressed as rigid a moralism as the Rococo had swept away. Watteau's great *Shopsign of Gersaint* shows a portrait of the dead monarch being packed in straw while the patrons of Gersaint's gallery, when they are not admiring themselves in ornamental mirrors, gaze raptly at fleshy mythologies of the sort Boucher was to carry to perfection.

Watteau's touch is as nervous as his subject, as though the paintings themselves belonged to the same psychic reality that was lived by his traveling companies of actors, or his amorists arising from the enchantments of Cythera, or his lords and ladies pausing to embrace or to execute a diversionary dance or to break for a moment the restless com-

ings and goings of frantic and distracted days. How Watteau, out of seemingly random squiggles of pigment the color of clay and putty, should have summoned garments that shimmer like silk is one of the hopeless secrets of his genius. Fragonard's touch is of slashes and sweeps: one feels he painted with his arm rather than with the ends of his fingers, like a swordsman parrying his way out of a tight corner. Boucher, never save at the end much on the defensive, flourished in the noontime of this period, and he lays paint on with a sweetness and accuracy that reminds me of the way a master *pâtissier* would decorate a cake. The work is almost edibly delicious, and it is an astonishment how paint becomes form instantly and accurately, as in the leaves in the lower right corner of *Aurora and Cephalus*. The edges of the stroke define the edges of the form, so Boucher is realist and expressive at once and in every touch. With Watteau, you see either the paint or the subject. With Fragonard, the subject dissolves in the paint. With Boucher, paint and subject are in some manner both one and distinct. The brush strokes are not strokes as sword strokes are but as caresses are. Fragonard is like de Kooning when he built terrifying females out of slashes. The only contemporary painter who reminds me of Watteau is Philip Guston in his period of high Expressionism, when the work consisted of tense shimmers in shallow space. Boucher is like Cézanne in his clarity of touch, but more sure: an apple materializes through knowledge rather than through the search for it. And he radiates a sensuousness Cézanne repressed.

You might now begin to work into one of the paintings, perhaps *The Toilet of Venus* of 1751, from the Metropolitan's own collection. Venus is seated on an elaborately carved chaise, placed on a sort of dais, with an ornamental perfume burner at her feet and a park behind her, visible through drawn drapes of heavy green taffeta. Her body forms a gentle spiral, and her hair is being done by a cupid. Another cupid is fishing a necklace of pearls from a silver tray in the shape of a scallop shell, and a third cherubic attendant is engaged with a ribbon of blue silk. Venus is nude, but a throw of striped silk conceals her pubis. She is fantasizing, distractedly holding a dove, while another dove flutters at her feet. She is doubtless being prepared for her lover, but Venus is in no hurry, and one senses the preparation may be more enjoyable than the encounter. Everything in the painting is of something soft or smooth to the touch: velvet, silk, damask, satin, polished wood, the feathers of doves, the plump bodies of cherubic attendants, and of course Venus's own young flesh and delicate hair. The trees are like green clouds or moss. It is a

sensuous atmosphere, but an oddly chaste one, and it seems to me in every respect a woman's world. Venus luxuriates as women tell me they luxuriate in beauty salons. A militant feminist I know used to withdraw to just such a space as Venus's of restorative indulgence. The painting was commissioned by Mme. de Pompadour, and was installed in the *salle de bain* of the retreat she contrived for her royal lover. There, like Venus, Mme. de Pompadour made herself desirable. It is not clear that she, any more than Venus, was eager for sex. History records a curious diet with which she tried to cure herself of a certain frigidity the king found in her.

The paint participates in the sensuousness it depicts, which must be why he was such a favorite, Boucher, with women who withdrew to caressing private precincts. It is sometimes held against Boucher that he is absent from his work, save on its surface, where his marvelous skill and power are palpable. And sometimes, just because of what must seem an obsession with soft feminine nudity, he has been charged with a certain licentiousness, for which there is no evidence outside the pictures themselves. My view is that what made him so successful was his uncanny capacity to represent a world from within feminine consciousness, looking, as it were, outward onto a reality of softnesses. He showed women as they liked to feel themselves to be: tender, warm, desirable, in an atmosphere of smooth and fluttering things and in a world without threats. Though it has been said that Boucher had difficulty with masculine physiognomy, I believe he rendered it as he did because that is how his patronesses wanted men to be—youthful, almost girlish, playmates in effect, like the lambs. They might like to hold these tender males in their laps, as in *Amyntas Reviving in the Arms of Sylvia.* Amyntas is safely incapacitated, and so can be held without danger against Sylvia's perfect, unthreatened breasts.

Because most of the masculine presences are maimed or simply harmless, I find confirmation that these are feminine fantasies; even when there is some truly powerful masculine presence, it is shown under a feminine spell. Consider Boucher's version of *The Rape of Europa,* shown in the Salon of 1747. He chose that moment of the story when the great bull feigns an incredible docility. Europa has allowed him to lick her hand, and has fed him herbs and blossoms. Now the bull is kneeling as Europa sits sidesaddle on a damask throw a cupid is tucking under her soft flanks. A handmaiden is bringing the necessary flowers, and Europa holds a blue ribbon loosely in one hand. The ribbon is tied to the bull's horn as though that fragile rein would suffice to tether all the dark muscu-

larity of this paradigmatically masculine beast. Europa looks complacent, and her silken garment is thrown open to display the triumphant emblems of her femininity. Of course, the viewers of this painting knew that betrayal was at hand ("Men!"); that in a moment Europa would grip in panic those terrible horns in order not to drown in the waves as Jove bore her to her ravishment in Crete. The Europa we know in Western art is usually shown then, helpless and lost. Boucher instead shows her at a moment when it seems just possible that some mysterious feminine strength can subdue even this most powerful of brutes with nothing more than a fragile strap from one of her garments.

To confront true female power, you must pause before the great portrait of Mme. de Pompadour herself. It is a large painting, and at eye level one is looking into the deep hem of her amazing skirt, literally at her feet, next to her spaniel. The skirt is a cascade of scallops and flounces, in green silk embellished with nearly a hundred rosebuds. It is like a vast meadow, and as one follows its curves upward, one traverses an elaborate escarpment of ribbons to reach the glacial whiteness of her décolletage. Above that, set off by a circlet of flowers, is her clever head, gazing pensively out the window. Behind her is a mirror in which, by showing the nape of her neck, Boucher solves a problem that tormented Giacometti two centuries later. "When I see the face," Giacometti wrote, "I don't see the nape of the neck . . . and when I see the nape of the neck I forget the face." The mirror also shows a heavy bookcase, evidence of Mme. de Pompadour's intellect and literacy. She has let fall a book, and is surrounded by manuscripts and volumes of every sort, pieces of music, scrolls and, of course, the flowers that are the substance of her universe. Historically, the picture is poignant in a way neither she nor Boucher could have known. The books Mme. de Pompadour is reading must be by her favorite authors, Voltaire, Montesquieu and the Encyclopedists, whose ideas, at last, were to blow her world sky-high. Diderot, indeed, would become Boucher's most severe critic: he would condemn him for precisely the virtues he celebrates in this painting. I am moved by the historical vulnerability to which Mme. de Pompadour is blind, and I did not at all mind being, for a moment, at the feet of this remarkable woman. France, after all, was truly at her feet, and it is only right that the viewer of her portrait should be as well. The visions surrounding her, through which Boucher achieved his greatness, are her visions. Her power is attested by the fact that her fantasies represent her age, so far as we can know it from its art.

· 33 ·

RICHARD SERRA

THE DOMINATING LINK OF HISTORICAL EXPLANATION THAT RECOMMENDS itself to art historians is that of influence. No doubt this is so because influence defines that posture of expert appreciation known as connoisseurship, which consists in seeing in the works of X the signs and traces of Y, naturally invisible to the layman. But the dense network of historical causation has many subterranean passageways, and The Museum of Modern Art's overlapping exhibitions of Mies Van Der Rohe (until April 15) and Richard Serra (until May 13) provide a good example of a historical link invisible to connoisseurship. It connects the two artists through the materials of their respective projects, and the differential esthetics of oxidation.

Cor Ten steel has become an emblem of Serra's sculptural persona; it is, for example, what his most notorious work, *Tilted Arc,* is made of. As a so-called weathering steel, Cor Ten has become the standard material for a certain genre of outdoor sculpture, for reasons the moody commuter might appreciate as he or she inches past the parking garage at La Guardia Airport and casts a grateful eye on the rich, chocolately coloration of its exposed posts and girders. Cor Ten was designed to weather graciously, to use the processes of rust against itself, transforming that sign of decay and neglect into something rich and strange instead. It needs no painting, is self-maintaining, and the rate at which it oxidizes is fractionally slower than that of ordinary steel, growing more beautiful as it does so. It is a triumph of metallurgy, and it was the steel industry's brilliant response to the exhorbitant cost of bronze cladding, of which Mies made such extravagant use in the Seagrams Building. That breathless masterpiece, which was to define urban architecture through the succeeding decades, was also far too expensive to emulate. The trick

ARTHUR C. DANTO

was to find a material that would, at a distance, look just like the bronze of the Seagrams Building but be within the budget of your ordinary steel-and-glass box in Hamtramck or Des Moines. And Cor Ten steel was the elegant answer to that esthetic-economic prayer.

So Mies and Serra, museum mates for the moment, are dialectically connected through the material substance in which their work was respectively realized. On the other hand, it is interesting to ponder differences in their response to Cor Ten's singularities. Mies had a weakness for austere opulence, and a philosophy of material integrity. My one encounter with him was at the Farnsworth House (1945), which a pal of mine, a student of Mies's, drove me out to see. I was curious that he had used travertine marble for the floor of that glass-and-steel country retreat which Doctor Farnsworth, to her sorrow, had commissioned him to design. Well, I recall Mies saying, what is it but four walls and a roof? It's got to have *something* extra. A man who insists on travertine marble for a weekend house is unlikely to consider using rusted steel because it is cheaper than bronze cladding: it would be like suggesting artificial marbleizing, or formica. There is a certain aggressiveness to Serra's sculptural approach that suggests to me that Cor Ten's propensity to bronzify in six or seven years would not be a recommendation. Nor do I recall as an argument in the controversy over *Tilted Arc* that at some point in its eternal tenure at Federal Plaza, it would be transfigured by the elements into a thing of beauty. The usual thought was that with time and education we would come to appreciate *Tilted Arc* more and more for its uncompromising esthetic, not that it would meet us halfway by turning into something gratifying to an esthetic it set out to challenge.

Ashes, dust, moth and rust have, since biblical times, been natural symbols of the decay of earthly things, and rust most particularly afflicts those items of daily life that embody our deepest senses of adequacy and prosperity. The rusted horseshoe, like the rusting truck chassis, connotes immobility and breakdown and loss, the rusting saw or rusted plough communicates disuse and abandonment. It is difficult to abstract from so iconographically reduced an object as *Tilted Arc* its most conspicuous material property and treat its rustedness as invisible. And because rust carries so negative a symbolic charge in our culture, that, in conjunction with the ordinarily positive symbolic charge still carried by the concept of high art, raised the esthetic offensiveness of *Tilted Arc* to a higher power. It was rust that counted against Serra's *Terminal,* a work erected in Bochum, West Germany, in the heart of the country's steel-producing

area, and also composed of Cor Ten. *Terminal* "is already rusted and disgusting in appearance," said those who made it an issue in the political campaign of 1979. Would an object of comparable size but made of travertine, buttery and soft and palpably luxurious, have elicited such a violent response? Perceived as adding to the injuries of inconvenience the symbolic insult of rust, *Tilted Arc* had to arouse a certain pitched antagonism. On one of my visits to its site, blackened snow lay in awful piles against its scaling face. When first exposed, there is little to distinguish Cor Ten from ordinary industrial steel. It may not have mattered much at the La Guardia parking facility, where the assumption was that sooner or later they would get round to painting it, thus giving the metal the time necessary to acquire its marvelous patina. But it mattered at Federal Plaza, when that vast ferrous curve appeared from an alien cultural space to agonize its unhappy crossers.

The final switchback in this ironic chronical is this: in the chaste white galleries of MoMA, the cultural space in which they belong as art, the rusted sculptures look as beautiful as they were intended to look outdoors but seldom do, I think, because of their proximity to the unavoidable flotsam of urban life with which rust symbolically belongs. I was struck by the subtle shifts or gradations of metallic texture and coloration, which reflected here red, there blue, or displayed a shower of golden spots. Wandering rivers of black or deep purple articulated the richly varied tonalities of the rusted steel, in which one could mark out the rude numbers that must have served some identifying function in the steelyard, and had been kept. One scarcely saw it as rust, and in a curious way the surfaces seemed as oddly elegant as those of travertine marble; one might even suppose that Mies, a model of whose Farnsworth House may be admired on the subjacent level of the museum, could have been educated to appreciate Cor Ten in the intended state of its metamorphosis. Whether their esthetic appeal, on the other hand, is at all integral to Serra's pieces—or instead a distraction from the demanded response—can hardly be discussed in isolation from his sculptural intentions, to which I had better turn. In earlier discussions of *Tilted Arc*, I have expressed considerable regard for its sculptural qualities while voicing severe reservations about its suitability to public space. Now we have an opportunity to come to terms with Serra's pieces in the sheltering atmosphere of a museum show, in their own space, as it were, rather than as claimants to rights in public space because of their being art.

My immediate thought is that visual pleasure is somehow too disin-

carnate to be greatly relevant to the meaning of the eleven works that make up this show. And in a way, the arrest by beauty must, if I understand these works at all, constitute a subversion of their intention. One used to speak of walking around a piece of sculpture, viewing it from different angles and under different aspects. But that implies that one's relationship to sculpture remains essentially visual. As such, the specific material properties of sculpture, as of painting, should matter little; recognizing them is but a concession to the material conditions of art itself, which properly refers us to a realm of imagination: we are not meant to see the bronze or marble any more than to see the pigment of the Sabine women of Poussin, and ancient theories even held that an actual personage was imprisoned in an alien substance, which Pygmalion might kiss away, restoring her to her displaced reality.

I suppose a fair amount of modern art can be understood as a rematerialization of art, with a certain kind of abstraction as a means to that. With Serra, we are conscious, always, of material as material, so rust is a declaration of steel as steel. But this recognition, while central to our experience, remains too distant and cognitive to connect us vitally to the sculpture. Knowing it to be made of metal—steel or lead—or that it has this shape or that is once more too disincarnate a stance. My sense is that the sculpture must seek to incarnate the viewer, to make the viewer conscious of his or her own embodiment as flesh, so that one's encounter with it, as in sex or combat, is as body to body.

There is a transition, magnificently described by Sartre and central to his philosophy, where consciousness, up to then simply flooded by the objects of which it is aware but never a part, becomes aware of itself as embodied, as an object in its own right and part of the world rather than logically outside it. In a sense, that is what Serra undertakes to achieve in his characteristic works, not so much as an end, but as a means of releasing latent structures and forces that will be accessible only to the spectator who has been transformed into a participant.

One way to achieve this, and a way that is congruent with the personal style of this artist, is to make the visitor simultaneously aware of a danger in the work and the vulnerability of his or her own body. The work must be perceived not simply as heavy but as *crushingly* heavy. It is striking, for example, that several of the pieces are roped off (as was Serra's piece in the recent Guggenheim exhibition), not to protect the work, which is patently immune to the sprays and slashes of the vandal, but to protect the visitor. These pieces are typically composed of lead or steel

plates propped against one another, or balanced on one another's edges and buttressed by a wall. Heaviness acts against heaviness to create a certain lightness—much in the manner, according to famous philosophical example, that by pressing downward the keystone stays up and brings about the verticality it struggles against. At any moment, however, like a house of cards (which is the subtitle of one of the roped off pieces), the sculpture could come crashing to the floor, flattening the viewer who may have taken the imperatives of participation too literally. Push can quickly come to shove in Serra's work, and the ropes do not so much thrust us back into our ocular identity as remind us of the fragility of bone and flesh for which the precariousness of balanced and propped plates is at once a metaphor and a threat.

The modality of direct or implied physical interaction runs from the ponderously playful to the menacingly confrontational. An example of the first is a near cousin to *Tilted Arc,* a curved wall ten feet high, which runs from one corner to its diagonally opposed corner of a room, thus transforming the work by architectural circumstance into an obstacle. One can circumnavigate *Tilted Arc* or even, if athletic enough and equipped with rubber soles and a good start, climb over it, but *Two Corner Curve* is too high to scale (if the guards would allow so enthusiastic a participation), and, revealing its space as usable by refusing to allow us to use it, forms a steel grin from ear to ear at our frustrations. I headed toward the far corner, only to realize that I would have to see the other side, if indeed it were visible, through some intervening exhibits. One of these, *Delineator II* (1974–86), consists of two plates of one-inch steel, each ten feet by twenty feet, which form a cross—but the top plate is attached to the ceiling while the bottom plate is on the floor. Of *Delineator,* Serra wrote:

> The juxtaposition of the steel plates forming its open cross generates a volume of space which has an inside and an outside, openings and directions, aboves, belows, rights, lefts—coordinates to your body that you understand when you walk through it . . . you sense a volume of verticality lifting up from the floor to ceiling you become part of.

Everyone I saw walked around it, chiefly in order *not* to become part of it. The spontaneous response was to skirt the damoclean plate, hugging the walls with nervous glances upward: one senses a volume of verticality

crushing downward, as in a press. One gets a wonderful sense of the reciprocal geometry of straight and curved, the material polarities of wood and steel, when one sticks one's head through the lethal space of the guillotine, but I know relatively few for whom even the remote risk is worth it. It is with a marked sense of relief that one enters the other half of the room. *Two Corner Curve,* like an iron conquistador, has claimed its own in the name of art.

Serra's work is at the intersection of traditional sculpture and what I have elsewhere designated the art of disturbation. Disturbational art is not simply disturbing, like the images of Leon Golub or, latterly, Eric Fischl—or like the skinning alive of Marsyas in the Titian masterpiece which sets so many of us shivering these days. In all these cases the fact that the work is art interposes itself between us and the disturbing reality. In disturbational art, a work's being art is rather an impediment that the artist seeks to dissolve or remove, bringing the disturbing realities into our own lives, making its implied dangers real. Happenings were mildly disturbational in this sense, seeking to invoke a dramatic alteration of reality. And disturbation has roots that go back to the very beginnings of art, where the artist aspired to a kind of magic, in which, for example, a god might descend into what began as a mere theatrical presentation. Serra is set apart from the sculptural genre to which he has otherwise contributed so powerfully through the ingredient dangers, through the jostlings and implied aggressiveness, of his difficult pieces, even though his own remarks on participation make it sound as if little more were involved than an enhanced appreciation of space and matter. He is un-likely to weather gracefully, like Cor Ten steel, and it would be a shame if he did. There is a sector of artistic experience that he dominates and keeps from becoming frivolous; he is engaged in returning us to artistic forces the centuries have succeeded in repressing.

I recommend the catalogue highly. It contains essays by Rosalind Krauss and Douglas Crimp, which harmonize with each other as little as either harmonizes with this essay. Krauss's is phenomenological; Crimp's is Marxist. That three such contrary interpretations can be given of a single sculptor is a measure of his depth and at the same time a testimony to the nature and limits of art criticism itself.

· 34 ·

DÜRER AND THE ART OF NUREMBERG

THE MUSEUM OF FINE ARTS AS WE KNOW IT TODAY HAS TWO ARCHITECTURAL roots in the princely habitations of the Renaissance, the *museo* and the *galleria*. The *museo* was a space of wonders—what the Germans called a *Wunderkammer*—which housed objects rare and magical. There would be works of great virtuosity exercised on materials of corresponding preciousness, as well as natural objects believed to possess benign or dangerous powers: narwhal or walrus tusks, rhinoceros horns, crystals, nautilus shells and, oddly enough, coconuts. There might be stuffed birds and animals from exotic climates and flamboyant minerals, as well as figurines, sometimes sacred, and small paintings, often of family members. The paintings would be defined by that mysterious luminosity for which jewels or gold is cherished: things with their own light. Outside, in the *galleria*, would be tableaux, hangings and pieces of statuary too large to be picked up and studied.

There is a natural difference in scale between *museo* and *galleria* objects, and there is also an extreme difference between the experience of being closeted in a dark space with things rare and potent and that of promenading past works whose intensity is dissipated by the natural outdoor light. *Museo* objects are to be pored over and touched, *galleria* objects are to be paused before and looked at. That paintings were to be enclosed with things of secret potency and magic usage connects them with some very ancient beliefs about the power of images themselves, which capture and hold a reality as the jewel captures and holds its flame, rather than merely replicating it. The works ranged along the *galleria* walls doubtless derive their aura from kinship with the wonderworks of the *museo*, but the *galleria* is an open space, with an esthetics at odds with the protocol of the *museo*, and belongs to the stroller rather than the

sorcerer. It is a place of pleasure and distraction, and it is the esthetics of the *galleria* that defines our attitude toward art today, even if the concept of art retains components that are intelligible only given assumptions that apply to the *museo*.

The *galleria* is said to be derived from the ideas of the Italian architect Sebastiano Serlio, in the early sixteenth century. One of the earliest of the galleries is the Uffizi (from about 1580), and though it came to be the architectural format for museum display down to our time—The Guggenheim Museum is a gallery coiled around its own center—the protocols of the gallery cannot be said to have penetrated very deeply into the consciousness of Northern Europe during its brief Renaissance, and its art belongs primarily in the *museo.* But since we have adopted the *galleria* stance in looking at art, there is an initial obstacle to appreciating the remarkable works exhibited until June 22 in the Lehman Wing of the Metropolitan Museum, of Gothic and Renaissance Art in Nuremberg: 1300–1550. These extraordinary and intricate objects are Gothic in spirit and intention, even if the later ones are transradiated by certain Renaissance ideas brought back by Albrecht Dürer from his excursions to Venice. Dürer's Gothicism was deep and ineradicable, despite his humanistic ambitions, and since it was disseminated back into Italy through his engravings and woodcuts, it can be argued that Dürer succeeded in swamping the Renaissance by giving rise to Mannerism. Mannerism appropriated the extravagance of Gothic invention, which is at home in the *museo* in the form of goldsmiths' fantasies, and gave it a place in the *galleria,* where it seems grotesque and out of place. In any case, if you are to get much out of this singular exhibition, you must leave your *galleria* attitudes behind and confront what you see with those of the *Wunderkammer*—as objects animated by mystic forces and arcane powers whose makers were magicians and wonderworkers.

Consider, for example, the *Holzschuher Goblet*, done before 1540 by Peter Flötner, a man of demonic invention. It is a richly carved coconut mounted in an elaborate gilded silver framework, and one must reflect on how much modern knowledge and modern attitude must be erased in order to contemplate a coconut as something marvelous and unaccountable, mysteriously present in a world that has nothing to compare with it, and doubtless possessed of unimagined virtues. Flötner has given it a heavily twisted, vinelike stem, a speculation on what a coconut plant would look like in order to be consistent with its extraordinary fruit: it would have been disillusioning to learn that coconuts grow in clustered

THE STATE OF THE ART

profusion and that their greatest value is as a source of cooking fat. Part of the power ascribed to the fruit may be inferred from the riotous and licentious imagery with which Flötner has brightened the goblet. The base is a kind of mound, where two goats are fornicating. On the other side, a satyr is snoozing off the effect of wine, as implied by the flagons and the basket of exquisitely wrought grapes elsewhere on the base. He has a terrific golden erection, which is being grasped by a smiling nymph "taking things in her own hands" *(in die Hand nehmen)* which may be construed as a witty piece of advice to the bride whose husband may have drunk too heartily from the *Holzschuher Goblet* at the wedding feast. Behind the satyr is a woman pretending to be modest but peering over her veil at the goats, who show the way the little naked boy, holding the family shield, is to be brought into the world. It is a very Dionysian scene there on the base, and we are not surprised to see a bloated Bacchus being wheeled by celebrants, carved onto the shell, or a gilt satyr pouring wine down the gullet of a tubby drunkard, the two forming the handle of the lid. The classical references to nymphs and satyrs are clearly of Renaissance origin. The instructive catalogue informs us that the drunk Silenus comes from an engraving by Andrea Mantegna, which Dürer copied and Flötner got from Dürer. Still, it is a goblet. It connotes potions and philters. The coconut was said to detect poison, the sixteenth century's agent of terrorism. The humanistic iconography is fused with Gothic superstition and Nuremberg practicality—after all, you were intended to drink out of it, on appropriate occasions. Its habitat is the treasure chamber and then the bridal chamber. It loses half its being in the gallery.

The *Holzschuher Goblet* belongs in the company of the *Schlüsselfelder Ship,* an amazement in precious metals, from about 1503. Seventy-four tiny personages throng the deck and rigging of a galleon which resembles what Auden describes, in *Musée des Beaux Arts,* as an "expensive delicate ship." Like the base of the goblet, the deck of the ship holds the whole of life: the tiny figures eat and drink, play cards, make love, meditate and read, are entertained by a fool, a pair of pipers and a drummer, sustained by a crew of sailors and protected by a bristling cannonry. This whole society of voyagers may be lifted, deck, mast and rigging along with them, so the commodious hull can be filled with wine, which will then be poured through the dragon serving as a figurehead, by someone who grasps the two-tailed mermaid holding the ship aloft. So the *Schlüsselfelder Ship,* displayed together with its extravagant carrying case, belongs with the aquamaniles, which were drinking vessels in the form of unicorns or

griffins, mastiffs or lions, and leaves us with the question of what these fierce shapes transmitted to the liquor poured from their muzzles? What access do we have to the imagination that fashioned a ship that houses its own wine-dark sea?

The *Schlüsselfelder Ship* is somewhat shakily ascribed to Albrecht Dürer the Elder, a goldsmith, Dürer's father. Dürer's father-in-law was a fabricator of ornamental table fountains that must have made perpetual motion seem like a mechanical possibility. There is here a drawing for a double goblet by Dürer himself and another of a saddle ornament dense with monsters and twined foliage. There is an astonishing goblet by Ludwig Krug which "demonstrates what direction Dürer's efforts as a goldsmith would have taken had he not become a painter, instead." Whatever he learned in Italy, however much humanistic culture he took aboard, the work of Dürer, which crowns this exhibition and makes visiting it imperative, grows almost organically out of the flagons and ewers, the masqueraded utensils, the complex metaphoric references of fountains and goblets, of steel gauntlets and breastplates bearing the images of madonnas, that defined his world as an artist and thinker. It was almost as though the decision as to which Nuremberg metier to go into was an economic choice, but that the same artistic possibilities were available in each, and we must look at the goldsmith's work as if it were a painting or at a painting as though it were a table ornament, and at both as though they were esoteric texts. Of the engravings of Hogarth, Charles Lamb wrote (getting the esthetics of *galleria* and *museo* precisely right) "Other pictures we look at—his we read." And if we are incompetent to read the goblets and inkpots, the ewers and spouting manikins, it is not clear how much we are getting out of the engravings. Dürer's personality is a Gothic text: What are we to make of a man who portrays himself with his sidekick, Willibald Pirckheimer, strolling, as if through a gallery, in the midst of ten thousand martyrs being graphically slaughtered? His life has the mystery of his woodcuts.

Spend some time studying the engraving *Melencolia I* of 1514, a work which "amazed all who saw it," according to Vasari. The title is incised in a scroll which forms the underside of a bat's wing. Why the "I" in the title? What relationship between words and wings is implied? Nothing can be taken for granted in this work filled with polyhedrons, with rude instruments of carpentry and refined tools of mensuration—an hourglass, a balance, a bell, a matrix of numbers—and also an aged dog with crumpled ears, a scribbling *putto*, all surrounding a winged woman hold-

ing a compass, her fist supporting a darkly scowling head wearing a garland of oak leaves. There is a notation Dürer made that "the key signifies power, the purse riches." Keys and purse would be standard items in *Hausfrau* costumery, so if they carry allegorical meaning, what single innocent thing can there be in a work which already raises the question of the connection between melancholy and power? Panofsky, who spent a lifetime pondering Dürer, describes this work as "a spiritual self-portrait," which, if true, confirms my thought that there is a parity between the mind and work of this dark artist.

There is a ladder leading out of *Melencolia I* in one direction, a rope leading out of it in another. Perhaps the implication is that we must go outside this difficult picture to get inside it. It is one of three astonishing engravings, the other two being *Knight, Death, and Devil* of the previous year, and *Saint Jerome in His Study* of the same year. Each has an hourglass, each shows a human skull and each has a dog. Is the absence of a skull from *Melencolia I* a deep fact, supposing the three are to be read together as a tripartite text on time, death and truth? In a sense, this is a scholar's show. But it is also a scholar's art, as though the scholar in the *Wunderkammer,* pondering objects whose secrets were to be found in the flickering lights, were the primary audience and exhibited the paradigm mentality these works call for. Each of the works in the show sets up intense interpretative controversy. My sense is that the controversy is what the work is about, that the difficulties of interpretation define the proper experience, so that if you miss the puzzlement, you miss the work. As in the *museo,* these are objects meant to energize the mind to contemplation rather than to please and flatter the eye.

I am struck that the high point of this exhibition, the three transcendent engravings by Dürer, should have been prints, hence works of mechanical reproduction, to use Walter Benjamin's famous phrase. I do not know who bought these engravings, but it speaks for the breadth of learning in Dürer's clientele that it should have been eager for work which condensed systems of recondite belief and required such concentrated analysis. Dürer owed his international fame to printmaking—it is primarily as a printmaker that he is entered in Vasari's *Lives*—and in large measure it was to his prints that he owed his prosperity. He complained about painting from the financial point of view and might have complained about it from a metaphysical point of view as well, for he could never have had the speculative freedom in painting that he could have as a matter of course in his prints. Paintings were commissioned and so not

done on speculation, as an engraving might be, and if this is so, such works as *Melencolia I* or *Saint Jerome in His Study* reveal what the freed mind would do in the sixteenth century, and reveal as well the restraints otherwise invisible in the paintings.

Do not expect to make a lot of headway with this show, in which each object is so impacted with meaning. The catalogue is indispensable: each entry is illuminating in an art world where we need all the help we can get. And be sure to spend some time with another legendary master, the great limewood sculptor Veit Stoss. Throughout Stoss's work, the draperies are whipped into violent folds by a wind that must, as in the Gospel of Saint John, be a metaphor for spirit, for the violent energy of things unseen. Stoss's figures are caught up in the crosswinds of spiritual intervention, their wooden skirts fly and flutter like souls desperate to flee the body, and only the martyr is at peace. Saint Vitus sits calmly in his cauldron, his hands clasped in prayer, his mop of perfectly arrayed curls matching in form the instrument of his martyrdom. He is like a double goblet.

· 35 ·

DIEGO RIVERA: A RETROSPECTIVE

THE EXPRESSION ROUTINELY USED THESE DAYS TO DESIGNATE PUBLIC ART—
"art in public spaces"—implies that there is nothing especially public
about the art in question, apart from the external circumstance of its
placement. So, on occasion, a given bit of statuary, whose natural habitat
is the museum, is sent into the field to elevate and enhance public con-
sciousness. But when public consciousness proves inhospitable to the
esthetic missionary, it is rotated back to the museum, where it can be
appreciated for the very values and virtues the graceless public re-
sponded to with hostility. The esthetician Dale Jameson once described
to me the peregrinations of a Red Grooms piece. Initially commissioned
for a condominium complex in Denver, Colorado, where an Original
Work of Art would be among the expected luxuries, together with the
Olympic-size swimming pool, the squash court, the sauna and the jogging
path, what Grooms fabricated was something finally too rowdy for yuppie
taste—which really wants something reassuringly portentous and decora-
tively bland, like the lobby embellishments in Gateway Plaza. Thinking
it was, after all, the Far West, he sent a cowboy and Indian locked in
combat, the air between them dense with funky arrows and comical bul-
lets. No doubt the possibility of tax write-offs recommended transferring
the work to the University of Denver, where one would have thought it
exactly suited to undergraduate sensibilities. Instead it offended, since it
was perceived as disparaging to Native Americans. But matters of offen-
siveness simply do not arise in the museum, where being a work of art
neutralizes any moral attributes a piece gathers in its public transits, and
one can imagine mommies and daddies hushing their offsprings' inap-
propriate exclamations before Grooms's work, which, in The Denver Art

Museum, will be vested with the sacredness that is its ontological due—beyond good and evil.

It is almost certainly because the artwork is supposed to carry its sacral immunities into public space that murmurs of "Philistine" are heard when the public insists that other priorities trump those of artistic edification. So it is not surprising that when public art meant something profoundly more political than it does now—when art was in public spaces not to transform the public into esthetes but to express and validate its social aspirations—the aura of sacrilege attached to treating art badly could be cleverly utilized by artistic guerrillas like Diego Rivera. It is widely appreciated that one of the most powerful weapons the guerrilla possesses is the moral self-image of the immeasurably more powerful enemy. The terrorist would be powerless, for instance, if the attacked nation were indifferent to the fate of hostages, or if the possibility of execution were regarded as a moral opportunity by travelers who ventured abroad in the hope of being martyrized. Hunger strikes would be counterproductive if the public found starvation a form of entertainment and giggled at emaciation. Rivera imagined that no one, least of all a Rockefeller, would treat an artwork with anything but devout restraint and used this belief as a shield to carry the class struggle behind the lines, as it were, into the RCA building at Rockefeller Center. In a mural that bore a title that defines the period in which it was undertaken—*Man at the Crossroads Looking with Hope and High Vision to the Choosing of a New and Better Future*—Rivera placed an unmistakable portrait of Lenin to Man's left.

Now, Rivera put the portraits of actual persons everywhere in his murals—Edsel Ford, Charlie Chaplin, Cantinflas, Jean Harlow, his wife Frida Kahlo and often himself—but this was always done in the spirit of metaphor: Ford as Donor, Cantinflas as Saint, Rivera as Worker, Harlow as Ministering Angel, Kahlo as Victory or the Spirit of Fertility. But Lenin's mug, like the American flag, is too potent an image to be transfigured, or is already so powerful a metaphoric presence that any further effort at metaphorization must fail. That the same universally recognized features that dominated Red Square or May Day demonstrations the world round could be rendered innocuous when placed in a work of art, over the bank of elevators in a building explicitly intended to stimulate the recovery of capitalism—"because it was art!"—was hardly something even an art lover like Nelson Rockefeller would have been prepared to accept. Just as there are certain words whose very appearance in a text

transforms it into obscenity, there are images that eat through art and turn it into weaponry. It was exactly such images that public artists of Rivera's period sought, and in ordering that Rivera's mural be chiseled off the wall, Rockefeller demonstrated that he took the art seriously, and on its own terms, and treated it with the respect with which a soldier treats another soldier when he shoots him through the head, despite the camouflage of the priest's costume. *À la guerre comme à la guerre!*

With true fresco, which Rivera revived and used brilliantly, there is no alternative to the chisel. Fresco is a watercolor medium and depends for its effect on the transparency of washes. As with any watercolor, overpainting renders opaque and dead those qualities for which fresco is precisely sought. Beyond that there are the chemical facts that make fresco so natural a choice for an art intended to endure. Washed onto damp plaster, pigment is absorbed by capillary action and a film of calcium hydroxide is formed which interacts with air to become calcium carbonate. Impervious to water, as indifferent to light as tiles, physically one with its surface, the fresco lasts as long as the wall, and under ideal circumstances should retain its freshness forever. (Of course, smoke from candles and oil lamps, the depredations of graffitists and hooligans, may interpose a screen of decay between the viewer and the fresco.) Rivera could have chiseled out Lenin's portrait. He did not hesitate to alter his Mexican murals when it suited him, for example, removing the phrase "God does not exist" from his mural at the Hotel de Prado some months before his death on November 24, 1957. Nor do I know what reasons he gave Rockefeller for not doing so—after all, the portrait might have saved the building when revolutionary hordes swept up Sixth Avenue, intent on hanging capitalists from Paul Manship's Prometheus Fountain by the skating rink. But he preferred to leave the excision to his antagonist, allowing him to be the barbarian—and Rockefeller responded with characteristic overkill, chipping off the whole thing, 100 square meters in all.

For his next New York commission, Rivera prudently used the portable mural format—plaster over cement in steel frames—which he had invented in response to a commission from The Museum of Modern Art, for his exhibition in 1931. And the portable murals—from MoMA and from The New Workers School on East 14th Street, which he painted in 1933, after Rockefeller discharged him—found their way into private collections and onto museum walls. These murals are somewhat inconsistent with the intentions of a public art advanced by the great revolutionary Mexican muralist movement Rivera joined in 1922, and which he

ARTHUR C. DANTO

dominated to its end. The portable mural is, in fact, simply an unwieldy easel painting, and it was precisely the easel painting that was anathema to the Mexican muralists: "We repudiate," their manifesto had proclaimed, "the so-called easel painting and all the art of ultraintellectual circles, because it is aristocratic and we glorify the expression of Monumental Art because it is a public possession."

In subscribing to this credo at almost the exact middle of the road of his life, Rivera in effect repudiated his career up to that point, for his art until then had been precisely ultraintellectual and aristocratic. In the beautifully installed centennial exhibition of his work at The Philadelphia Museum of Art, one can trace his wandering through the wilderness of Cubist experimentation. Had he not been summoned back to Mexico, after his protracted *Wanderjähre* in Europe, to participate in the great program of public art sponsored by the visionary minister of culture José Vasconcelos, Rivera would have had a place, but perhaps not an especially important place, in the history of twentieth-century art—a B to B-plus Cubist, of about the rank of De la Fresnaye. Perhaps by 1922 he was already looking for a way to stop being a Cubist, and muralism gave him that. Rivera's place in twentieth-century art is still a problem, but that is because it is difficult for us to come to terms with the mission of public art to which he so colossally and ambiguously contributed. The history of world art since 1945 has been pretty much the history of American art, centered in New York, where the great New York School shifted the direction of artistic expression decisively away from public concerns. The New York painters were absorbed, instead, with abstract questions of the nature of art and concrete questions of personal expression, and at least one major critic, Harold Rosenberg, connected these two preoccupations in a single powerful theory: that painting is the act of painting and that action is personal expression.

But the personal is the political, as feminists often say, and seeing the public works of Rivera through the lens of a revolution in the concept of art to which he did not contribute, makes me appreciate the degree to which the personal preoccupations of the New York painters must have been a form of political reaction against what one might term *public* politics—the politics which, whether in Mexico or Germany or Italy, or in the Soviet Union and among its satellites, found its artistic expression in heavily muscled members of the heroicized class—or race—resisting some suitably allegorized embodiment of evil. (Or in depicting selectively swollen women sacrificing the emblemata of their fertility to the father-

land, the master race, the working class, the agency of the bright future of an exalted humanity.) These severe groupings—the worker, the soldier, the athlete, the mother—look more and more like moral cartoons, and it is easy to sympathize with those who responded at last to those forms and that function of public political art with a kind of nausea and turned away from public celebration. And since our attitude toward art today, though its roots stretch back to ancient formulations, was formed in that period when American artists, and especially New York artists, took up the philosophical tasks that have defined the modern movement since its inception, it is hardly a matter for wonder that when we think of public art, we think of art in public spaces, where the intended effect is the transformation of the public into an extended museum audience, with the stance and values appropriate to that order of appreciation.

But nothing of the sort was intended by the public artists of the 1920s and 1930s, who had turned their backs on "ultraintellectual" esthetics and sought instead to give artistic embodiment to the general will. As an experiment, spend a while hanging out in the Equitable Building's atrium lobby, where Thomas Hart Benton's mural cycle, *America Today,* is flattened out against the marble walls like a zebra hide fresh from the taxidermist—and eavesdrop on the comments. The sophisticated visitors invariably talk about the Art Deco moldings Benton used to solve the problem of partitioning spaces. The less sophisticated comment on the dated costumes and quaint machinery. The least sophisticated speculate on whether someone has his hand up the girl's skirt. But Benton had undertaken, in *America Today,* to magically connect the viewer with the continent, which, from the board room of The New School for Social Research where it was originally installed, opened up in every direction, so that sitting in that room one was *part* of America rather than the viewer of a series of paintings with some modern touches and *style-trente* figurations. Benton's work was not generated by the principles of museum installation but was a stimulant to patriotic identification. The Equitable lobby is a museum annex (it contains two galleries on furlough from the Whitney), in which Benton's work is reduced to an esthetic artifact, a disjunction of tableaux which we address from without rather than participate in from within—a trophy brought back to symbolize the cultural goodness of the corporation.

Although I cannot speculate at length here, the corporation's impulse to proclaim its cultural goodness through the acquisition and public display of art cannot be terribly remote from the Mexican government's

impulse to proclaim the goodness of its revolutionary aims through the commissioning of art. One must suppose that it was to have been a matter of spontaneous popular pride that the Mexican people could behold, on vast walls and in open spaces, the epic of themselves in an art that belonged to them—that the prerogatives of wealth and cultivation that art has always connoted were being exercised by a people through its artists. What is something of a miracle is that there should have been great artists capable of responding to the imperatives of a public art so conceived. The huge and powerful images, which went up on wall after wall, in public building after public building, were meant to celebrate the donors who were also its subjects, to teach them their past and paint their future. The peon could point to those paintings and say that he was them. Of course such an art had to be recognizable and idealized, and though Rivera drew upon what he had learned in France and Spain and Italy in order to organize his immense panoramas, it was a condition of their being public art that they be directly accessible at some basic level to the artistically illiterate and the historically ignorant.

In truth, Rivera's mural programs are iconographically complex. The Philadelphia Museum's show originated at The Detroit Institute of Arts, which houses Rivera's masterpiece, the stupendous *Detroit Industry,* which Rivera painted in the Garden Court of the museum. I was taken there as a child, my mother feeling it important that I see the great master at work, and I cannot count the times when, at various stages of my youth, I stood before those walls and tried to puzzle out their meanings, some of which are extremely abstruse and require archaeological information, even if, on a certain level it is obvious enough what is going on. The north and south walls depict the automobile industry, which almost everyone in Detroit was involved with in one way or another. Rivera painted in a group of tourists: a trip to the plant at River Rouge was a standard schoolchild excursion in the 1930s.

It was on the occasion of discovering a roll of large cartoons Rivera had given the museum that it was decided to plan an exhibition to mark the centenary year of his birth. Some of these are to be seen in Philadelphia—a characteristic *Figure Representing the Black Race* will give you some idea of the scale and form of the figures in the upper register of the Detroit murals—but the Philadelphia show, in concession to necessity, cannot give you more of the public artist than, perhaps, the few portable murals installed there may afford. This is not a crushing difficulty. The show sensibly stresses the private Rivera and places his life at

the center. It unfolds as you progress, from some early prodigy drawings until the final, moving last painting, which is of watermelons—a tableful of gargantuan fruits as a *nature morte* for a dying giant—through all the stages of a life that can no longer be lived.

The lives of the artists, as Vasari knew, tell us a lot about the meaning of art, different lives going with different arts. If someone were to juxtapose the life of Andy Warhol with the life of Diego Rivera, no better key to the art history of our century could be found. Rivera's life is as inaccessible to artists today as the life of a knight was to Don Quixote, and it is not to Rivera's discredit that we cannot assimilate him to our esthetic. Wandering through the wonderful exhibition, I was reminded of something John Maynard Keynes wrote about the geometrical proofs Isaac Newton used in the *Principia.* They were, Keynes thought, like great and ancient weapons in some museum, and he marveled that men could fight with what he could barely lift. Rivera is not for our times, but for just that reason it is important that we look at him intensely. It tells us as much about ourselves as about him that he is not.

· 36 ·

THE VITAL GESTURE: FRANZ KLINE IN RETROSPECT

AN ARTIST I ADMIRE OFTEN SAYS HOW MUCH SHE LOVES TO CREATE. "CREATing," as an intransitive verb, is synonymous in her vocabulary with what defines her as an artist, namely painting and drawing; and it refers, beyond that, to the pleasure she takes in surprising herself, when forms and images that she had not especially anticipated materialize at the ends of her fingers. This is a valid enough use of the term, even if in danger of debasement by the California ideolect that enables people to be creative through salad making or moped repair. But it is not the deep sense of creativity that has to do, rather, with breakthroughs in art that resemble great discoveries in science. I have in mind those saving moments in the creative life that come rarely and to very few, when it is as though a dark glass had shattered or a blank wall had fallen, and the person to whom this happens enters, abruptly, onto fresh artistic or cognitive territory, his or her energy augmented, secure in the knowledge of having been graced. This experience bears only the palest resemblance to the day-to-day creativity available to all except those condemned to labor of the most mechanical or routine order.

The closest the ordinary lives of men and women come to such moments, I suppose, is when we are touched by love. We do not expect *l'amour fou* to happen to us over and over again, just because it so profoundly alters reality for us when it happens and it is perhaps beyond rational expectation that we should be given new world after new world in this way. Deep, transformative love comes once or twice to a life and contrasts with the succession of relationships, of amatory encounters, of affectionate liaisons and sexual affairs that knit up the fabric of emotional existence. My artist indeed had her moment of creation, when she accidentally hit upon a subject that precipitated a stylistic response that was

uniquely hers, making her work thereafter unmistakable and autographic. It lifted her above the common run of gifted, competent, trained and disciplined artists who make art and have shows and hold down jobs that enable them to be creative in the harmless, unexalted sense of that term. It was a creative moment for her, but it was not, I think it fair to say, a creative moment for the history of art, for she was situated at some wrong juncture for the transformation in her to be a transformation of art itself. It was not the sort of discovery that puts art on a new course or enables other artists to make their own breakthroughs within a new framework.

Historical breakthroughs are of two sorts, instrumental and personal. The instrumental breakthrough makes it possible for artists to achieve goals they were in some measure able to pursue before, though not as effectively. These are the sorts of discoveries that could in principle be kept secret, like recipes, or handed down to apprentices, giving them a competitive edge in securing commissions. But sometimes, as with perspective or chiaroscuro, the new technique is so apparent as to be there for the taking. Such discoveries are sufficiently in the public domain that those who use them do not bear the stigma of being mere imitators. The discovery of abstraction by Kandinsky, for example, effected a certain opening for artists eager to be liberated from representation, without it being thought that their work was derivative of his. The discovery of Cubism may also have been of this order, since it seemed to promise a whole new way of construing space and form; Picasso and Braque were not imitating each other, even if it takes expert knowledge to tell their early Cubist works apart. Pollock's discovery of the drip lies on the borderline, for while Pollock did "break the ice," as de Kooning said, opening up new possibilities of gesture and abstraction, he simultaneously created a personal style so marked that those who wished to exploit his technique were obliged to find their own way of doing so, or be mimickers. Artists who became both abstract and expressionist were deemed no less original for having built upon the breakthroughs of Kandinsky and Pollock. So de Kooning and Kline and Motherwell developed personal idioms so clearly theirs that the use of them by others was a form of impersonation.

There are two moments in the career of Franz Kline that enable us to make the distinction between instrumental and personal artistic discoveries more vivid. The first was when he became an abstractionist; the second was when he became Franz Kline. There is some controversy as to whether Kline went abstract all at once or whether abstraction came

gradually into his work, and the fact that this cannot be settled suggests it was the kind of decision one makes in joining a party or getting involved with someone or entering a profession. One weighs the pros and cons, and one's resolution weakens or strengthens. The decision must have been particularly difficult for Kline—who enjoyed and was good at hitting off likenesses and derived a certain pleasure from pleasing and entertaining others by doing so—especially since his early abstractions were not so marvelous as to justify the shift. Kline claimed that *The Dancer,* of 1946, was his first abstract painting, but whatever agony he may have gone through in forsaking representation is hardly redeemed by the result. *The Dancer* is muddy and opaque, dimly Cubistic and somewhat halfhearted: there is a recognizable slipper attached to what must be a leg, and a triangular form in the upper right that is then read as a bent arm. The horizontal stripes must imply motion, much in the way the circular lines a cartoonist puts around a figure inform us that it is rotating. Reality is not far away, and had Kline persisted in abstraction at that tentative level, however personally momentous it may have been for him to do so, he would have remained one of the obscurer members of the abstractionist tribe, much as, before then, he had been a modestly capable practitioner of 1940s-style representationalism. All that set him apart was a certain unusual draftsmanly talent.

But then, at a certain moment in 1948 or 1949, described for us in a famous passage of Elaine de Kooning's, Kline became Kline in a way so immediate and unpremeditated that the concept of decision has no application. The force that effected the change came from without, and was grasped with the certitude of a mystical revelation. Kline could have changed his name at that point, as Saint Paul did, so slight was the continuity between the new Kline and the old. It can be argued that this particular revelation could have been granted only to someone who had had specifically the life in art that Kline had had up to the shattering self-disclosure, but it can also be argued that had it not been for an almost entirely accidental intervention, like a fate, Kline would simply have gone on as he had been. It was a moment like the falling of the apple in the myth of Newton, or the fluorescence of a nearby barium screen in the case of Röntgen, or the flames the dozing Kekulé saw as interlocked snakes when he got the idea of the benzene ring. Or like Proust's tasting of the madeleine, without which he would have remained the marginally distinguished *belle époque* writer of the works that preceded *Remembrance of Things Past.*

THE STATE OF THE ART

Kline's transfigurative experience came when he saw some of his drawings projected on the wall of de Kooning's Fourth Avenue studio in late 1948. De Kooning had got hold of a Bell-Opticon opaque projector for a few days, and when Kline saw his drawings there, on that scale, it was, in Elaine de Kooning's phrase, "total and instantaneous conversion." The projector is today a standard item in the artist's instrumentarium, especially since physical bigness has become a presupposition of painterly significance. It replaced the grid, the *mise en carré* painters had used for centuries in translating a small sketch onto a large area. Bigness of that order was quite new for the New York painters of the 1940s, who thought, Meyer Schapiro once told me, that they might as well paint big, since they had the space for it and nobody was going to buy the work in any case. It was as though they were adapting the large format of the public commission, the mural, to the most personal art imaginable. Kline's work up to that point, aside from a hometown commission and some barroom murals, had been of standard easel proportions, including the abstractions. But he must have seen at that moment, with the intuition of genius, the expressive power of size. Most of us pay little attention to the fact that what we see projected on the wall or screen is a vast enlargement of an image, mainly because we see enlargement as a means for making the image more perspicuous. The image, in our era of reproduction, is an invariant which may appear in black and white or in color, or be smaller than the original, as in an art book, or larger than the original, as in an art history lecture. Scale is rendered invisible by the variety of sizes in which we may see the same work in the various modes of its transcription. But for Kline, at that instant, scale became palpable and crucial, as if the drawing were not so much reproduced and projected as magically transformed and gigantified. The energized squiggle on a scrap of cheap paper—perhaps a sheet from the telephone directory—was metamorphosed into something immense and sublime.

Heidegger once introduced a fascinating concept to which he attached the term *Zeugganzes,* which means, roughly, "a complex of tools." Any item in such a complex implies the other tools, without whose existence the item itself would not exist. Thus the hammer refers to the nail, the nail to the board, the board to the stud, the stud to the beam. A *Zeugganzes* comes into being all at once and, when technology changes, goes into obsolescence as a totality. Think of the forge, the hammer, the anvil and the tongs of the blacksmith's shop. An anvil would never have existed save as part of such a *Zeugganzes.* Now there is, I believe, an artistic

counterpart to this. The moment Kline recognized the place of scale in the transformation of his drawings, everything had to come at once—the wide house-painting brush to lay down the lines with a single gesture, the large containers of fluid pigment to give the liquidity of ink, the buckets of white paint and black paint to get the light-dark contrast of the drawing, the abandonment of the easel in favor of the wall, which in turn altered the painter's touch and changed his posture, as he swung the loaded brush across an ample surface rather than drew a line bent over a drawing table. The Franz Kline painting followed with nearly logical necessity. The artist himself is part of the *Zeugganzes* of his art: when everything else changed, he changed. Kline became a great painter.

Like divine grace, artistic grace seems fortuitous and arbitrary, missing those who seem most to deserve it and touching those whose gifts and comportment seem not especially to have destined them for exaltation. I find it terribly moving that Kline should have set out to be a cartoonist, like someone who sees an advertisement in a matchbook and imagines fame and fortune. Judith Stein, the organizing curator of the Kline exhibition at The Pennsylvania Academy of the Fine Arts in Philadelphia, told me that Kline's hero had been the cartoonist John Held Jr. Held's swanky drawings of flappers and college boys gave graphic embodiment to the ethos of *This Side of Paradise,* and his world of fast cars and dizzy girls, toothy boys in smart clothes and patent-leather hair, jazzy music and highballs, had great appeal for Franz, as even those who never knew him like to call him. Franz was sexy, good-looking, and liked a fun time. His models, when an art student, were illustrators like Phil May or Charles Keene of *Punch.* He always drew fluently and incisively, and drawing was the avenue through which grace reached him when he saw, projected on the wall and turned into something monumental, what he did best and most spontaneously. Drawing was the matrix of his work through the dozen years of greatness that remained to him before his death, at the sad age of 51, of a rheumatic heart.

Drawing is notoriously difficult to define, but two properties of drawing on paper must account for its attractiveness to artists. The background color of the paper confers an instant unity on the drawing, and the line interacts with the medium of the paper to create an astonishing difference between solidity and transparency. Draw a face on a piece of paper, and everything enclosed by the line becomes solid while everything outside it dissipates as atmosphere, though the color and texture of the paper are the same on both sides of the line. You have to work very

hard to achieve this effect in painting. But Kline transformed black and white paint to transfer the properties of drawing to his work. When it was first shown, critics thought of it as calligraphic, a not inexcusable suggestion, given the depth to which Zen concepts and attitudes had at that time penetrated artistic consciousness in New York. Kline nevertheless rightly denied that he was writing, and one may confirm his position by considering the distinction between drawing and writing in Chinese watercolors. The calligraphy remains on the surface, the drawing goes into the space of the paper; the writing cannot but be two-dimensional as the drawing cannot but be three-dimensional. The same touch is present in the writing as in the drawing, but why the one creates solidity—or mistiness, as in the Sung—while the other simply defines a meaning, as in a text, is a beautiful problem for the perceptual psychologist. The difference survives the abandonment of monochrome: the red seal occupies the surface, the red maple leaves go back in space, though it be the same red in each. Even when Kline introduced color, as he did masterfully and effectively at a time when people thought of him as only black-and-white, his work derived its power from the power of the drawn image. Of course the matter is more complicated than that, because we are also aware of the quality of the brushing, as of the glaze and sweet softness of the pigment.

Harry Gaugh, guest curator of the show and a leading Kline expert, contends that this is likely to be the last full-scale retrospective Kline will be given in our lifetime. For all their power, the paintings are physically fragile, like drawings. This is due to the poor quality of the materials the artist used, as dictated at first by poverty and then by the exigency of the *Zeugganzes.* Having to squeeze paint from tubes interposes an obstacle that has to be overcome when one paints like Kline. The exhibition gives the three moments or stages of Kline's career: the early figurative work, the limited abstractions and the inspired Klines. As you mount the elegant stairway of the Academy, two marvelous Klines, hung against piers of the central rotunda, draw you on. Two more magnificent, internally related canvases, *Siegfried* and *Requiem,* great late works hung on the opposing piers, see you out. On your right the galleries show the early work, on your left, as you enter, the triumphant grandeur of the later work. It is a wonderful show, and a wonderful way to say hello and goodbye to Franz.

APPROACHING THE END OF ART

I WANT TO CITE THREE PROPOSITIONS THAT OCCUR IN HEGEL'S MONUMEN-
tal lectures on the philosophy of art—his *Vorlesungen uber die Aesthetik*—
which has been described, by Martin Heidegger, as "the most compre-
hensive reflection on the nature of art that the West possesses." There
Hegel writes:

> Art no longer counts for us as the highest manner in which truth
> furnishes itself with existence.
>
> One may well hope that art will continue to advance and perfect
> itself, but its form has ceased to be the highest need of the spirit.
>
> In all these relationships, art is and remains for us, on the side
> of its highest vocation, something past.

I am obsessed by the thought these propositions express, that art "in its
highest vocation" might have come to an end, and that the period we
have been living through is a kind of epilogue to the history of art. At the
very least this thought offers an opportunity to speculate on what one
might call the philosophical history of art.

There is a curious and rather touching passage in the *Autobiography*
of John Stuart Mill, in which that philosopher responds with considerable
melancholy to the thought that sooner rather than later, music will all be
used up. There are only, Mill reflected, a finite number of combinations
of a finite number of tones, so before too long all the melodies possible
will have been discovered and there will be nothing left to compose. The
augmentation of the octave by the twelve-tone scale, something Mill of

course had not counted on, would but postpone an inevitable exhaustion, and the future history of music must be repetitions of all the combinations of tones that there are. Mill might have taken comfort from the fact that concert performances themselves seem infinite repetitions of the same compositions, but his concern was with creativity and the closing off of its possibility in musical composition.

Mill's argument, which I do not mean especially to examine here, anticipates a much grander cosmological speculation of Nietzsche's, to the effect that the universe itself, consisting, as he supposed it did, in a finite number of possible states, of which there can be again but a finite number of possible sequences and combinations, must finally exhaust the possibility of novelty and begin to repeat itself monotonously and eternally. This was Nietzsche's notorious theory of Eternal Recurrence, but unlike Mill (whom the thought of finitude sent into a depression uncharacteristic in a man who typified the optimism of his era) Nietzsche was exhilarated by what he thought was an immense discovery. Mill was depressed, perhaps, precisely because he was by conviction an optimist who saw his optimism limited just here, whereas Nietzsche may have been exalted because he was by nature and conviction so deeply pessimistic about the human material. Nietzsche thought Eternal Recurrence was a test, and that if we could pass this test there might be some hope for us. If we could, in the face of knowledge he presumed scientific and certain, continue to act despite having acted in just this manner countless times before in periods of the universe exactly like the present one, which itself is a phase that will return again and again and again, then one will have achieved a certain meaning in one's actions and a kind of moral strength. For the action will be seen as done for its own sake and not for any consequences it might have, for it cannot, on Nietzsche's theory, ultimately make any difference as to how the universe will be. We know, he believed, that whatever we do, we will do it again, infinitely and eternally. So there can ultimately be no different outcome.

Since making art has often seemed to be an internally rewarding and self-contained activity, it might seem as though artmaking were a perfect example of a meaningful act in Nietzsche's view. "Do everything you do as though you were making a work of art!" might be a form of the imperative his theory of Eternal Recurrence recommends. Now the period of artmaking I wish to discuss, that of the 1970s, seemed to many to represent that timeless circulation of the same after the same that connotes a vision not unlike Mill's or even Nietzsche's. But the malaise

to which this gave rise underscored the degree to which art had been thought of by its makers as historical rather than timeless, with the imperatives being those of breaking through, making everything new, revolutionizing all that had gone before, carrying forward the history of art to new levels of achievement. And indeed, a great deal of art was made that would have made little sense but for the belief that one had achieved a historical advance by means of it. The discoveries in question had to do with the nature of art itself, for it is possible to read twentieth-century art as the collective quest for the essence and nature of art—a reading that is confirmed by the intolerance each stage in this advance provoked when the new forms were displayed as having captured and distilled the pure being of art.

But then, in the 1970s, all this seemed to stop. Season after season passed without any of those abrupt reversals and transformations of artistic vision the art world had come to take for granted. Instead one saw the same things being done, over and over, with some slight modifications and variations. And the old puritanisms and intolerances—the charge that everything other than what one was doing was *not really art* —gave way to a sort of pluralism, which itself is a concession that one no longer believes in a truth of art. The abstractionist of the 1970s was prepared to allow realism, the minimalist resigned to allow decoration, the hard-edgers tolerated soft-edgers, the seekers after absolute flatness saw all about them the exploiters of illusory space—and if one wanted, one could paint the flaying of Marsyas or the descent from the cross or appropriate styles and images of the discarded past. Anything was permitted. Pluralism has much to recommend it, since under it one is allowed to do what one wants to do, but it is striking that when anything is allowed, a certain point in doing whatever one chooses to do is lost, and there is no question that a certain melancholy settled over the art world in those years. This is largely, I believe, because the historical presuppositions that made a given art meaningful were inconsistent with another kind of art being equally meaningful and allowed. Why even make art of the one kind if it was perfectly all right to make art of different kinds? Why stain color fields into canvas when others were painting landscapes or making installations or doing performances?

So through the 1970s, the thought was irresistible that art might have come to an end, in the sense of having been used up. The present began to seem the way the past is always assumed to be: All the music of the nineteenth century is already composed and there is now no way to add

to the music of the nineteenth century, since the whole of that history is in place. In the 1970s it was as though the whole history of the future were already in place, as though the most one could hope to do was repeat—as it were perform—a known thing. No further breakthroughs were expected, and "the end of painting" or "the end of art" were phrases used by critics and theorists, and indeed by artists themselves. To be sure, this might have been part of a general attitude toward culture. Certainly people spoke of the death of the novel and the end of philosophy as well, and in the field of philosophy pluralism, as in art, seemed to be inescapable. But few cultural forms had been so transformative as painting, and *its* coming to an end seemed especially dramatic. "The problem with painting," one commentator wrote near the end of this period (1981) "is that by now all possible variations on neat-messy, thick-thin, big-little, simple-complex, or circle-square have been done." How exactly like Mill this sounds!

Perhaps just because pluralism was felt as a problem, as it was in so many places where art was discussed and debated in those years, there was an unstated premise that the answer to the question of what art really is must exist among the known forms. It was only that its identification was no longer regarded as a matter of artistic discovery but of philosophical argument of a kind that no one knew how to frame. But at the same time that artists must have seen their task as increasingly philosophical in this way, the institutions of the art world continued to believe in—indeed to expect—breakthroughs, and the galleries, the collectors, the art magazines, the museums and finally the corporations that had become the major patrons of the age were also awaiting prophets and revelations. I thought at the time that there was an influential segment of the art world that rushed about the scene with Cinderella's glass slipper, but the slipper was huge and the feet were tiny. There would, even so, be ecstatic cries of "It fits! It fits!" as one very small foot after another found it could not fill enough of the immense slipper to take even a baby-step into the historical future. And those who believed in historical closure might have said that in any case there would be no place to set one's foot, because art was walled in by its own internal logic. History was over.

So the 1970s were a kind of unstable or even a contradictory period, and the art world was the scene of conflicting beliefs about art and the history of art. All the institutions of the art world operated on the belief that art had one kind of history which may have been momentarily inter-

rupted. But a good many artists and critics were of a different view: What others saw as interruption, they saw as exhaustion. They saw history as closed where others saw it as open and luminous.

All of this is meant to fill in the background of the event that really concerns me here, namely the explosive eruption, in the early 1980s, in Europe as in America, of a brash new style, Neo-Expressionism, which seemed to many to introduce a foot large and strong enough to move the glass slipper of artistic history forward a step. All at once there was something important enough for collectors to acquire—*growth* art as what one might call it—art destined, in analogy with certain legendary stocks, to appreciate enormously in value over time. The art of the 1970s might have been collected by *amateurs,* in the French sense of the term: informed enthusiasts for a certain style of minimalism or realism. But as I have observed, there was a whole complex of art institutions waiting for an art of a different order, novel and big and important, a demand that had existed, perhaps even increased, through the fallow period of the 1970s when there was nothing especially to satisfy it. I was struck by the fact that in Hilton Kramer's book of critical essays, which covers the years 1972–1984, he discusses artists who already had reputations when this period began, and who merely refined a given vision without anything truly novel coming about save at the end of those twelve years with Neo-Expressionism itself. So there was almost what Marxists might construe as a contradiction in the art world between demand and supply. And here were the Neo-Expressionists to rectify the inconsistency, providing works of art that carried the look of historical importance and gave collectors something to buy which would, in no time at all, increase in value as the paintings of the Abstract Expressionists had done, or even, more astonishingly perhaps, as the irreverent works of the Pop artists had done. Jasper Johns's *Three Flags* sold for $1 million (to The Whitney Museum of American Art) in 1980. Roy Lichtenstein's comic-strip paintings bring that amount from collectors today. De Kooning's *Two Women* sold at Christies for $1.98 million in 1984—a price which, though still the highest paid for the work of a living American artist, was certain to be overtaken. The Neo-Expressionists appeared in terms of scale and frenzy to be in this league. "Buy before it is too late!" was the implicit imperative, and a market was made. These were not the kinds of works that were acquired by the artist's friends and a few admirers: They demanded instant acknowledgment and acquisition, and they proclaimed the preemptive merit of important art almost simultaneously with their being

made. It was a moment of heady effervescence, like the discovery of oil. Art had sailed out of the doldrums.

The jubilation, of course, was not universal. There was an inevitable resentment that young and flashy painters should have seized the stage, getting immense attention and reckless prices. Kramer, in his essay of November 1982, devoted to this upsurge, remarked on its "swift and formidable presence on the international art scene." And he explains it in a kind of philosophical way, writing that "Change, after all—incessant and insistent change—has been the rule in the life of art as long as anyone can now remember." But this, I think, is too weak an explanation for the kind of change it was. Even in periods of extreme stability, as in the production of statues of pharaohs or the painting of icons, there is doubtless an insidious change, and indeed for all the outward inertness, there must have been changes in the 1970s. Nothing stands quite that still in art or for the matter in life. But here was a change of a cataclysmic sort, a *discontinuous* change, a change of a different order. Changes as sharp and, as it were, punctuated, were not "the incessant and insistent change" of art history. The question then is: What can account for the sense of a break in history, a shift in artistic direction?

Kramer is certainly aware of the shift. "Unquestionably," he wrote, "it represents one of the most spectacular and unexpected 'divorce' cases in recent cultural history." And "Not since the emergence of Pop Art in the early 1970s have we seen anything of comparable consequence in the realm of contemporary painting." There really is the resemblance Kramer notes. But my view, which requires putting forward a different sense of history than his, is that we are dealing with different kinds of cataclysms. The first of them, I want to claim, was a cataclysm internal to the history of art. The second was a kind of willed cataclysm, unconnected with the history of art. Or, one was a real cataclysm and the other merely resembled one.

It is a complex enough matter to relate the art of a single individual to those dimensions of his or her life that explain what it expresses, but art is more than the collective biographies of individual artists, and this is especially so when we are dealing with a *movement* of art. Why, at a given moment, should so many artists, various as their biographical circumstances must be, begin to work in much the same way? To be sure, there may be one or two who happen to hit upon some novel thought and to communicate it to others—But why do these others accept it? What is there in the soil of a culture that enables the seeds of a new art to grow?

ARTHUR C. DANTO

Some larger concept of art history, it seems to me, is needed for there to be answers to such questions. For me, a given movement of art must be understood in terms of a certain historical necessity, and in my view, Pop Art was a response to a philosophical question as to the nature of art that had more or less energized the whole of twentieth-century painting. Abstract Expressionism, after all, had posed this question and had elicited answers of some ingenuity—painting is paint, it is the act of painting, it is an action of a certain sort, and everything else that seems to belong to the essence of art is really incidental. Pop Art put the question differently, and in its true philosophical form: Why is this art, it asked, when something just like this—an ordinary Brillo box, a commonplace soup can—is not, especially when the artwork and the real thing so exactly resemble each other as not to be told apart? This question was raised for me, vividly, in the exhibition of Andy Warhol's Brillo cartons at the Stable Gallery in 1964, and though one must resist the temptation, as a philosopher, to identify that which may have awakened one from one's own dogmatic slumber with that which may have awakened history from *its* dogmatic slumber, I cannot refrain from supposing that I grasped what art was asking about itself at that moment in 1964. Art had raised, from within and in its definitive form, the question of the philosophical nature of art. All questions in philosophy have, I remarked in the Prologue, the same form: They ask why two things of an outwardly similar appearance should belong to deeply distinct philosophical kinds. Why should artworks look outwardly so like commonplace objects? Until the advent of Pop (with the dubious exception of Duchamp) artworks never had looked outwardly enough like anything else to raise the question in this form, though when art was believed to be imitation, the intuition was already there that something like this was true. The fact that this kind of question could be raised about art proved that art itself was a philosophically important category, which of course philosophers had in some sense understood since speculation on the nature of art had always been part of what philosophers did. It really required an indiscernibility from objects that were neither exalted nor beautiful nor picturesque for the issue to be felt—and the banal, drab, empty Brillo box served this end magnificently.

An artist I knew loathed that Warhol show, and scribbled an obscenity in the guest-book. Years later I said to him that one difference between artists and philosophers was that artists write "Shit" where philosophers write such things as *The Transfiguration of the Commonplace,* my own way of

responding to an exhibition perceived as a problem rather than an affront.

By contrast, Neo-Expressionism raised, as art, no philosophical question at all, and indeed it could raise none that would not be some variant on the one raised in its perfected form by Warhol. On the other hand, the fact that Neo-Expressionism arose in the cataclysmic manner in which it did raised a question about the philosophical structure of the history of art that one might never have grasped had it not been for something as flamboyantly empty as this new painting style. My response to its advent was in effect: *This was not supposed to happen next.* I had that thought while working through the Whitney Biennial of 1981, in which Neo-Expressionism made such boisterous inroads. And my next thought was: *Well, if this was not supposed to happen next, what was?* And I realized, suddenly, that I was subscribing to some sort of philosophy of history, according to which art must have the history it does because it has the nature it does: There is a certain necessity, or a certain logic, in the history of art. And so I saw Pop Art as an internal event in the history of art construed philosophically. Neo-Expressionism, on the other hand, seemed but an external event, caused, perhaps, by the drives of the art market and its hopes for the history of art. So though the two events really did resemble each other, just as Kramer said, they belonged to philosophically distinct histories, and represented different orders of change. And they called for different kinds of historical explanations.

The thought I wish to present is that with Warhol, art was taken up into philosophy, since the question it raised and the form in which it was raised was as far as art could go in that direction—the answer had to come from philosophy. And in turning into philosophy, one might say that art had come to a certain natural end. Neo-Expressionism was a solution to a different problem altogether, namely, what are artists to do when art is over with and where the mechanisms of the market require that something happen that looks like a continuation of the history of art? Let me now spell out some of the grounds for this difference.

The idea that art should come to an end like this was advanced in the great work I cited at the beginning of this chapter, Hegel's *Vorlesungen uber die Aesthetik,* which he delivered for the last time in 1828, three years before his death—a very long time ago indeed—and a great deal of art has been made since Hegel last held forth in Berlin. So there is a natural temptation to say, Well, Hegel was just wrong, and drop the matter there.

ARTHUR C. DANTO

Philosophers have said some crazy things about the real world. Aristotle insisted, for reasons I can only guess at, that women have fewer teeth than men. In medieval representations of him, Aristotle is often depicted on all fours, being ridden by a woman with a whip in her hand. This was Phyllis, the mistress of Aristotle's pupil, Alexander. One might suppose, from his posture of erotic domination by a woman he was mad about, that Aristotle would have supposed she had more teeth than men, showing that even masochists can be sexist. In any case, one need only look in the nearest female mouth to refute that mighty thinker. Hegel himself had a proof that as a matter of cosmic necessity there must be exactly seven planets, but Neptune was discovered in 1846 and Pluto in 1930—and if we reckon in the minor planets, of which there are more than a thousand, an argument on rational grounds that there must be seven shatters against the universe. So the claim that art must be over by 1828 sounds like another of those unfortunate thoughts philosophers have from time to time about the uncooperating world. Heidegger, whose essay on the *origins* of art appeared in 1950, was not much impressed by a refutation of Hegel based on the continuation of art since his death.

> The judgment that Hegel passes . . . cannot be evaded by point-
> ing out that since Hegel's lectures were given for the last time
> during the winter of 1828–29, we have seen many new artworks
> and art movements arise. Hegel did not mean to deny this possi-
> bility. The question, however, remains: is art still an essential
> and necessary way in which truth that is decisive for our histori-
> cal existence happens, or is art no longer of this character?
> . . . The truth of Hegel's judgment has not yet been decided.

I suppose the simplest way to connect the possible truth of Hegel's judgment with the facts of art history since 1828 is to distinguish between something stopping, and something coming to an end. Stopping is an external matter, in that something is caused to stop when it could have continued. But coming to an end is an internal matter of pattern and consummation, when, as in a melody or a narrative, there is nothing else that can happen to cause the melody or narrative to go on. A storyteller breaks a tale off, to continue it the next night, when we learn what happens next. A novelist puts her novel aside and never takes it up again, so that though it stopped we have no way of knowing how it would have ended. Or a writer drops dead and we are asked, as with *The Mystery of*

Edwin Drood, to imagine alternative endings. We all understand this difference even if we are not prepared with a good theory of narrative closure that will explain the fact that there are stories that stop *because* they have reached the end. But in such cases, though the story has ended, life goes on: A lot happens when the prince and princess live happily ever after—the king, his father, dies, so he is now ruler and she his queen, they have their children, she conducts discreet affairs with Sir Lancelot, there are border uprisings . . . but still the story ended when the love toward which their destinies drove them came to mutual consciousness when they knew, each knowing the other knew, that they were meant for each other.

Hegel thought that art had come to an end in the *narrative* sense of ending, namely as an episode in a larger narrative in which art played a certain role. The story of art is the story of art's role in the grand history of the spirit. There was art before and there will be art after, but the highest vocation of art was to advance some grander matter. There was a moment when the energies of art coincided with the energies of history itself—and then it subsided into something else. If there could have been a change of that order, then it would have been change of a different order than the changes that preceded and succeeded it. So there is a question of whether there is a narrative structure to the history of art, in which case coming to an end would be almost a matter of logic, or whether the history of art is merely a chronicle, first this and then that, the record of which is so many columns of art criticism, one after the other, as in the present collection. The record of insistent change, which is all that Hilton Kramer allows, is the philosophy of history of the practicing journalist, following the day-by-day events in the art world: the news, the latest, the next. So the question then is whether art has the one sort of structure or the other (which is a nonstructure); hence, whether it can come or can have come to end—or whether it can merely stop. One could imagine art stopping, as under some terrible government or during the chill darknesses of the nuclear winter when all our energy goes into keeping ourselves alive.

Now once upon a time painting was certainly thought of as narrativistic, as the progressive conquest of visual appearances. The artists sought cumulatively to present the eye with what it would receive as a matter of course from natural appearances. Gombrich's account of the history of art as a matter of making and matching is just such a story of progress. Mill's despair at the collapse of melodic possibilities implies a similar

narrative for music, where perhaps the development of instruments, which allow more and more compositional possibilities, corresponds to the technical instrumentation of the painter to achieve visual equivalences by artifactual means. This must certainly have been the aim of Greek art if the severe criticisms found in Plato have any basis in practice, though the Greek artists were severely limited in what they could do by way of constructing appearances that could not be told apart, by merely optical means, from what reality itself would present. There are famous legends that confirm this goal and even record some startling successes at fooling the birds into pecking at sham and two-dimensional grapes.

In terms of this sense of the history of art, the discovery of perspective would have marked a climax, and perhaps the discovery of aerial perspective marked another. Who, unless concerned with changes in atmosphere induced by distance, would have chosen the grayed pale hues needed to register distal objects? Who even needed to register distance, unless verisimilitude was an objective? The great dramas of medieval art take place in mystical spaces, whose geometry and optics have little to do with the body's eyes. In any case, we can readily imagine this narrative coming to an end, namely with those discoveries in which, finally, the progress is achieved. Of course painting might very well continue to be made, but its real history would be over with. It could not any longer have climaxes of the order of the work of Michelangelo, according to Vasari's stirring account:

> While the best and most industrious artists were laboring, by the light of Giotto and his followers, to give the world examples of such power as the benignity of their stars and the varied character of their fantasies enabled them to command, and while desirous of imitating the perfection of nature by the excellence of art . . . The Ruler of Heaven was pleased to turn the eye of his clemency toward earth, and perceiving the fruitlessness of so many labors, the ardent studies pursued without any result . . . he resolved, by way of delivering us from such great errors, to send the world a spirit endowed with universality of power in each art. . . .

This highflown and manneristic passage gives an incidental reason why imitation should have enjoyed a renaissance as a theory in the Renais-

sance. The artist, in imitating nature, imitates God: Artistic creativity is the emulation of divine creation. In any case, with Michelangelo, the story is over, but of course art goes on and on: halls had to be decorated, portraits executed, marriage chests embellished.

There are certain inherent limits to this progress, simply because there are certain properties of things discernible to vision that cannot be directly represented in painting. Motion is clearly one such property—an artist can represent, as it were, *the fact* that something is in motion, but he cannot imitate the motion itself. Rather, the viewer must infer that the subject shown is in movement as the best explanation of why the painting looks the way it does—the man's feet do not touch the ground, say. Here I must rather ruthlessly cut my account, but I have argued at length elsewhere that the entire concept of painting had to change when it was discovered that only through an altogether different technology could motion be directly shown, namely that of cinematography or one of its ruder predecessors. The history of art as the discovery of perceptual equivalences did not come to an end with cinema, but the history of painting so far as it was regarded as the mimetic art par excellence came to an end. The goal of history could no longer be believed attainable by painters, and the torch had been handed on. My own sense of history suggests that the history of painting took a very different turn when this was recognized. It is striking that photography presented no such challenge—it provided, rather, an ideal. But motion picture photography showed something not in principle attainable by painting, and by 1905, when we are roughly at the period of the Fauves, all the structures for narrative cinema were in place.

The very fact of the Fauves recommends the view that at some level of consciousness, artists realized that they must rethink the meaning of painting, or accept the fact that from the defining perspective of mimetic progress, painting was finished. Painters could behave archaistically just as sword-makers carry on a ceremonial trade in the era of firearms. But instead they began to reexamine the foundations of their practice, and the decades since have been the most astonishing period in the history of art. This is mainly, I believe, because the immense problem of self-definition had been imposed on painting, which could no longer acquiesce in a characterization taken for granted through two-and-a-half millennia, with some interruptions. Cinematography was immensely liberating for art, but it also changed the direction of art. Art must now, whatever else it does, come to terms with its own nature. It must discover

what that nature really is. In Hegelian terms, it had reached a kind of consciousness of itself as a problem. Up to now, art had a set of problems, but it was not a problem for itself. Perhaps it had been a problem for philosophers. But now, in becoming a problem for itself, it began to attain a certain philosophical dimension. It faced that crisis of self-identity a sensitive person may face at a certain moment of her or his life, when existence can no longer be taken as given, where one can only go ahead by discovering whom one is—and consciousness of that problem henceforward becomes *part* of what one is. Heidegger speaks of man as a being for whom the question of his being is part of his being. It is a profoundly philosophical moment when this becomes a matter of consciousness in one's life, and it is my claim that such a consciousness began to define art after the advent of cinematography. In rethinking its identity, art had of course to rethink the meaning of its history. It could no longer assume that its history had to be the progressive endeavor it had seemed up to then to be.

There are two theoretical responses to this problem that I know of, one of which is quite familiar today. This is a theory of art history best exemplified perhaps in the great and groundbreaking thought of the art historian Erwin Panofsky. Panofsky put forward a remarkable thesis in a no-less remarkable paper of 1927 (just a century after Hegel's prediction). Called *Die Perspektive als symbolische Form—Perspective as Symbolic Form* —Panofsky's bold thesis was that, instead of marking a certain stage in the advancing conquest of visual appearances, perspective marked a certain change in historical direction: It was a form through which its civilization began to represent the world on a symbolic level, as though optics was a matter more of meaning than mimesis. Perspective, or optical exactitude, for example, would have no meaning for an artistic tradition in which even if it were known about, its practitioners were concerned with other ways of symbolizing the world. It plays no role in the mask-making artforms of the Guro people of the Ivory Coast, whose works, concerned with magic and with dark powers, with a different intervention of art into life than optical similitude would allow, would have no use for the kind of knowledge perspective represents. For Panofsky, perspective then was symbolic of what one might call the "Renaissance philosophy of man and world."

It is certainly true that painting in the period after 1905 abandoned perspective, not because artists had lost the technique but because it bore no relevance to what they were seeking. Indeed, if perspective was sym-

bolic, its rejection would be symbolic as well, and part of the meaning of the new work would be carried by its palpable absence or by distortion. And with this new symbolic form, a shift analogous to what has come to be called a "paradigm shift" in science took place. So in Panofsky's view, there is no progress in the history of art, simply the working out of different symbolic forms until, in whatever way it takes place, some internal upheaval gives rise to a new culture and new sets of symbolic forms. Panofsky's own discipline, what he termed "iconology," was concerned specifically to identify those points in history at which such transformative changes took place, and to map the symbolic forms through which the new period was defined. Its art, but its art no more than anything else distinctive to it, expressed the culture as our behavior and speech express our personality.

In any case it is clear that Panofsky's view of art history is that it has no narrative structure. There is instead just the chronicle of symbolic form succeeding symbolic form. The history of art can stop, though it is not clear that there would ever be a social life without some idiom of symbolic representation, however bleak its reality. There is no story to tell. It must have been something like this that Gombrich meant when, somewhat inconsistently with his own progressive theories of history, he suggested in his textbook on art that there is no such thing as art, only the lives of the artists.

This is one way of thinking about the history of art. Hegel's is the other.

I have often said that there is no nutshell capacious enough to contain the philosophy of Hegel in the extravagance of its mad totality—but in a nutshell, his thesis about history is that it consists in the progressive coming to philosophical consciousness of its own processes, so that the philosophy of history is the end of history, and internally related to its drive. Hegel congratulated history for having achieved consciousness of itself through him, for his philosophy, he supposed, was the meaning of history. This coming to consciousness proceeds by discontinuous stages, which is the dialectic of which certain theories of history make so much. So that in a way Hegel's model of history combined features of both the models I have discussed here: It is narrativistic, in that it has an end, but it is discontinuous in that there is an internal reason why there are those cataclysmic changes outwardly expressed by symbolic forms. (Panofsky's idea of symbolic forms is in fact a rephrasing of Hegel's own theory of the spirit or *Geist* of a given time.) Once more, the best example of

something that exhibits this structure would be a single life, not as one event after another, say as it would be represented at a low level of biography, but as the moving from stage to stage of consciousness through growth until the person comes to understand his or her own history at some moment of maturity—after which one's life is up to oneself. Hegel, and Marx as well, supposed that once we become aware of history—or history becomes aware of itself through us—we enter the realm of freedom, no longer subject to the iron laws of development and transformation. The whole of history is the structure of a full human life writ large. It is a progress, but not a linear progress. Each stage is the revolutionization of the preceding stages, until the seeds of revolution have worked themselves out.

Now something like this structure is what I want to say is illustrated by the history of art. My sense is that with the trauma to its own theory of itself, painting had to discover, or try to discover, what its true identity was. With the trauma, it entered onto a new level of self-awareness. My view, again, is that painting had to be the avant-garde art just because no art sustained the kind of trauma it did with the advent of cinema. But its quest for self-identity was limited by the fact that it was *painting* which was the avant-garde art, for painting remains a nonverbal activity, even if more and more verbality began to be incorporated into works of art— "painted words" in Tom Wolfe's apt but shallow phrase. Without theory, who could see a blank canvas, a square lead plate, a tilted beam, some dropped rope, as works of art? Perhaps the same question was being raised all across the face of the art world but for me it became conspicuous at last in that show of Andy Warhol at the Stable Gallery in 1964, when the Brillo box asked, in effect, why it was art when something just like it was not. And with this, it seemed to me, the history of art attained that point where it had to turn into its own philosophy. It had gone, as art, as far as it could go. In turning into philosophy, art had come to an end. From now on progress could only be enacted on a level of abstract self-consciousness of the kind which philosophy alone must consist in. If artists wished to participate in this progress, they would have to undertake a study very different from what the art schools could prepare them for. They would have to become philosophers. Much as art on one model of its history turned the responsibility for progress over to cinema, it turned the responsibility for progress over to philosophy on another model of its history. Painting does not stop when it ends like this. But it enters what I like to term its post-historical period.

THE STATE OF THE ART

In its great philosophical phase, from about 1905 to about 1964, modern art undertook a massive investigation into its own nature and essence. It set out to seek a form of itself so pure as art that nothing like what caused it to undertake this investigation in the first place could ever happen to it again. It realized that it had identified its essence with something it could exist without, namely the production of optical equivalences, and it is no accident that abstraction should be among the first brilliant stages in its marvelous ascent to self-comprehension. There have been more projected definitions of art, each identified with a different movement of art, in the six or seven decades of the modern era, than in the six or seven centuries that preceded it. Each definition was accompanied by a severe condemnation of everything else as *not* art. There was an almost religious fervor, as though historical salvation depended upon having found the truth of one's own being. It was like the strife of warring sects. That has all but vanished from the art scene today. And this returns me to the decade of the 1970s, with which I began this philosophical narrative. The 1970s were the period of relaxed toleration, a period of benign pluralism, a period of "do as you like," after the great style wars had subsided.

Those were the first years of the post-historical period, and because it was, as a period, so new, how could it not have been incoherent? On the one hand there was the sense that something had come to an end. On the other there was the sense that things had to go on as before, since the art world was possessed by a historical picture that called for a next thing. I am suggesting that in that sense there are to be no next things. The time for next things is past. The end of art coincides with the end of a history of art that has that kind of structure. After that there is nothing to do but live happily ever after. It was like coming to the end of the world with no more continents to discover. One must now begin to make habitable the only continents that there are. One must learn to live within the limits of the world.

As I see it, this means returning art to the serving of largely human ends. There is after all something finally satisfying in making likenesses, and it is not surprising that there should have been a great upsurge in realism. There is something finally satisfying in just moving paint around. Drawing pictures and playing with mud are very early manifestations of the impulses that become art. So it is not surprising that there should have been an upsurge in expressionism. These were next things, but not the kinds of next things that the art world with its view of history as

· 217 ·

demanded by the art market had in mind. So it is not surprising that there should be wild swings in that market.

It is no mean thing for art that it should now be an enhancement of human life. And it was in its capacity as such an enhancement that Hegel supposed that art would go on even after it had come to an end. It is only that he did not suppose happiness to be the highest vocation to which a spiritual existence is summoned. For him the highest vocation is self-knowledge, and this he felt was to be achieved by philosophy. Art went as far as it can have gone in this direction, toward philosophy, in the present century. This is what he would have meant by saying art reaches its end. The comparison with philosophy is not intended as invidious. Philosophy too comes to an end, but unlike art it really must stop when it reaches its end, for there is nothing for it to do when it has fulfilled its task.

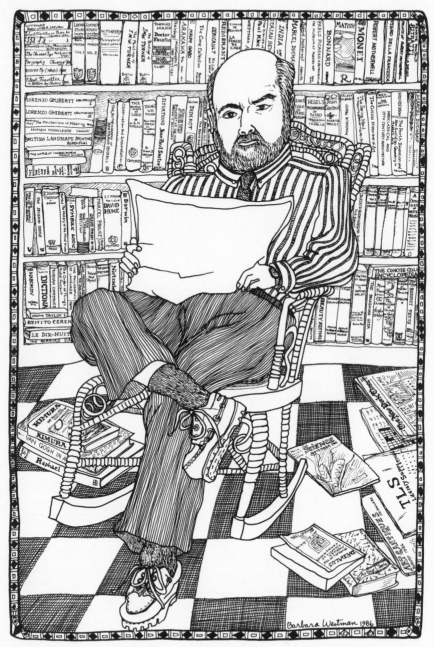

Drawing of Arthur C. Danto by his wife, Barbara Westman.

ABOUT THE AUTHOR

I was trained as an army engineer and spent three years of World War
II in North Africa and Italy—before that my life is a fog. My thought was
to become an artist when I was discharged. I was reasonably successful
at this, mainly in the field of prints where I gained a certain reputation.
I decided to study philosophy at Columbia University—I wanted to be in
New York and had two years left on the GI Bill that I did not know what
to do with. After a Fulbright year in France, I began teaching philosophy
at Columbia. For some years I carried the two careers forward until I got
bored with doing art. At the same time I began to see myself pursuing
philosophy on a serious level: I gave up art cold turkey, and have not
touched it since that abrupt resolution. I am grateful for that decision,
since I am certain that I am better at being a philosopher. In any case I
would not have fit into the art world after 1960. But I have done ex-
tremely well as a writer of philosophy in the analytical manner and was
appointed president of the American Philosophical Association in 1983.
My book on the philosophy of art, *The Transfiguration of the Commonplace*,
had a certain impact on the consciousness of the art world. This pleased
me greatly and led to various invitations to write on art for one or another
nonphilosophical publications. Chief among these was *The Nation*, of
which I was made art critic in 1984. Since then I have found myself once
more carrying two careers forward simultaneously. This has given me a
remarkable opportunity to put philosophy into practice.

I have two daughters from a first marriage, and since 1980 have been
married to Barbara Westman, whose drawings appear on and in *The New
Yorker*. We live with two Springer spaniels—witty and urbane dogs—on
the Upper West Side of Manhattan and in Brookhaven Hamlet on Long
Island.

INDEX

Abstract Expressionism, 3, 5, 6, 8, 10, 11, 23, 43, 50, 58, 98, 140, 206, 208
Abstractionism, 8, 197, 217
 geometric, 136–39
 and Franz Kline, 197
 of 1970s, 204
Adam and Eve (Chagall), 97
Addison, Joseph, 6
Akbar the Great, 132
Albers, Joseph, 136
Albertina drawings, 72–76
Albertina Museum, 72
Alma Mater (Columbia University), 93
Along the Way (Arakawa), 83
Altestil of an artist, 62, 63
American Pre-Raphaelites, 85–89
America Today (Benton), 193
Amyntas Reviving in the Arms of Sylvia (Boucher), 175
Andre, Carl, 155
Antoinette, Marie, 172
Arakawa, 81–84
Arbus, Diane, 21
Aristotle, 4, 210
Arnold Herstand and Company Gallery, 84
Arp, Hans, 62
Art Institute of Chicago, 96
Artistic creativity, Renaissance theory of emulation of God, 212–13
Ascher, Celia, 136, 139
Asceticism, art and in twentieth century, 159
Association for the Advancement of Truth in Art, 85
Aurora and Cephalus (Boucher), 174
Ausstellungskritik, 6, 125
Austin, J.L., 87, 91

Baglione, Giovanni, 54
Balzac, 51
Barbarelli, G., 29
Barbizon movement, 88, 171
Barnett, Vivian Endicott, 65
Baroque art, 56–57
Barr, Alfred, 64
Bartlett, Jennifer, 165–70
 Rhapsody, 166–70
Beham, Hans Sebald, 126
Benton, Thomas Hart, 53, 193
Berard, Christian, 97
Berman, Eugene, 97
Bernini, Giovanni Lorenzo, 56
Beuys, Joseph, 160
Black Square (Malevich), 136
BLADE, 30
BLAM!, 8
"BLAM!" exhibition, 5, 8–12
Blind Time drawings (Morris), 111
Blue, Grey, Black (Crawford), 145
Blue Painting (Krasner), 35
Bodhidharma, 81
Bonnard, Pierre, 12, 78
Borofsky, Jonathan, 38–42
Boucher, François, 171–76
 Amyntas Reviving in the Arms of Sylvia, 175
 Aurora and Cephalus, 174
 handling of paint, 172–73, 174
 Rape of Europa, The, 175–76
 Toilet of Venus, The, 174
Braque, Georges, 26, 27, 97, 197
Brauner, Victor, 25
Break dancing, 28
Brooklyn Museum, 85, 165, 166
Butler, Bishop, 37

Calder, Alexander, 42
Calling of Saint Matthew, The (Caravaggio), 56

INDEX

Caravaggio, 6, 53–57
Caravaggio (Hibbard), 57
Carnegie Institute, Museum of Art, 170
Carraci, Annibale and Ludovico, 53
Carrier, David, 108
Carson, Jo Anne, 79
C-Change (Sugarman), 162–63
Céline, 29
Cézanne, Paul, 15, 126, 128, 151, 174
Chalfant, Henry, 28
Chagall, Marc, 95–100, 138
 Adam and Eve, 97
 Firebird, The, 100
 I and the Village, 98–99
 To Russia, Donkeys, and Others, 100
Chardin, Jean-Baptiste Siméon, 173
Chicago, Judy, 122
Christian art, 20
Christo, 92
Cinematography, impact of on direction
 of art, 213–14
Collages
 Krasner's, 36
 Motherwell's, 50
 Schwitters's *Merzbilder,* 101–5
Constructivism, 137–38
 See also Russian Constructivism
Contrasts of Form (exhibition), 136–39
Conversion of Saint Paul, The (Caravaggio),
 56
Cook, Clarence, 85
Corcoran Gallery, 39
Corporate art, 91–92
Corporatization of art world, 11
Courbet, Gustave, 93, 110
CRASH, 30–32
Crawford, Ralston, 140–45
 Blue, Grey, Black, 145
 Fishing Boats #6, 142
 New Orleans #7, 143
 New Orleans Still Life, 143
 Overseas Highway, 141
Crimp, Douglas, 182
Cubism, 8, 27, 67, 97, 98, 136, 142, 151,
 192, 197

Dabrowski, Magdalena, 138
Dadaists, 102
Dali, Salvador, 96
Dancer, The (Kline), 198
Dancing Clown (Borofsky), 42
d'Arpino, Cavaliere, 53
Das Merzbild (Schwitters), 104
David, Jacques-Louis, 173
DAZE, 30, 32
Death of Phocion, The (Poussin), 165

Degas, Edgar, 127
de Kooning, Willem, 23, 58–61, 156, 174,
 197, 199
 Two Women, 206
Delineator II (Serra), 181
Denver Art Museum, 189
de Pompadour, Mme., 175, 176
Descartes, 134, 135
De Stijl, 139
Detroit Industry (Rivera), 194
Detroit Institute of Art, 172, 194
Diagonalists, 139
di Cione, Nardo, 69
Dickie, George, 122
Diderot, Denis, 176
Dinner Party (Chicago), 122
Disturbational art, 182
Divan Japonais (Toulouse-Lautrec), 149
Domenichino, 33, 37, 53
DONDI, 30
Draftsmanship, elevation of, 72
Drama, tragic, 56
Drawing, effect of availability of paper on,
 72–75
Dressing Room of Ludwig I of Bavaria, 1836
 (Nachmann), 126
Drip, Pollock's use of, 35, 197
Duchamp, Marcel, 58–59, 60, 83, 208
Duff, John, 79
Dufy, Raoul, 97
Dürer, Albrecht, 74, 75, 184, 185, 186
 Knight, Death, and Devil, 187
 Melencolia I, 186–87, 188
 Saint Jerome in His Study, 187, 188
Dürer the Elder, Albrecht, 186

Each for Himself (Kandinsky), 63
Elderfield, John, 103
Ellis, Chris, 30
Endless Column (Brancusi), 79
Englishman at the Moulin Rouge, The
 (Toulouse-Lautrec), 150–51
Esthetics, 4–5
Evening Landscape (Inness), 88
Exhibitions, as basic unit of artistic
 meaning, 125
Expressionists, attitude toward painting,
 157, 217
 See also Abstract Expressionism

Faith of Graffiti, The, 32
Fall of Man (Gossaert), 75
Farnsworth House, 178
Farrer, Thomas, 89
Fauves, period of, 213
Federally funded artworks, 92

INDEX

Federal Plaza (Manhattan), and Serra's
 Tilted Arc, 90
Ferber, Linda, 87
Festival of India, 131
Figure Representing the Black Race (Rivera),
 194
Fischl, Eric, 78, 79, 182
Fishes with Red Stripes (Motherwell), 50
Fishing Boats #6 (Crawford), 142
Flötner, Peter, 184–85
Forming of Nameless, The (Arakawa), 83
Fountain (Duchamp), 58, 60
Fragonard, Jean-Honoré, 73, 127, 173,
 174
FRED, 31
Frege, Gottlob, 124
French Line, The (Motherwell), 50
Fresco painting, 15
 Diego Rivera and, 191
Friedrich, Caspar David, 127
Friendly Giant, The (Borofsky), 41, 42

Galleria, Renaissance, 183–84
Gateway Arch (Saarinen), 120
Gaugh, Henry, 201
Gauguin, Paul, 14, 26, 97
Gazing Other, The (Arakawa), 84
General Services Administration Program
 for Public Art, 164
Gentileschi, 53
Geometry
 geometric abstraction, exhibition,
 136–39
 geometric painters, 134
 role of in Kandinsky's works, 64
Gerdts, William, 87
Géricault, Theodore, 107, 125
Giacometti, Alberto, 23, 27, 60, 153–54,
 155, 156, 176
Gide, André, 50
Gins, Madeline H., 83
Giorgione, 29
Giotto, 69, 135, 212
Goldwater, Marge, 170
Goltzius, H., 126, 127
Golub, Leon, 18–22, 182
 "Napalm" series, 18
 as reporter, 21
Gombrich, Ernst, 70, 75
 and progressive theory of art history,
 211–12, 215
Gossaert, Jan, 75
Gothic and Renaissance Art in
 Nuremberg: 1300–1550
 (exhibition), 184–88
Graf, Uras, 76

Graffiti, 28–32, 39
Grand Palais, 71
Grant's Tomb, 92, 93
Great Wave Off Kanagawa, The, 110
Greek art, 212
Greuze, Jean-Baptiste, 173
Grisaille, 15
Grooms, Red, 189
Grottaferrata, 33
Guernica (Picasso), 68, 162
Guggenheim Museum, 48–49, 62, 153,
 154, 155, 158, 184
Guidi, Tommaso, 29
Guston, Philip, 174

Hammering Men (Borofsky), 40, 41, 42
Happenings at the Whitney Museum,
 9–10
Haring, Keith, 30, 31
Harrow, Gustave, 119
Hart, Frederick, 114
Haskell, Barbara, 11, 142, 144
HAUS MERZ (Schwitters), 102–4
Hegel, Georg Wilhelm Friedrich
 and concept of *Aufhebung,* 36, 51, 83
 philosophy of art, 202, 209–10, 215–16,
 218
 Vorlesungen uber die Aesthetik, 202, 209
Heidegger, Martin, 210, 214
Held, Jr., John, 200
Here I (to Marcia) (Newman), 155, 157
Herodotus, 112
Hibbard, Howard, 57
High Baroque, 53
Hip-Hop culture, 28
Hiroshige, 15
Hofmann, Hans, 33, 35, 36
Hogarth, William, 186
Hokusai, 15, 110
Holzschuher Goblet, 184–85
Hume, David, 4

I and the Village (Chagall), 98
Iberia (Motherwell), 49
Illusionism, 65
Impressionism, 15, 78
Independents Exhibition, 59
India! (exhibition), 6, 129–33
Inness, George, 88–89
In Plato's Cave No. 1 (Motherwell), 51
Inscape (Sugarman), 163
Institutional Theory of Art, 122
Interior with Pink Nude (Motherwell), 50
Interpretation of Dreams, The (Freud), 99
Irregular Column (Orange) (Duff), 79
Islamic art, in India! exhibition, 129–30

INDEX

Jameson, Dale, 189
James, Henry, 33, 86, 92
Janis Gallery, 30
Japanism, 15
Johns, Jasper, 11, 12, 77, 156, 160
 Three Flags, 206
Jordaens, Jacob, 127
Judd, Donald, 51, 78

Kandinsky, Vasily, 62–66, 138, 159, 197
 Each for Himself, 63
 Sky Blue, 65
Kant, Immanuel, 4, 5
Kaprow, Allan, 9, 10
KASE 2, 30
Keene, Charles, 200
Kepler, Johna, 135, 136
Keynes, John Maynard, 195
Klee, Paul, 23, 62
Kline, Franz, 23, 196–201
 abstractionism, 197–98
 Requiem, 201
 scale, importance of to, 199–200
 Siegfried, 201
 This Side of Paradise, 200
Knight, Death, and Devil (Dürer), 187
Kramer, Hilton, 122, 206, 207, 209, 211
Krasner, Lee, 33–37, 59
Krasner-Pollock: A Working Relationship
 (exhibition), 35
Krauss, Rosalind, 182
Krug, Ludwig, 186

La Jolla Museum of Contemporary Art, 170
Lamb, Charles, 186
L'Arlesienne (Van Gogh), 14
Last Communion of Saint Jerome
 (Domenichino), 33
Last Judgment (Michelangelo), 134
Lead Piece (Andre), 155
Les Demoiselles d'Avignon, 23
Letter C as Comedian (Sugarman), 163
Lewitt, Sol, 138
Lichtenstein, Roy, 8, 12, 31, 156, 157,
 206
Lincoln Memorial, 112, 113
Lin, Maya, 93, 114–16, 120
Lissitzky, El, 135
Little Spanish Prison, The (Motherwell), 50
Louis XIV, 173
Louis XV, 171

MacConnel, Kim, 79
McCrory Corporation, 136
Magritte, 99
Maidenform Woman, The (Borofsky), 39

Mallarmé, Stephane, 49
Malevich, Kasimir, 97, 136
 White on White, 143
Man at the Crossroads Looking with Hope and
 High Vision to the Choosing of a New
 and Better Future (Rivera), 190–91
Mannerism, 53, 56, 184
Mantegna, Andrea, 126, 185
Man with a Briefcase (Borofsky), 39, 42
Martha Jackson Gallery, 10
Martin-Gropius-Bau, 38, 39
Masheck, Joseph, 42
Mask of Fear (Klee), 23
Matisse, Henri, 36, 97, 143, 162
Matos, John, 30
Masaccio, 29
May, Phil, 200
Mechanism of Meaning, The (Arakawa and
 Gins), 83, 84
Melencolia I (Dürer), 186–87
Merzbilder (Schwitters's collages), 101
Metropolitan Museum of Art, 6, 14, 30,
 53, 88, 129, 172, 184, 191
 Rockefeller Wing, 26
Mexican muralist movement, 191–92
Michelangelo, 53, 74, 156, 212
Miess, Millard, 69
Mill, John Stuart, 202–3
Minimalism, 9, 160
Miró, Joan, 62
Mistakes Of Blank (Forming Space)
 (exhibition), 81–84
Modernism, 159–60, 165
Moholy-Nagy, 138
Mondrian, Piet, 138, 139, 159
Mondrian Dancing (Rothenberg), 79
Monet, Claude, 15, 38, 143
Monuments, compared to memorials,
 112–13
Moore, Charles Herbert, 86
Moore, Henry, 96
Morandi, 100
Morris, Robert, 108, 111
Munch, Edvard, 24
Motherwell, Robert, 48–52, 100
 collages, 50
 occasional paintings, 50
 opens, 51
 Spanish elegies, 50–51, 52
Movements in art, phenomena of, 207–8
Murals, portable, of Diego Rivera, 191–92
Musée d'Ethnographie de Trocadéro, 26
Museo, Renaissance concept of, 183–84
Museum of Fine Arts, 183
Museum of Modern Art, 6, 23, 26, 27, 33,
 34, 43, 45, 61, 67, 68, 71, 91, 96,

INDEX

Museum of Modern Art (*cont.*)
103, 108, 111, 125, 136, 146, 177,
179
Museums, as consumers of artwork, 45–46

Nachmann, Franz Xaver, 126
Natanson, Alexandre, 148
National Gallery (Washington), 129, 131
Nauman, Bruce, 110
Neo-Expressionism, 38, 206, 209
Nevelson, Louise, 154
Newman, Barnett, 153, 155, 156, 157
New Orleans #7 (Crawford), 143
New Orleans Still Life (Crawford), 143
New Path, The (magazine), 85, 86, 87
New Museum, The, 19
New School for Social Research, 193
New Workers School, 191
New Work on Paper 3 (exhibition), 108
New York, art world in 1950s, 2–3,
140–41
New York School of Painting, 34, 43, 192
New Yorker, The, 2, 3
Nietzsche, Friedrich, 13, 14
Eternal Recurrence, theory of, 203
1970s, "end of art" in, 203–5
1980s, and Neo-Expressionism, 206–7
Noon (Krasner), 35
NRF (French magazine), 50
Nyamwezi, 23, 27

Oldenburg, Claes, 11, 12, 29, 116
Orcagna brothers, 69–70
Orientalism, 25, 26
Oudry, 127
Overseas Highway (Crawford), 141

Pace Gallery, 43
Panofsky, Erwin, 187
and thesis of *Perspective as Symbolic Form*,
214–15
Paper
availability of and emergence of
drawing, 72–74
works on, 106–11
Patronage, concept of in late twentieth
century, 45–46
Paula Cooper Gallery, 40, 41, 165
Pearl Mosque of Agra, 132
Pennsylvania Academy of the Fine Arts,
200
Perpendicularists, 139
Perspective, discovery of, and impact on
art, 212
and Panofsky's theory, 214–15
Phenomenology of Mind (Hegel), 83

Philadelphia Museum of Art, The, 39, 96,
192, 194
Phillips, Liz, 78
Philosophical history of art, 202–18
Gombrich and progressive theory,
211–12, 215
modern art, and self-comprehension,
216–17
movements in art, 207–8
narrative sense of ending of art, 211,
215
1950s, and New York influence on art,
140–41
1970s, and "end of art," 203–5, 217
1980s, and Neo-Expressionism, 206–7
painting, and discovery of true identity,
216
perspective, discovery of, 212, 214–15
post-historical period, 216–17
Philosophy of art, versus criticism, 4–6, 7
See also Philosophical history of art
Photography, impact of on painting, 86,
213
Picasso, 24, 25, 26, 27, 36, 38, 91, 97,
102, 157, 162, 197
and Rousseau, 67, 70
Pickvance, Ronald, 16
Pierpont Morgan Library, 72, 107, 126
Piranesi, Giovanni Battista, 127
Pirckheimer, Willibald, 186
Plato, 1, 4, 52, 172, 212
Pluralism of 1970s art world, 204–5
Pochoda, Elizabeth, 5
Pointillism, 15
Pollock, Jackson, 23, 30, 34, 35, 53, 59,
60, 143, 165, 197
Poor Streetwalker! (Toulouse-Lautrec), 149
Pop Art, 5, 9, 31, 98, 140, 206, 208, 209
Porter, Fairfield, 78
Portrait of the Artist as an Old Man (Fischl),
78
Posters of Toulouse-Lautrec, 146–49
Postmodernism, and geometric forms, 135
Potter, Beatrix, 85
Poussin, Nicolas, 33, 165
Praying Hands (Dürer), 74
Pre-Raphaelite Brotherhood (English), 85,
88
"Primitivism" in 20th Century Art
(exhibition), 6, 23–27
Prince Charming (MacConnel), 79
Proust, Marcel, 146
Public art, 189–90
America Today (Benton), 193–94
criteria for, 90–94
Mexican program of, 192, 193–94

INDEX

political use of, 190–91, 192–93
underinvolvement of public with, 119–21
See also Rivera, Diego; Serra, Richard; Vietnam Veterans Memorial

Radke, M., 13, 116
Raft of the Medusa, The (Géricault), 107, 125
Rape of Europa, The (Boucher), 175–76
Raphäel, 33, 165
Rappers, 28
Rauschenberg, Robert, 11, 61, 157
Redon, Odilon, 127
Reinhardt, Ad, 136, 144
Rembrandt, 55, 73, 75, 127
Renaissance painting, 56
 painters, snobbish attitude of, 156
Reni, Guido, 53
Renoir, Auguste, 125
Requiem (Kline), 201
Rest on the Flight into Egypt, The (Rembrandt), 126
Rhapsody (Bartlett), 166–70
Riklis Collection, 136
Rivera, Diego, 190–95
 Detroit Industry, 194
 Figure Representing the Black Race, 194
 Man at the Crossroads . . . , 190–91
 and Mexican muralist movement, 191–92
Robert Miller Gallery, 164
Robusti, Jacopo, 29
Rockefeller, Nelson, 190–91
Rodchenko, Aleksandr, 135, 136
Rome, Baroque, 56
Ronald Feldman Fine Arts Gallery, 81, 82
Rondanini Pietà, 74
Rose, Barbara, 34, 35, 59
Rose, Bernice, 108–9, 111
Rosenberg, Harold, 3, 4, 6, 192
Rosenquist, James, 11, 12, 108, 109, 156
Rothenberg, Susan, 79
Rothko show, 49
Rousseau, Henri, 67–71
Rubens, Peter Paul, 20, 53, 75
Running Man (Borofsky), 39
Ruskin, John, 85, 86, 87, 89
Russell, John, 131
Russian Constructivism, 102, 135
Russian Modernists, 136
Ryman, Robert, 108, 110

Saarinen, Eero, 120
Saatchi, Doris and Charles, 21, 22
Said, Edward, 25

Saint Catherine (Rubens), 75
Saint Jerome in His Study (Dürer), 187
Salon des Indépendants, 70
Santayana, George, 146
Sartre, Jean-Paul, 180
Saskia as Flora (Rembrandt), 55
Savarin Can (Johns), 160
Schiele, Egon, 21
Schapiro, Meyer, 199
Schlüsselfelder Ship, 185–86
Schnabel, Julian, 43–47
Schwitters, Kurt, 101–5, 106, 137
 and *Merz*, 102–5
School of Paris, 96
Scully, Sean, 50
Sculpture
 Andre, Carl, 155
 de Kooning, Willem, 156
 Giacometti, 153–54, 155, 156
 Nevelson, Louise, 154
 Newman, Barnett, 155, 156, 157
 Renaissance prejudices, 156–57
 Segal, George, 157
 Serra, Richard, 90, 92, 93, 118, 122, 177–82
 Smith, David, 157–58
 Stankiewicz, Richard, 155
 Stoss, Veit, 188
 Sugarman, George, 159–64
 Transformations in Sculpture (exhibition), 153–58
Seagrams Building, 177–78
SEEN, 30
Segal, George, 157
Sense of Smell, The (Goltzius), 126
Serlio, Sebastiano, 184
Serra, Richard, 90, 92, 93, 118, 122, 177–82
 Delineator II, 181
 Terminal, 178–79
 Tilted Arc, 90–94, 118–19, 122, 177, 178, 179, 181
 Twain, 118
 Two Corner Curve, 181, 182
Sert, Misia, 148
Seurat, Georges, 15
Shah Jahan, 132
Shopsign of Gersaint (Watteau), 173
Shriek, The (Munch), 24
Siegfried (Kline), 201
Silverpoint, 15
Sixties, The (artworks of), 11
SKEME, 30
Sky Blue (Kandinsky), 65
Sky Cathedral — Moon Garden + One (Nevelson), 154

INDEX

Slave Ship, The (Turner), 134
Sleeping Gypsy, The (Rousseau), 67–68
Smith, David, 157
Socrates, 21
Spanish Painting with the Face of a Dog (Motherwell), 49
Spector, Professor Robert, 6
Stable Gallery, 208, 216
Steel Drawing 1 (Smith), 157–58
Steele, Richard, 6
Stein, Judith, 200
Steir, Pat, 110
Stieglitz, Alfred, 59
Storm King Sculpture Center, 93
Stoss, Veit, 188
Strozzi altarpiece, 70
Study for a View of Malakoff (Rousseau), 68
Sturgis, Russell, 85
Style Wars, 28
Subway art, 28–29
 See also Graffiti
Subway Art, 32
Sugarman, George, 159–64
 color, use of, 162–63
 reaction to prohibitions of 1960s, 160–61
Suprematism, 97, 136
Surrealism, 67, 155

Table (Rosenquist), 109
Taj Mahal, 132
Tall Figure (Giacometti), 23
Tatlin, Vladimir, 135–36, 138
Terminal (Serra), 178–79
Thales of Miletus, 168
Thaw Collection, 6, 124–28
This Side of Paradise (Kline), 200
Three Apostles (Mantegna), 126
Three Flags (Johns), 206
Three-seater toilet, de Kooning's, 58–61
Tintoretto, 29, 54
Tilted Arc (Serra), 90–94, 118–19, 122, 177, 178, 179
Tobey, Mark, 36
To Heal a Nation (Scruggs and Swerdlow), 116
Toilet of Venus, The (Boucher), 174
Toulouse-Lautrec, Henri de, 146–52
 Englishman at the Moulin Rouge, The, 150–51
 posters of, 146–49
 prostitutes, pictures of, 149–50
Transfiguration (Raphael), 165
Transfiguration of the Commonplace, The (Danto), 5, 6, 41, 208

Transformations in Sculpture (exhibition), 153–58
Twain (Serra), 118, 119, 121, 123
Two Corner Curve (Serra), 181
Two Studies of a Young Woman (Watteau), 73–74
Two Women (de Kooning), 206

University Art Museum (Berkeley, CA), 39
Untitled (Krasner), 35
Untitled (Stankiewicz), 155

Valenthuomini, 54
Van der Rohe, Mies, 177–78, 179
Vanderveer, Charles, 58, 59
Vanderwoude Tananbaum Gallery, 162
van Doesburg, Théo, 138, 139
van Eyck, Jan, 72
Van Gogh in Arles (exhibition), 6, 13–17
 Japanism and, 15
 orchards of, 15
 self-portrait, 16–17
Vasari, Giorgio, 70
Vertès, Marcel, 97
Vietnam Veterans Memorial (Lin), 93, 112–17, 120
von Kobell, Wilhelm, 128
von Saxe-Teschen, Duke Albert, 72

Waldman, Diane, 154
Walker Art Center, 39, 170
Warhol, Andy, 11, 12, 153, 156, 195, 208, 209, 216
Washington Monument, 112, 113
Watteau, Antoine, 73–74, 127, 173, 174
Weber, Max, 25
Welch, Stuart Cary, 131
Wesselmann, Tom, 12
White on White (Malevich), 143
Whitney Museum of American Art, 5, 6, 8, 9, 10, 11, 12, 39, 40, 141, 160
 Biennial of 1983, 18
 Biennial of 1985, 6, 77–80
Whitney Windspun (Phillips), 78
Wilson, Robert, 111
Wölfflin, Heinrich, 61
Wood, Grant, 141
Works on paper, 106–11
Writers (graffiti artists), 28–30, 31, 32

Yard (Kaprow), 10

Zeitgeist (exhibition), 38–42
Zen painting, 81